LAND OF
THE TURKS

LAND OF THE TURKS

Journeying through a Land of History and Hospitality

DENNIS JONES

NEW JERSEY • LONDON • FRANKFURT • CAIRO • JAKARTA

BLUE DOME
New York

Dennis Jones would like to thank his dear friend, retired English teacher extraordinaire, Thelma Rubenstein, for her insightful and invaluable help in editing the text.

Published by Blue Dome Press
535 Fifth Avenue, Ste. 601
New York, NY 10017-8019, USA

www.bluedomepress.com

Art Director Engin Çiftçi
Graphic Design Veysel Demirel, Nihat İnce
Photographs Dennis Jones

ISBN: 978-1-935295-47-1

Printed by
Neşe Matbaacılık A.Ş., Istanbul - Turkey

CONTENTS

WHY TURKEY?

As a bridge between East and West, Turkey is the home of remarkable and astonishing contrasts between the traditional and the modern. With a history that stretches from prehistoric Mesopotamia through the ancient, cosmopolitan Greco-Roman civilizations to the opulence of the Seljuk and Ottoman heritage and into today's gleaming cities of steel and glass, Turkey's unique patrimony is unmatched in the world.

Layered upon one another, Turkey's history extends to the earliest flickers of human civilization as each culture in turn gained power, blended together and died out. Their enduring universal values provided the foundation for contemporary Turkey. The ghosts of many of western history's most notable people can be discovered along the roads and in the towns of Anatolia: Alexander the Great, Suleiman the Magnificent, Julius Caesar, Antony and Cleopatra, Hippocrates, St. Paul, Rumi, Mother Mary and yes, even Santa Claus.

It is therefore, no doubt presumptuous that someone with only seventy days of in-country experience should attempt to write a book on a subject as culturally rich and historically complex as Turkey. I make no claim to expertise. There are others with a far more intimate connection to this fascinating country, people who should be read for their political, historical, and cultural insights.

What I hope to bring, first and foremost, is an artistic eye honed by thirty years of earning my living as a professional photographer.

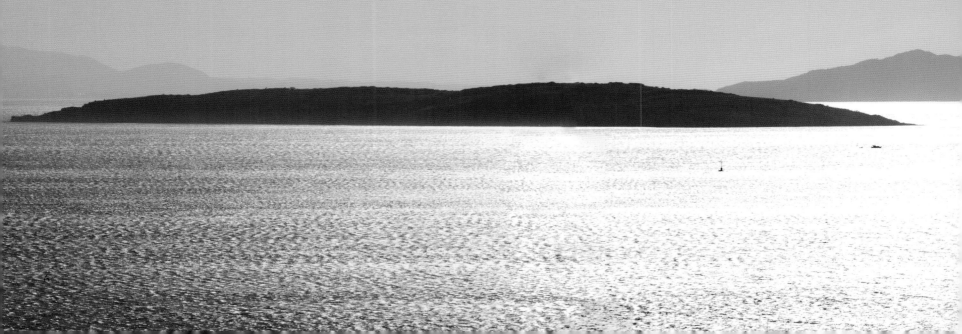

Additionally, I aspire to a childlike wonder, a cultivated sense of innocence tempered by extensive world travels that is, I pray, open and unbiased rather than naive. I would rather risk the scorn of the cynical than allow skepticism to distort my perceptions.

My tendency is to take people at face value until proven otherwise and to travel without expectation. I believe firmly in the goodness of my fellow man. In Turkey, that virtue was on display time and again.

They say that not all who wander are lost, and one of my greatest joys is to wander. I rarely travel with fixed plans, two ten-day tours in Turkey being the rare exception. My first tour, sponsored by the Los Angeles-based Turkish-American group, the Pacifica Institute, opened invaluable doors of insight into Turkish culture and its people which would have been next to impossible to gain otherwise. The second one, a commercial tour two years later, took me to places not visited on the first and provided a broader historical context while reinforcing and deepening my cultural understanding.

But I much prefer the freedom that allows being open to diversion and leads one to experiences never imagined. In Turkey, diversions are often manifest in cups of tea; to always saying "Yes!" to that proffered cup, offer of assistance or merely to a curious question.

I strive to be open to whomever and wherever these detours lead. Barring a language barrier—which is sad for both parties—they can lead to

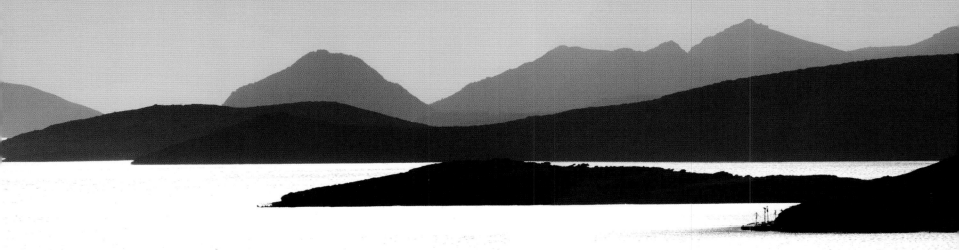

The islands and peninsulas of Turkey's southwest Aegean coast, Bodrum

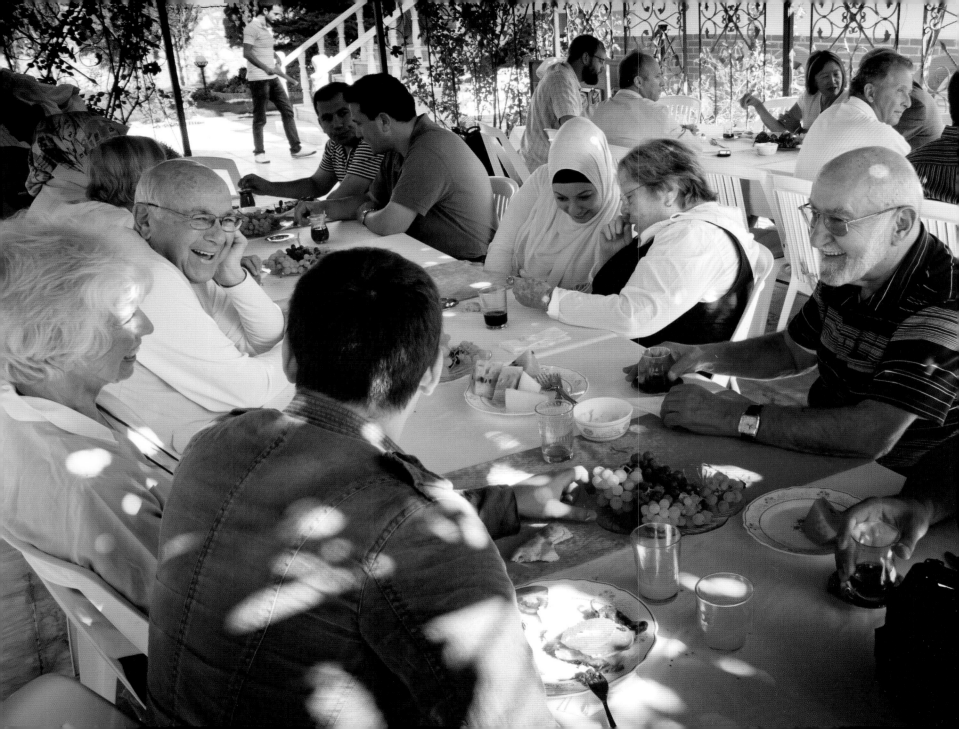

fascinating conversations and learning opportunities, several of which are recounted in this book.

Additionally, I never refuse someone's request to be photographed. Elsewhere in the world, it is rare for a stranger to ask to be photographed. In Turkey, it happens all the time. Turks love to have their picture taken! I cannot say I fully understand, but I believe this is related to their innate sense of hospitality, their generous spirit and desire to share themselves.

It's true that I miss things in these wanderings. I can spend hours ambling along side streets while the thoroughfares harboring the "most important" landmarks are passed by. Occasionally these explorations prove unfruitful, but that is the exception. The people I meet and the images I happen upon while meandering about are frequently the most rewarding.

Additionally, even wandering the choked alleys of slums, there wasn't a minute in which I felt unsafe. The watchful eyes of grandmothers from balconies or their roof-top perches were constantly on guard.

Like most Americans, Turkey was not on my radar. Out of the 30 or so million foreign tourists traveling to

Our new friends from Mardin read our fortune in the coffee grounds of the delicious almond-flavored Surian coffee.

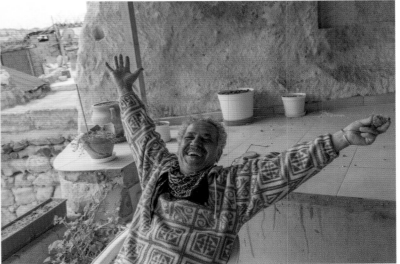

Mehmet Bilgin in front of his house in Nar, Cappadocia

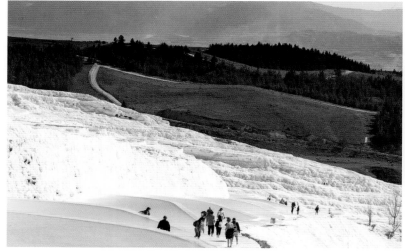
Tourists wander the travertine terraces of Pamukkale

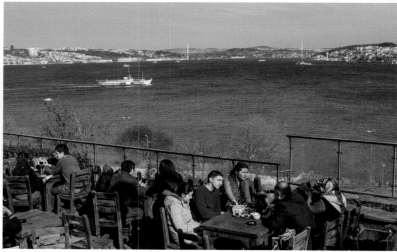
A lovely winter afternoon for tea above the Bosphorus

Turkey each year only a surprising 200,000–300,000 are Americans. The majority are Germans, Russians, British and other Northern Europeans taking advantage of inexpensive, all-inclusive deals, many of whom never set foot outside their gorgeous Mediterranean or Aegean resorts.

Ask most Americans about Turkey—one of the top ten travel destinations in the world—and they will think of camels and deserts, of radical Islam and Al Qaeda. They may believe it to be in the Middle East (it is not) or to be governed by Sharia Law (definitly not!). Worse yet, they may remember the 1979 movie, "Midnight Express," a terrible attack on Turkey's image and an aberration if ever there was one.

They may conjure images of bedouins and the "savage, marauding Turk" of 17th century Viennese nightmares, or of Sultans on golden thrones surrounded by dozens of beautiful harem girls along with images of turbaned pashas reclining upon luxurious pillows smoking water pipes.

Tell an acquaintance you're going to Turkey and their immediate reaction will be, "Why do you want to go there? Isn't it dangerous?" This couldn't be further from the truth.

For one thing, Turks are originally horse people of Central Asia who advanced westward and settled in Anatolia a millennia ago after the victory of Manzikert. They speak Turkish, not Arabic. Turkey is an extremely diverse country with an amazing heritage of rich cultures. Its people are as varied as its landscape. Additionally, major mountain ranges, majestically snow-capped in winter, extend over huge portions of the country, allowing all kinds of winter sports. Turkey is the land of four seasons. With almost six months of summer, the coastal regions and southern parts of the country, especially the Turkish Riviera, enjoy a

10

Looking east toward the Taurus Mountains from the ancient Greco-Roman city of Hierapolis

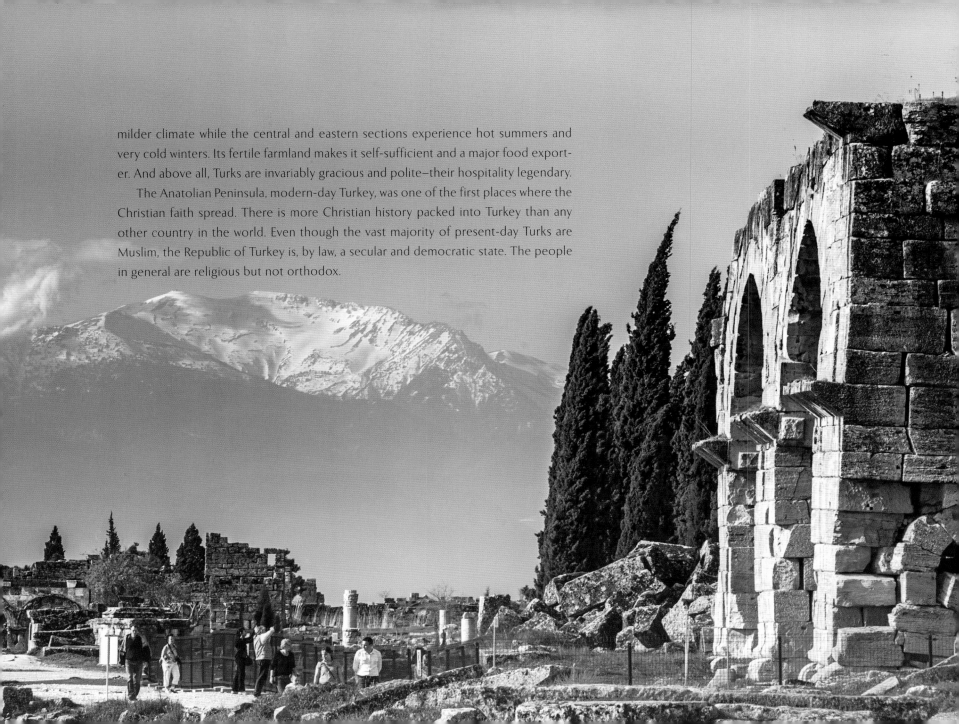

milder climate while the central and eastern sections experience hot summers and very cold winters. Its fertile farmland makes it self-sufficient and a major food exporter. And above all, Turks are invariably gracious and polite—their hospitality legendary.

The Anatolian Peninsula, modern-day Turkey, was one of the first places where the Christian faith spread. There is more Christian history packed into Turkey than any other country in the world. Even though the vast majority of present-day Turks are Muslim, the Republic of Turkey is, by law, a secular and democratic state. The people in general are religious but not orthodox.

The depth of history in Turkey is staggering. The literal roots of civilization have been unearthed outside of Şanlıurfa in upper Mesopotamia, present-day southeastern Turkey. Abraham, the patriarch of monotheism, called the area home.

It is said there are more Roman and Greek ruins in Turkey than in Italy and Greece themselves. I can believe it. The country is chock full of ancient sites from cultures long vanished.

The Old Testament of the Bible is full of references to civilizations that flourished in Anatolia. On Turkey's eastern border with Iran sits 17,000-foot Mt. Ararat, Noah's storied mountain from the book of Genesis on which his ark eventually came to rest after the flood.

And for perspective, the Neolithic Era, that momentous period when humanity made the leap from hunting and gathering to agriculture and civilization, took place between the Tigris and Euphrates in Anatolia 10,000 years ago, around 8,000 BCE.

In the Southwestern U.S., that leap happened nine thousand years later, during the 10th century CE.

So when the question "Why Turkey?" is asked, the brief answers above only begin to scratch the surface.

Today's Turkey is a modern, democratic state struggling between looking westward, toward acceptance into an integrated Europe, and glancing eastward, to its seemingly natural position of leadership in the Middle East.

This is a culmination of one hundred years of reinventing itself. With the 17th largest economy, the fifth largest army, a well-educated, youthful population, and a dynamic business sector, Turkey is gaining self-confidence and establishing its presence in the world.

I would like to express my deepest appreciation to the Pacifica Institute for including both Yolanda and me on one of their inter-cultural exchanges. I would especially like to warmly thank their counterparts in Turkey, who generously sponsored our group, invited us into their homes, shared meals with us, showed incredibly warm hospitality, patiently tolerated our probing questions, and weighed us down with gifts. I also have to express my heartfelt gratitude to our exceptional guides, Serkan Yıldırım, Cem Eruyan and Salih Bey, who provided not just excellent organization and information but, through their different personalities, insights into the sincere, heartfelt character of the Turkish people.

Hopefully, what follows will encourage more Americans, as well as people of all nationalities, to put aside their misconceptions and allow themselves to wander the cultural and historical vastness of this beautiful and hospitable region. I pray, in the name of inter-cultural relations as well as religious tolerance and understanding, that this book may inspire others to reach beyond the confines of their beautiful, all-inclusive beach resort and explore the diversity of this amazing country.

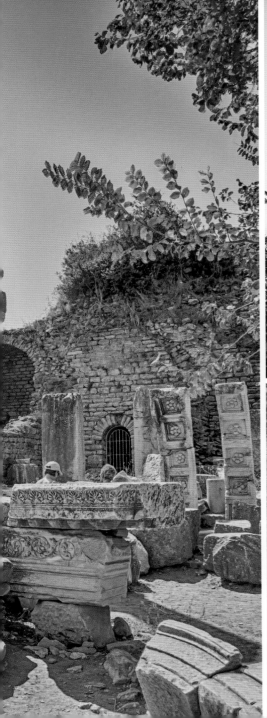

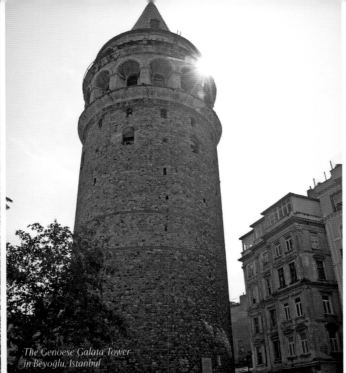

The Genoese Galata Tower in Beyoğlu, Istanbul

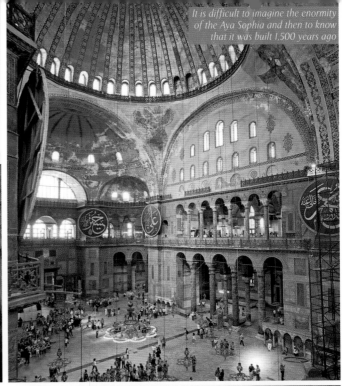

It is difficult to imagine the enormity of the Aya Sophia and then to know that it was built 1,500 years ago

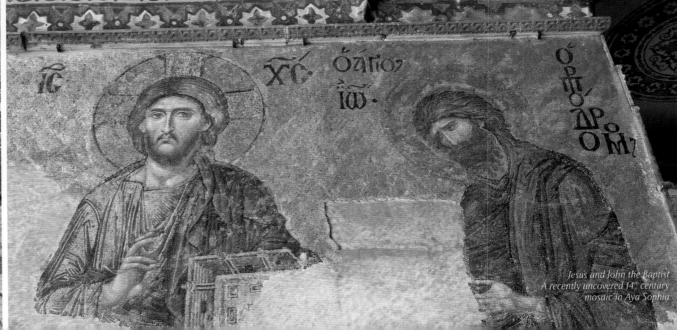

Jesus and John the Baptist
A recently uncovered 14th century mosaic in Aya Sophia

INTRODUCTION

I came to Turkey for the first time in the fall. I was incredibly fortunate to be part of a cultural exchange sponsored by the Los Angeles-based Pacifica Institute, a group of Turkish-Americans dedicated to promoting inter-cultural relations.

Yolanda and I spent ten enlightening days in the company of seven intelligent, inquisitive, liberal-minded individuals led by our two guides, Serkan Yıldırım and Cem Eruyan, both Turkish nationals. Serkan, an irrepressible, middle-school science teacher, had never been to the US but was moving immediately after the tour to teach in Los Angeles. Cem had been living in LA for

nine years. He happened to be returning to fulfill his military obligation—an imperative for every Turkish male. None of us knew what to expect from Turkey or each other.

To say we meshed is an understatement. We visited many of the historical wonders of Turkey, but more importantly, we spent time with its people. Every city we visited provided an opportunity to meet local families who generously shared their food and their world-views with us.

Yolanda and I were blessed to be in the company of this erudite group because the probing questions that continually came

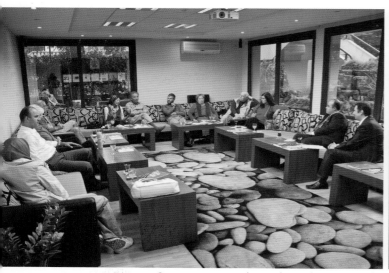

Our group meeting with journalists at the GYV in Istanbul

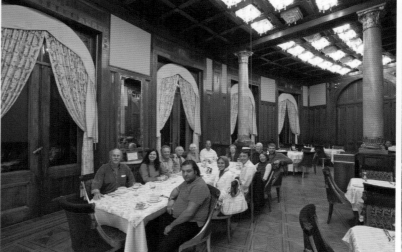

Having dinner together at a restaurant in a former Ottoman palace somewhere on the Asian side of the Bosphorus

Strolling along Dolmabahçe Avenue in Beşiktaş

up for the journalists, businessmen, civic leaders, university professors and Muslim clerics we met provided insights I could never have gotten on my own.

As is our wont, Yolanda and I arrived several days before the tour and stayed several weeks after to explore Turkey on our own. Armed with the knowledge we gained during the tour and from our guides, we were able to appreciate the culture and the people in ways we otherwise could not have. And through their suggestions, we visited areas we wouldn't have considered.

Our second trip came in the spring. Having received a contract to write this book from the Istanbul office of the New York-based Blue Dome Press, it was imperative that I return to explore areas not visited previously.

I happened upon an exceptional deal for a ten day tour. Knowing that we could book the tour date, arrive in Turkey much earlier and leave much later, it was a natural. We arrived in Istanbul during winter in northern Turkey. The trees were bare, but we were pleasantly surprised by the colorful blossoms already adorning Gülhane Park–the historical outer garden of the Ottoman Topkapı Palace–and the copious flower beds around the Sultanahmet Square in Istanbul's historic peninsula.

We wanted warmth though, so headed quickly to the rocky coves and headlands of the southeastern Aegean coast to experi-

Breakfast in Nigde

Modern and traditional, Istanbul

Selling donut holes and ice cream on a cold spring day on Büyükada

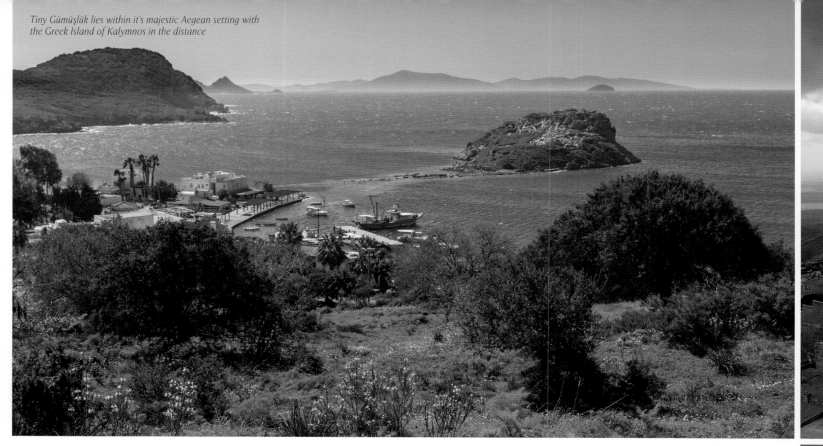

Tiny Gümüşlük lies within it's majestic Aegean setting with the Greek Island of Kalymnos in the distance

ence the extensive coastline and azure waters of the Bodrum Peninsula.

Returning to the transcontinental city of Istanbul, we met the tour and were again amazed at not just the quality of the accommodations and food, but especially with our guide, Salih Bey. His vast experience and understanding of his home country was amplified through decades living in the US, his Kurdish heritage, five languages and four passports. His insights into Turkish culture, family life and government, as well as his broad knowledge of its history, complement these pages.

After the tour, Salih encouraged us to visit Turkey's southeast and his Kurdish home town, the ancient Silk Road city of Mardin. Any com-

prehensive picture of the complexity of Turkey would be incomplete without this perspective; it would be kind of like trying to understand Louisiana's culture by visiting New Orleans alone.

Much of the history of monotheism is centered around Anatolia, or Asia Minor, which comprises most of present-day Turkey. It is the region the Apostle Paul traveled while spreading his "good news." His letters, codified in the New Testament, were written to followers throughout Turkey. The biblical city of Antioch is present day Antakya, the Nicene Creed (named after the northern city of Nicea) was written in İznik, now famous for its exquisite Ottoman-style tile and ceramics. The seven

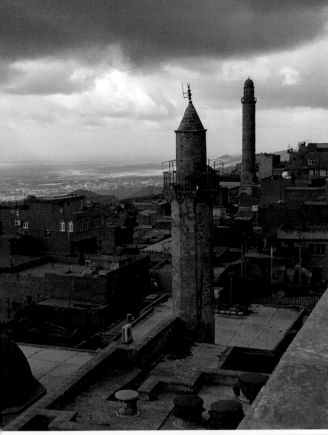

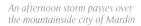

An afternoon storm passes over the mountainside city of Mardin

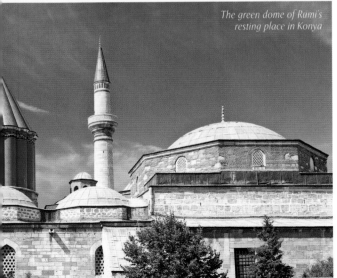

The green dome of Rumi's resting place in Konya

churches mentioned in Revelations–Ephesus, Laodicea, Pergamos, Philadelphia, Sardis, Smyrna and Thyatira–were all in the Anatolian Peninsula. It is also where Mary, the mother of Jesus, reputedly spent her last years.

What followed was 1,000 years of the Byzantine Empire during which the Eastern Orthodox Church was born and flourished.

There is also a long, deep Jewish history within Turkey. For 700 years, Anatolia was a land of refuge, extending an open invitation to those expelled from Spain or persecuted by Christians throughout Europe and Russia. An ancient synagogue, unearthed in the city of Sart, in Western Anatolia, indicates a Jewish presence since the third century BCE.

As for Islam, the Seljuk Turks brought it with them in the 11th century CE as they expanded into Anatolia. Konya, the 13th century capital of the Seljuk Empire, was the home of Rumi, the Mevlana, the poet and saint of Sufism. His teachings about love, hospitality, compassion, and tolerance are at the heart of this most spiritual, inner aspect of Islam and are exemplified in the Turkey of today.

Perhaps it is the depth to which Rumi's spiritualism pervades Turkish culture that Turks see themselves as very tolerant and welcoming and without resentment, even against aggressors. It is possibly this character trait that inspired the words of Mustafa Kemal Atatürk, the founding father of the modern Republic, which are inscribed into the Gallipoli Memorial dedicated to the hundreds of thousands of Australian and New Zealand youth who died in the World War I assault on Turkish soil:

"Those heroes who shed their blood and lost their lives, you are now lying in the soil of a friendly country. Therefore rest in peace. There is no difference between the Johnnies and the Mehmets to us where they lie side by side in this country of ours. You, the mothers who sent their sons from far away countries wipe away your tears, your sons are now lying in our bosoms and are in peace. After having lost their lives on this land they become our sons as well."

Perhaps this enlightened frame of mind came about not just through the spiritual influence of Rumi, but also from the perspective of looking down the millennia to the very earliest embers left by those long-dead hunter-gatherers who somehow organized around whatever long-lost spiritual yearnings they possessed to undertake the construction of the first religious center known to man.

So, what did I find?

A vast span of history reaching back literally to the earliest glimmers of civilization; a modern country, if not fully first world, then clearly right on the heels of those who might arrogantly claim their pre-eminent status; a deeply traditional culture living parallel with a secular society as advanced as any on the planet; a wealthy, have-it-all class side by side with itinerant workers living in shanty towns within major cities; new developments of expensive, single-family weekend homes surrounded by farming villages steeped in the traditions of agriculture and religion; vast stands of ticky-tacky, northern European vacation boxes running amok over the hills and along the coves of some of the most gorgeous coastline to be found anywhere; high, snow-capped peaks watching over enormously fertile valleys; ancient, wildflower-bedecked ruins of fabulously wealthy Greek and Roman cities; the silted-up harbor by which the most famous city of mythology, lost to time for almost two millennia, made its fortune; incredibly fertile gardens of Eden lying deep within the shadowed, steep-walled valleys of high mountain ranges; vast underground cities carved no less fantastically from the volcanic tuff than the other-worldly cave houses, rock-hewn churches and fairy chimneys sitting above them; a Victorian-era, Ottoman enclave directly beneath the gaze of Istanbul's bustling multi-millions whose

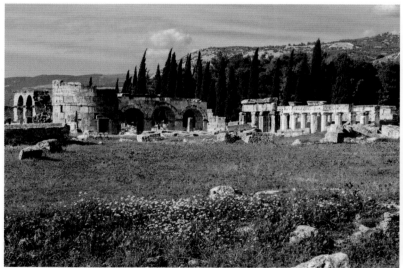

A profusion of wild flowers grows amidst the ruins of the ancient Roman city of Hierapolis

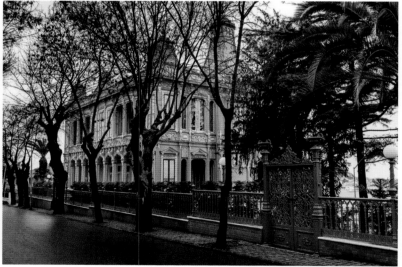

A gloriously restored Ottoman mansion sits majestically along Büyükada's main avenue

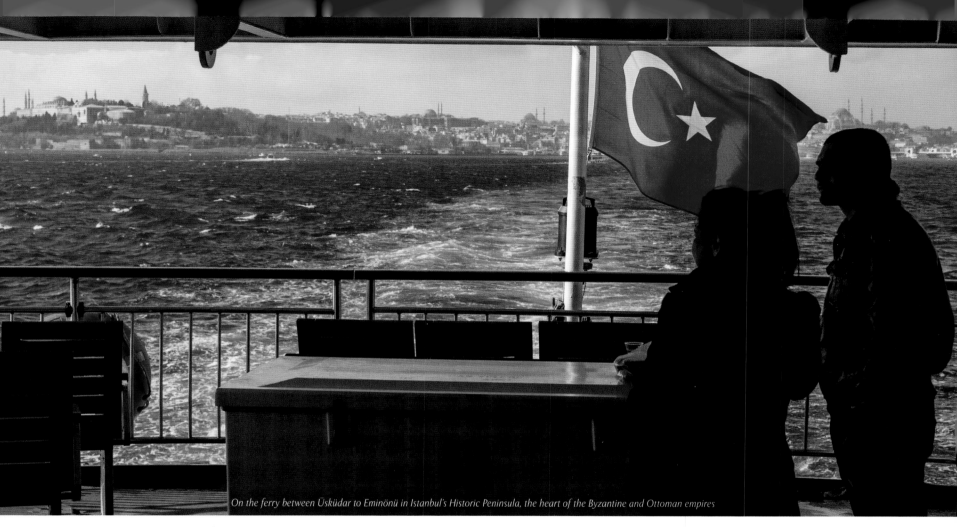

On the ferry between Üsküdar to Eminönü in Istanbul's Historic Peninsula, the heart of the Byzantine and Ottoman empires

quiet streets echo the muffled clip-clop of rubber-shod horses pulling carriages—this the only transportation; a vast, powerful empire that spanned the five hundred years preceding the industrial revolution; the cradle of the three, great, monotheistic religions, and if not the birthplace, then certainly the land in which Christianity spent its toddler years.

Above all though, I found a warm-hearted, exceedingly polite, family-oriented people; a people generous in their desire to help and eager to be understood; a tolerant, welcoming people; a people proud of the checkered heritage that brought them to this future and a people proud to call themselves Turks.

19

ISTANBUL'A HOŞ GELDİNİZ

Istanbul, Turkey's greatest city, is our introduction to the country's deep, fascinating history and famous hospitality. It is a bustling megalopolis of about 15 million people. My first impression is of a clean, modern city of broad avenues, low hills and a skyline punctuated with the needle-like minarets of numerous mosques rising out of the surrounding masses of multi-level apartment buildings.

Our taxi takes us on the highway running east along the north shore of the Sea of Marmara. This broad sea separates Europe from Asia. The narrows of the Bosphorus, leading to the Black Sea and splitting Istanbul in two, lie in front of us. A wide, tree-lined park with a recreation path extends for miles along the shore, eventually leading us to Sultanahmet, the ancient quarter of Istanbul.

Turning off the highway, we pass through Istanbul's 1,700 year-old Byzantine walls into a maze of crooked streets lined with restaurants. Men, appearing as timeless as the walls, sit in groups around low tables smoking nargiles, the classic Turkish water pipe.

Our driver deposits us in front of an Ottoman mansion, a pasha's home from the mid-nineteenth century, the Turkuaz Hotel, appropriately painted bright turquoise. Walking down a level through a cool, tree-shaded courtyard, Yolanda and I enter the lobby and step into another world. Here we find the aesthetic of exotic Turkey: marble floors, walls tiled in colorful, geometric designs, dark, wooden pillars supporting a low paneled ceiling and pillowed benches lining the walls. Ottoman lamps, like large jewels, drip from the ceiling.

Maria, the owner, speaking lightly accented English, shows us to our room, the Sultan's Room. It's beautiful with its decadent thick, velvet drapes and crystal chandelier. Though not a large or expensive room, it is richly furnished with frou-frou chairs, lamps, dark-wood cabinets and a curtained window seat which Yolanda immediately usurps for a jet-lag induced nap.

Two delicious hours later, we are awakened by the first of what will become innumerable *Adhan*s, the calling of the faithful to late afternoon prayer. Rising and washing, we set out for dinner at a nearby restaurant Maria recommends.

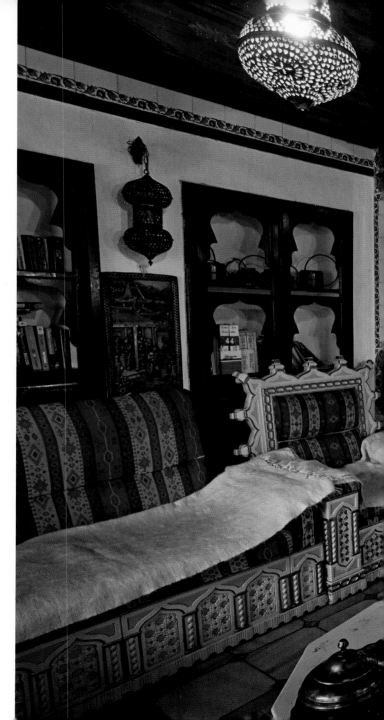

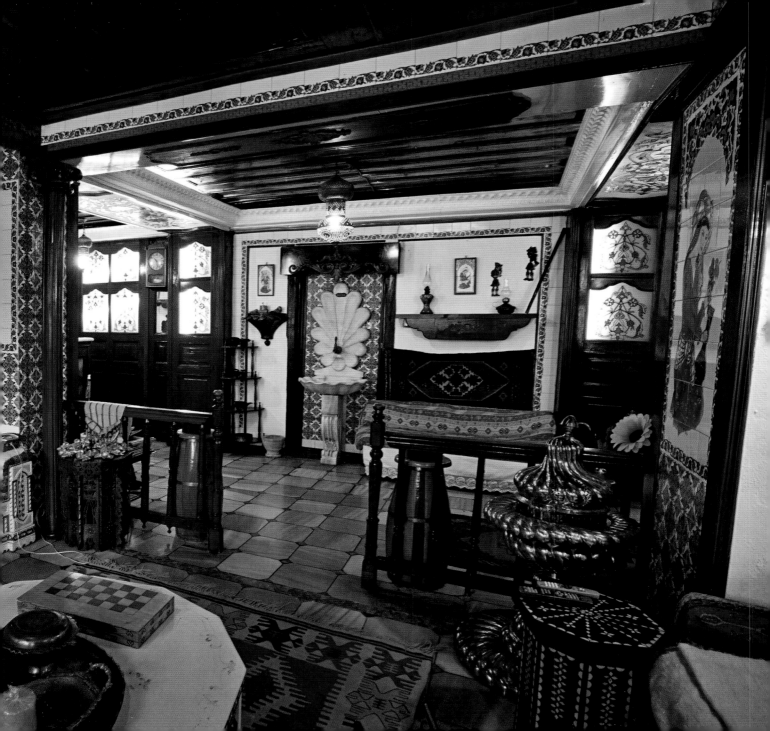

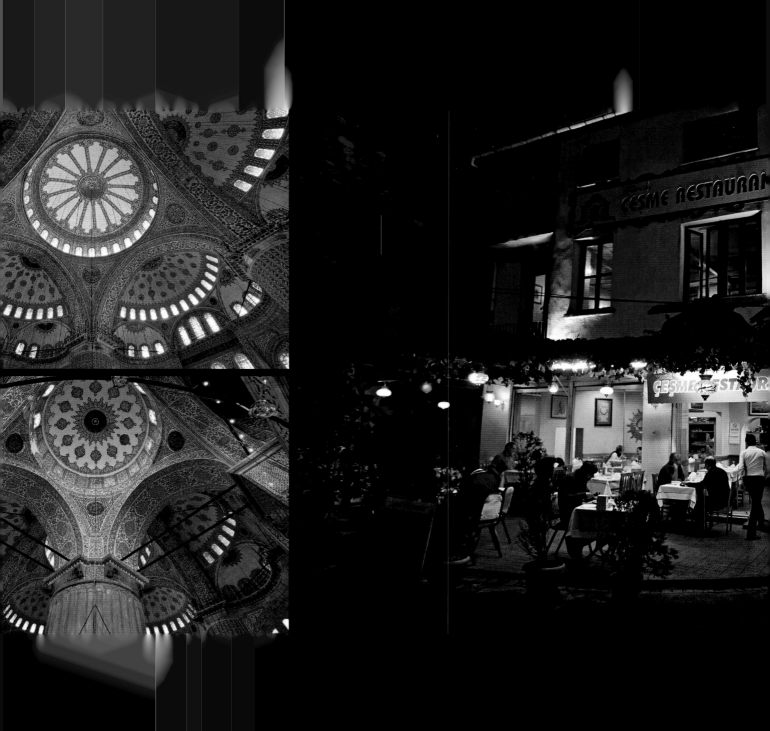

Tarihi Çeşme, meaning "historical fountain," is a find. The street-side tables beneath the shade of a broad grape arbor quickly fill with tourists and Istanbullus alike. The restaurant's namesake fountain sits beside the street while an ancient Byzantine wall forms a backdrop.

Perhaps ten different meze, Turkish appetizers, are brought on a tray. We pick a spicy eggplant dish and another of a yogurt-based sauce similar to Greek tzatziki. A scrumptious flat bread, puffed and piping hot from the oven, appears and we begin our first meal of renowned Turkish cuisine: chicken kebap and the house special lamb kebap.

Traffic flows sporadically along the cobbles of the ancient, narrow street, barely wide enough for two cars. The occasional truck or bus stops to negotiate the sharp corner, clogging traffic and causing honking and some entertaining arguing. As night descends, we finish our meal with the traditional tulip-shaped, glass cups of ruby-red Turkish tea and head up the winding street to the old Roman Hippodrome and Istanbul's famous Blue Mosque.

The long, narrow, well-lit plaza of what had been the city's racetrack two millennia ago is quiet. A few couples stroll between the monuments. An ice cream vendor fills an infrequent cone. Men, sitting among large pillows along the thousand-year old walls, talk quietly, drawing an occasional breath of pungent tobacco from a large nargile.

Meandering along, we find ourselves in the entry courtyard to Istanbul's largest and most famous mosque. The Blue Mosque, or in reality, the Sultan Ahmed Mosque, built by the sultan in 1616, is a sublime structure. Six elegant minarets rise high above the multiple domes, dramatically lit against the night sky.

The sacred silence is punctuated occasionally by the click of high heels on stones. Several tourists murmur in a far corner. A camera shutter softly clicks. Suddenly, the *Adhan*, the call to prayer, explodes in the courtyard, one long, loud, unbroken phrase: *Allahu Akbar-Allahu Akbar*–God is great– God is great.

It's spine tingling! Then from afar, the night turns magical as the Adhan is echoed by a distant mosque. The two *muezzins*, callers to the prayer, trade phrases back and forth until once again silence reins over the ancient city. A more beautiful and appropriate introduction to Istanbul could not have been experienced.

The following evening we meet with our small tour group. We are touring with seven others on a cultural exchange sponsored by California's Pacifica Institute, a group of Turkish Americans inspired by the philanthropic Gülen Movement's philosophy of dialogue and peace, seeking to build bridges of understanding between peoples.

Our group, which quickly becomes family, is composed of a neural-biologist and his wife who teaches Asian studies, both professors at UCLA; a former judge and constitutional law professor and his wife, an accomplished Israeli-born artist; a former Jesuit monk, now a motivational speaker and his wife who works with interfaith organizations; a twenty-something recent graduate who also works with interfaith organizations; a Turkish-American businessman returning to Turkey for his obligatory army service; and our Turkish guide, Serkan, a middle school science teacher, who will pack up his family immediately after the tour for a three-year stint teaching in Los Angeles. During our introductory dinner that evening, we learn that our proposed itinerary, along with our preconceptions about Turkish customs, could be thrown out the window.

We rise early the next morning for a typical Turkish breakfast of tea, bread, honey, olives, cheeses, tomatoes and cucumbers; we are to tour the Dolmabahçe Palace before the hordes of tourists arrive.

This is our first taste of Ottoman opulence on the European side of the Bosphorus. Built in the mid 1800's, it is an entirely European edifice-think Paris Opera. The palace is an enormous complex of lavishly decorated state and private rooms, 285 of them, set majestically along the Bosphorus. The Ceremonial Hall is an eye-boggling work of decadence. Its vast dome supports the largest crystal chandelier ever made, weighing 4.5 tons and containing 750 lights, a gift to the Sultan from Queen Victoria. Three thousand artists spent three to four years completing the gilt, faux marble and elaborate flourishes of this gigantic room alone. And yes, Sultan Abdülmecid, who reigned for over two decades during the decline of the empire, built this architectural masterpiece by borrowing large sums of foreign capital while mortgaging important revenue sources of the imperial treasury!

The Jewish Museum is next on the itinerary. 700 years ago, when the Spanish were driving out or forcibly converting Jews, the Ottoman Sultan welcomed them to his empire. Jews from around Europe, Russia, and Africa found refuge over the centuries. A thriving community exists today. The

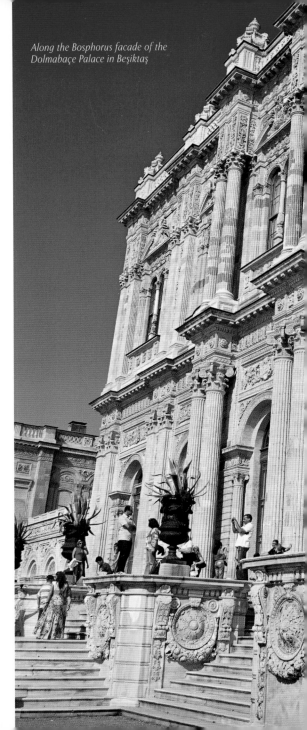

Along the Bosphorus facade of the Dolmabaçe Palace in Beşiktaş

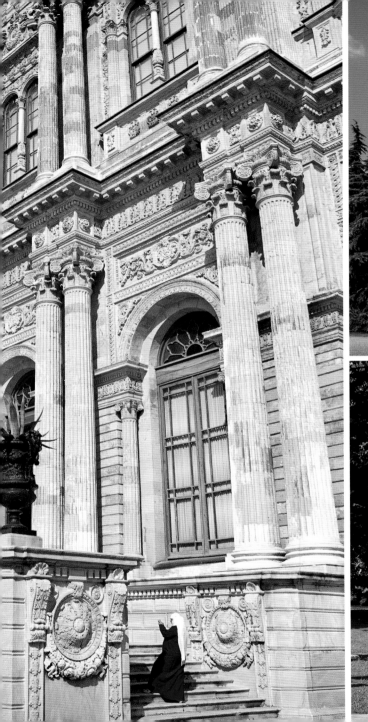

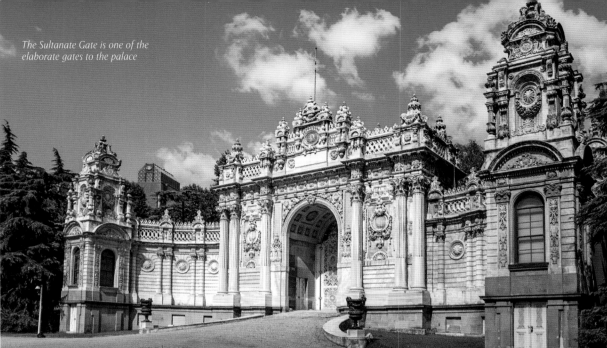

The Sultanate Gate is one of the elaborate gates to the palace

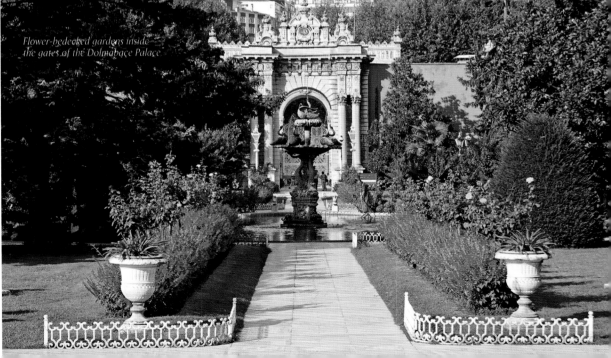

Flower-bedecked gardens inside the gates of the Dolmabaçe Palace

Fishing on the Galata Bridge, Istanbul

The fish restaurants next to the Galata Bridge in Eminönü with the Süleymaniye Mosque on the hill behind

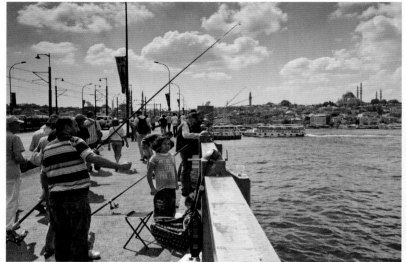

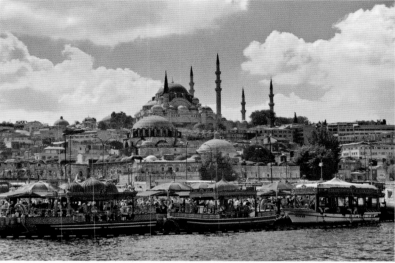

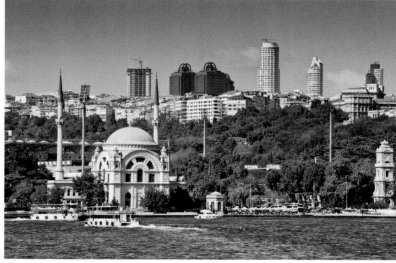

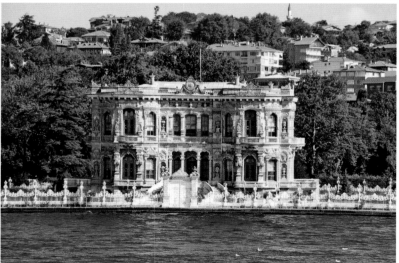

Along the European shore of the Bosphorus in Beşiktaş

19th century Ottoman palace on the Asian side of the Bosphorus

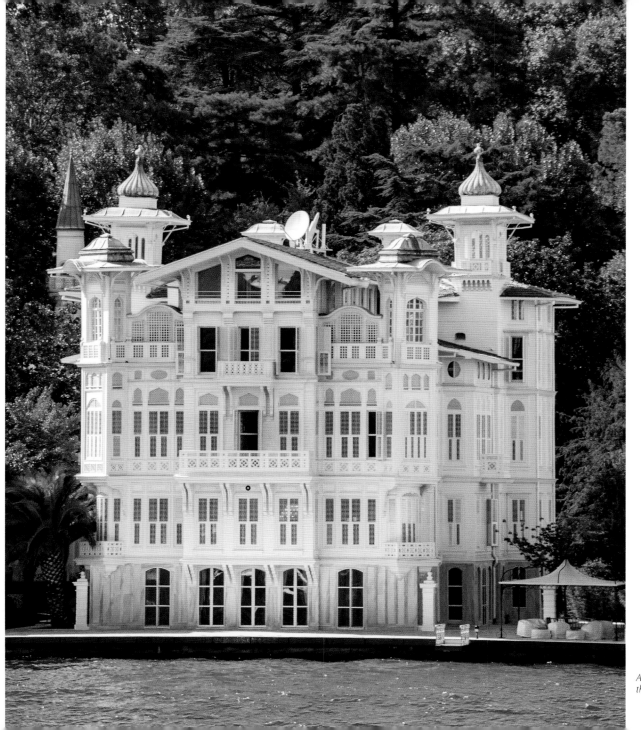

museum, in a lovely, old synagogue, documents Jewish life in Ottoman and contemporary Istanbul. It is an eye-opening look at religious tolerance under Islam.

An afternoon of perfect weather calls for a tour on the Bosphorus. For several hours we cruise between Europe and Asia. High hills, covered with dense forests of trees and apartments, rise on both sides. Tiny, quaint harbors filled with sail boats dot the coast.

Elegant, wooden mansions from the 19th century line the waterfront along with several stately palaces from the Ottoman era. The minarets of small mosques rise above the tree-lined shore as modern high-rises crowd the hilltops behind the majestic Victorian bulk of Dolmabahçe Palace.

The massive, stone bulwarks of 560 year-old Rumelihisarı (Rumelian Fortress), built by

A magnificently restored Yalı on the European shore of the Bosphorus

27

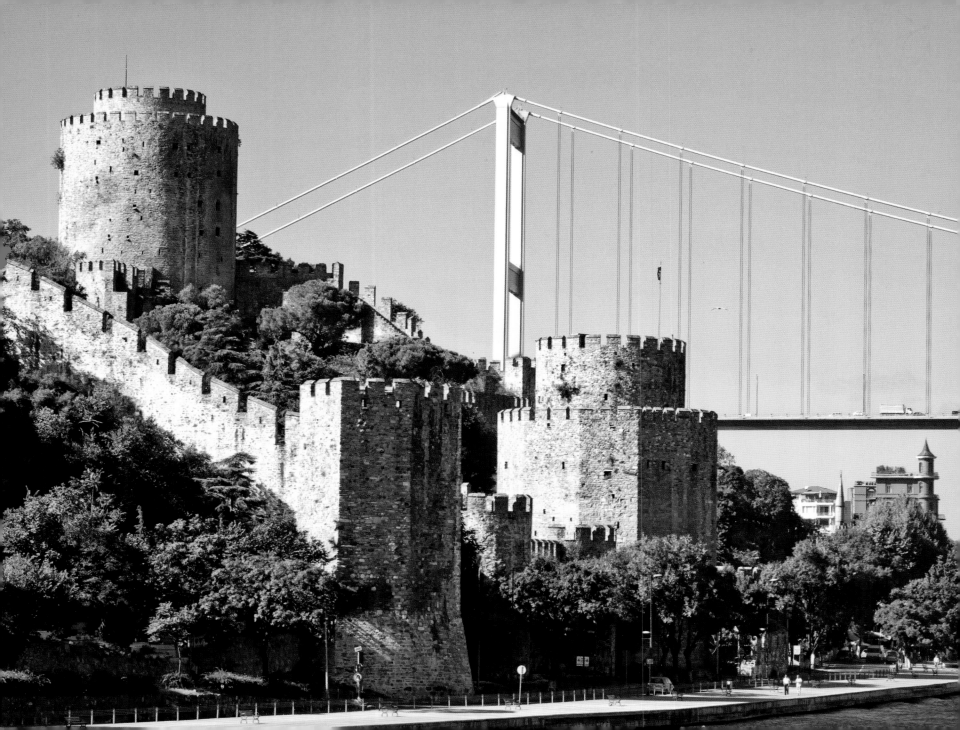

Sultan Mehmet II just prior to his conquering of Constantinople, lie in the shadow of the eponymous bridge.

Everywhere ferries criss-cross the waterway, moving passengers between Europe and Asia, while small fishing boats thread their way among them. Large cargo ships and tankers steam between the Black and Mediterranean seas. We pass beneath the beautiful and impressive Bosphorus and Fatih Sultan Mehmet bridges, not unlike San Francisco's Golden Gate, but for the elegant mosques, labyrinthine Ottoman for-tresses and Byzantine stone walls.

It is a glorious afternoon. The scent of salt water mingles with the per-fume of the trees and despite the constant bustle of water traffic, a feeling of calm emanates from the scene.

Afterwards we want rest, but are to join a local family in their home for dinner. We also need to gather the gifts we've brought for them. But no, we're late and traffic is terrible. Arriving around eight p.m., the family of four–the father, an engineer, the mother, a German teacher, and their two beautiful daughters, fifteen and ten–show us true Turkish hospitality. Though they speak little English, we smile, laugh, and share as Cem and Serkan translate. Loving kindness abounds. Following Turkish custom, everyone in turn tells a little about themselves.

Dinner then begins with a delicious, spicy, lentil soup and ends with sweet, sticky baklava and copious amounts of tea. It's now 10:30. I'm very tired, the others seriously jet-lagged. Presents though, are a must before we leave. Each of us receives a heavy bag of five beautiful books about Turkey and Turkish arts and crafts. We're overwhelmed and feeling badly that we hadn't the time to pick up at least flowers let alone our presents for them. As we leave, they load us down even more with boxes of Lokum, Turkish Delight.

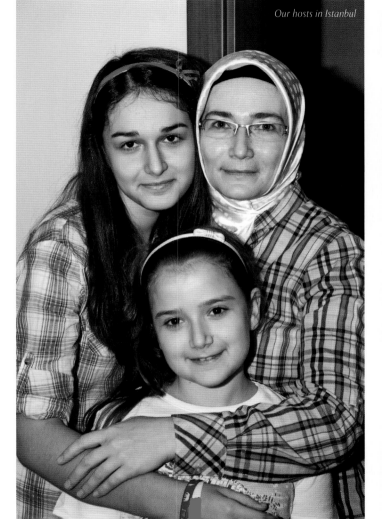

Freighters and tankers in the Sea of Marmara
await their turn through the Bosphorus to the Black Sea

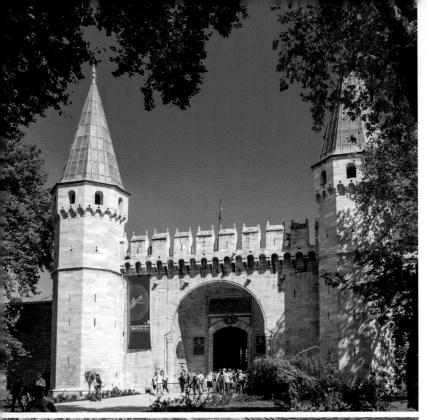

The Gate of Salutation in Topkapı Palace is richly decorated with gilded Ottoman calligraphy and monograms of sultans.

The next day begins early as well. We have to beat the hordes to Topkapı Palace, the primary residence and administrative center of the Ottoman emperors for four centuries of their six-century long rule. A multitude of magnificent marble buildings, each beautifully decorated with elaborate carvings and elegant Arabic calligraphy, are spread along a hill overlooking the Bosphorus, the Golden Horn, and the Marmara Sea. To give an idea of size, the huge kitchens prepared as many as 6,000 meals a day, not only for the members of the imperial family and other residents of the palace, but also for the petitioners, foreign envoys and statesmen, and whoever else came to the palace! However, one can see clearly that neither Topkapı Palace, which was built after the conquest in 1453, nor the nineteenth century Dolmabahçe Palace, are the grandest edifices of their time. Many other Ottoman period architectural works—including, and especially, the mosques designed by the great architect Mimar Sinan—are even more majestic and elegant than the Ottoman palaces along the Bosphorus. These huge mosques were usually built by the sultans, queen mothers, viziers, grand viziers, pashas, and the members of the imperial family.

Topkapı Palace is, however, the best example of the Ottoman palaces and mansions on the European and Asian shores of the Bosphorus. Here lie the crown jewels of Turkey. Displays of magnificent, emerald, ruby and diamond-encrusted golden chalices, swords, jewelry, dinnerware, and toiletry-sets line hall after hall. A highlight, the Spoonmaker's Diamond, is an eighty-six carat monster the size of a small egg set in silver and surrounded by forty-nine multi-carat diamonds. Along with the rich palace library, which holds more than 22,000 manuscripts in Turkish and various other languages, a great collection of ceramics and porcelains, comprising thousands of pieces unrivaled in the world, is exhibited in the imperial kitchen.

The afternoon and evening become a blur of too much good food, impressive ancient sights and exhaustion. Getting to bed too late again, I don't fancy the 4:30 wake-up call. Ephesus though, which is south of İzmir and where St. Paul preached, beckons.

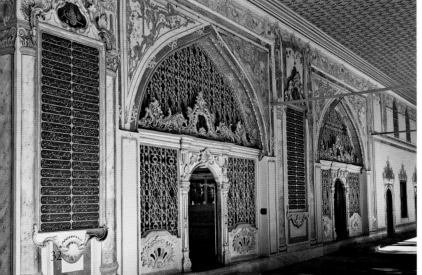

The ornate arcade of the imperial council chamber in the Topkapı Palace

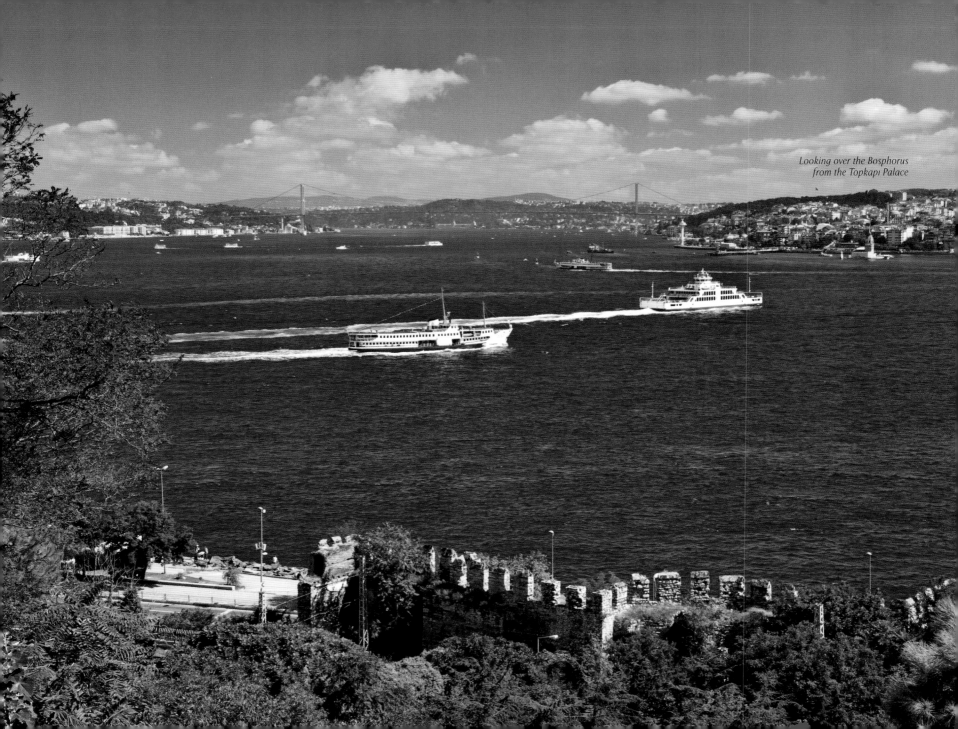

*Looking over the Bosphorus
from the Topkapı Palace*

FROM THE RUINS OF EPHESUS
TO THE MEDITERRANEAN BEAUTY OF ANTALYA

I am near exhaustion! It's been two days of intense touring and after rising before daybreak, our group is on a plane bound for İzmir in Western Anatolia. Serkan, our guide, is like the Energizer bunny. His shiny pate matches his disposition. He exudes hospitality.

Upon arriving in İzmir, biblical Smyrna and Turkey's third largest city, we are whisked from the airport to a roadside, outdoor restaurant on our way to tour the ruins of the ancient Roman city of Ephesus.

While grape vines and plump clusters of fruit shade us from the morning sun, and orchards of figs and almonds stretch to the steep mountains a mile away, our group sits at one long table, sharing breakfast. An ages-old fortress stands sentinel on a high ridge. In this idyllic setting, exhaustion from the previous days disappears with cups of thick Turkish coffee. Fresh olives, cheese, tasty, ripe tomatoes and bread slathered with local honey complete our meal.

Efes, its Turkish name, was a major crossroads of the Roman Empire. Formerly a port city, silting over the centuries has pushed the Aegean Sea more than three miles away. The apostle Paul walked these streets preaching his gospel to the Ephesians two millennia ago.

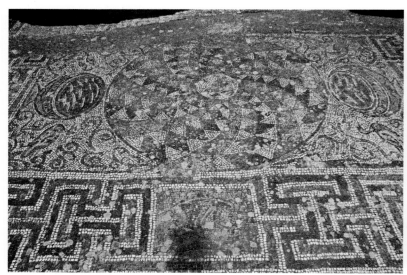

Mosaic floor in Ephesus

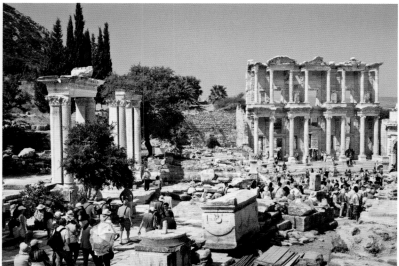

The Gate of Hadrian and the great Library of Celsus in Ephesus

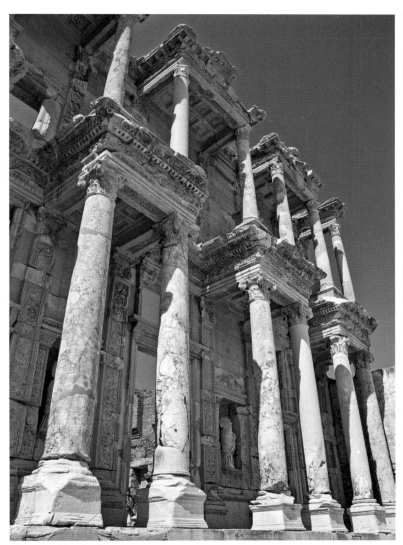

The restored facade of
the Library of Celsus in Ephesus

ΕΠΙΣΤΗΜΗ
ΚΕΛΣΟΥ

Episteme I believe, the Virtue of Knowledge, one of
the beautiful but now headless statues in the library facade

It must have been an impressive, beautiful city: broad streets, tall elaborately carved, marble buildings, numerous statues, gushing fountains, two large amphitheaters—one holding 25,000—and one of the greatest libraries of the ancient world.

We spend hours wandering the ruins, peering through broken doorways and climbing ancient steps. Ephesus was a diamond in the emperor's diadem, a city of wealth, power, and knowledge. Excavations are still underway. The city is much older than Rome and there is much left to unearth.

We return to the shade of the orchard restaurant for lunch. Afterwards, I snag an empty, pillowed platform, which is usually used for family meals, and doze off. All too quickly we're off again, this time to a small ceramics manufacturer specializing in exceptional (definitely not cheap) hand-made pottery.

I watch the demonstrations, photographing the women painting the vases and plates while Bruria Finkel, the artist of our group, puts on a demonstration of her own: turning a bowl. The showroom displays thousands of dishes in a panoply of eye-catching styles.

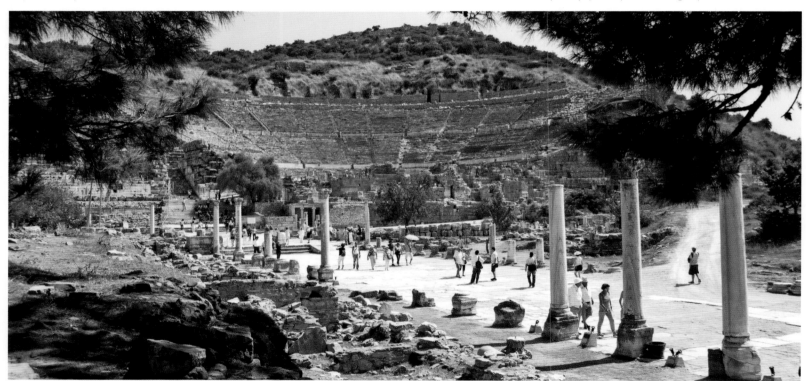

Harbor street and Ephesus' 25,000 seat theater

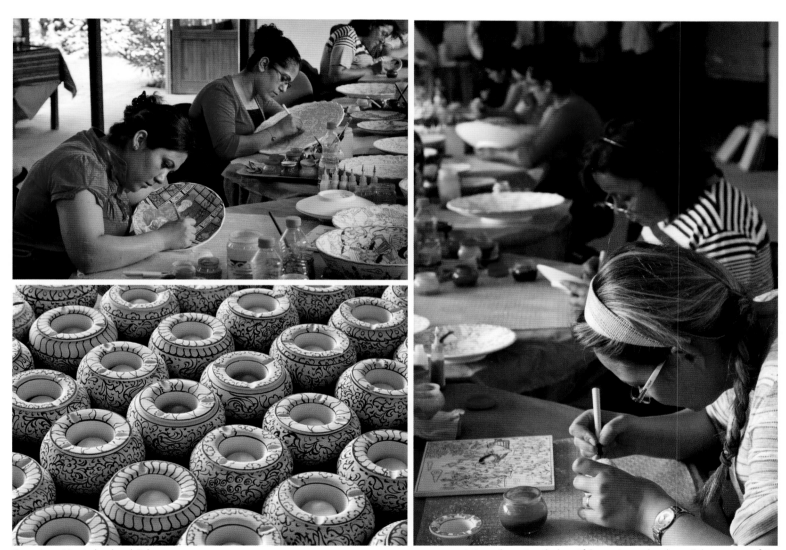

Ceramics waiting to be glazed, Ephesus

Artisans decorating the beautiful ceramics produced near Ephesus prior to firing

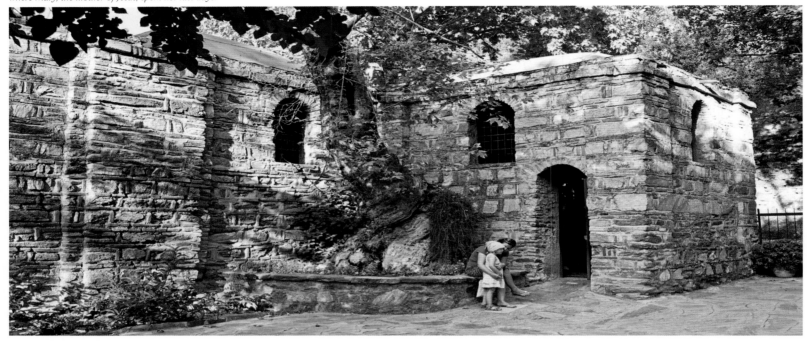

From the heat of the coastal plain, we drive into the cool mountains immediately to the south of Ephesus where, according to legend, Jesus' mother Mary lived out her days. As we climb, I catch occasional glimpses of the dramatic Aegean coast, a deep blue sea colliding with rocky cliffs.

The shrine is near the top of the mountain shaded within a thick wood. Pilgrims from around the world make their way here. The surface of a long, high, rock wall is blanketed with prayers in the form of millions of slips of paper, dazzling white against the forest in the late afternoon gloom.

Returning to İzmir with the setting sun, we meet our sponsors at a local restaurant. We are beginning to understand the reason for the cultural exchange; it is not simply to meet local leaders and learn about Turkish culture, but also to gain a better understanding of the Hizmet Movement, or the "Gülen Movement," as it is popularly known in the West–a worldwide group of moderate believers, mostly Turkish Muslims, seeking interfaith dialogue and understanding between peoples.

Fethullah Gülen is a Turkish intellectual and Islamic scholar now living in Pennsylvania. His writings have inspired a movement said to have the sympathies of seventy-five percent of Turks. One of its primary goals is education. Later in the tour, we are to visit several schools and a university built by the movement.

Following another evening of interesting conversation and too much good food, we reach our hotel and crash; Yolanda and I sleep through breakfast. Little is planned for the next day—lunch, a stroll through the bazaar and dinner with local families. We manage to find the İzmir Archeological Museum where we encounter fine examples of Greek and Roman ceramics as well as a number of beautifully decorated sarcophagi.

Seeing İzmir's extraordinary bay, I can understand why the city was so prominent throughout history. Its well-protected harbor lies at the eastern end of a two mile-wide inlet which extends ten miles west to a protective peninsula jutting north. The city lies at the junction of two broad, fruitful, well-watered valleys: one flowing from the east and the other from the south. As in Ephesus, I imagine that with silting, the bay has lost several miles of waterfront to the land.

That evening we meet several more local families at a kebap restaurant and begin to understand the importance of family in Turkish society. Clearly, family is the most important social unit.

A typical Turkish family is much closer than most Anglo-Europeans would be comfortable with. The children stick closer to home after embarking on their careers, often living with their parents and grandparents well into adulthood and in the case of boys, bringing their wives into the family home, especially in rural provinces. A very respectful hierarchy exists, not just between generations but among siblings as well. The elder siblings take on a much more important and authoritarian role than in western families and are greatly respected after the grandparents and parents.

Family members continually call each other, if for no other reason than to hear each other's voices. There is a deep abiding love within immediate and extended families. As anyone who has traveled within Turkey knows, breakfast in hotels is always a lavish affair. But what they likely never realize is that it is an extension of the Turkish family, where beginning the day within the loving embrace of the family while partaking of the healthful bounty of the land is a vital part of family life.

And Turks don't vacation in the same sense as in the west. We see vacationing as a time away from work and home, a time

Outdoor shoes taken off at the entrance of a local kindergarten we visited

spent on a beach or traveling to a national park or sightseeing in a foreign city. Turks visit family. More than touristic visits, they travel to an aunt's home, visit their cousins and see distant relatives, spending their weekends and time off within the warmth and hospitality of family.

Because of this focus on the family, along with the age-old traditions of strong family ties, there is very little divorce in Turkey. The divorce rate in predominantly rural areas is only around one to two percent, an astounding figure from an American perspective. The rate is much higher in cities.

Data from the Turkish Statistics Institute indicate that divorces have dramatically increased, especially during the last two decades. The divorce rate in Turkey in 2012 was 1.6 divorces per 1,000 residents while it was 2.0 in the EU. Hence, the divorce rate in Turkey is still significantly lower than that in the EU. According to the statistics, even in those families where couples get divorced after a long marriage of over 20 years, the underage children are the primary reason for these failed marriages lasting so long.

The parents, as well as the grandparents, are the primary caregivers in Turkey. Since family ties with the extended family members are very strong, one comes across many old couples, pleasantly spending time together with their grandchildren at home and in the street.

Though arranged marriages are common in the countryside, so are love marriages. Most marriages of the older generations were arranged. But, unless they are from small villages, not so many of the younger ones are. In smaller villages, marriages aren't about finding a parent- or kin-selected spouse; they're more a form of matchmaking, or mediation, between young people. The marriages aren't forced. Both parties are free to accept or decline.

There is also very little of what we would call dating. The youth in rural areas often prefer being introduced

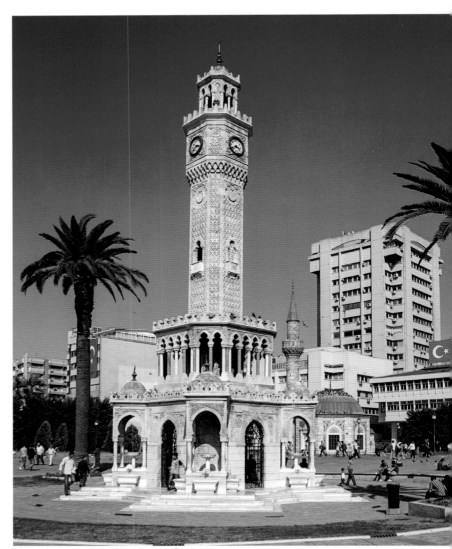

The historic clock tower along the waterfront in Izmir

to a "suitable person" by someone who knows both parties to falling in love and getting married to an unsuitable person. It is mainly this traditional "mediation" between the suitable candidates which underlies the low divorce rate in rural areas.

In the past, the age difference between the boy and girl was typically around five years. After the young male completed the compulsory military service (at age twenty-two, at the earliest), he would follow the strong cultural traditions and marry a younger girl, usually from the same city. The whole village would attend the wedding, especially the marriage banquet.

After marriage, the newlyweds would typically move into his parents' home, where the bride becomes a member of her husband's family. There would be great demands on the girl to conform, not just from the in-laws but from the neighbors and society. Extended family members get together often for family events and provide financial support, espe-

cially for the newlyweds. The mother-in-law usually has control of everyday chores. There would be little fighting between young couples and they would certainly avoid bickering in front of the parents. Under these conditions, many of the possible conflicts that would otherwise cause problems early in a marriage never surface. Of course, things are different in the cities—and are even changing in rural parts of the country.

Today, there is still a great deal of respect for the elders and no elderly person is left alone in Turkey. Once the grandparents can't live alone, they move in with the family or the family moves in with them. If adult children neglect their parents and don't assume this familial obligation, then the neighbors and relatives will take care of the elderly, and they will be very critical of the neglectful children.

Grandparents are the most respected members of the family. When grandpa or grandma enters a house, everyone welcomes them by

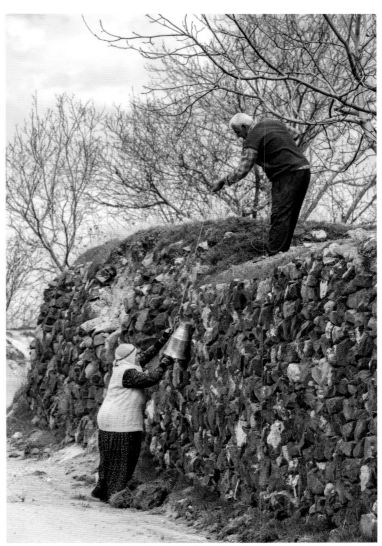

A husband and wife work together to water their crops, Nevşehir

standing up and kissing their hand as a token of respect. It is usually the grandparents who teach manners and religion, who take the kids to the park and do the babysitting. And they may also contribute their social security money to help the family, or pay for home improvements and also pay for the children's tutoring.

The grandparents are the neighborhood watch. You see them sitting on balconies or rooftops, watching over the neighborhood, keeping an eye on everyone and making sure no suspicious person comes around. If grandpa sees a suspicious person in the neighborhood, he will send one of the sons or neighbors out to bring the person to him and he'll find out what's going on. This, I am sure, is one reason I always felt safe during my travels throughout Turkey, even while wandering the choked alleys of slums in rural areas.

And another interesting aside: for centuries, as is the custom in some Muslim countries, everyone was known by their first name plus, perhaps, a nickname like Mehmet the Artist, Left-Handed Ahmet or maybe even Serkan with the Shiny Pate. Under the reforms initiated by Atatürk to westernize Turkey, the Name Law took effect in 1936. Everyone was encouraged to adopt a new family name of their choosing. People's affinity toward natural features and phenomena influenced their selections. You now have families like our guide, Serkan, named Yıldırım: lightning bolt. Turkey's Nobel prize-winning novelist Orhan Pamuk's last name means Cotton, while a woman I met has the family name Pınar: spring water. People took on poetic sounding names or names explaining their disposition: Fethullah Gülen means Fethullah, The One Who Smiles. They also named themselves after their home towns or after their father's professions, like Son of a Butcher or Son of a Chickpea Roaster.

The following day we fly to Antalya, a stunning, resort city on Turkey's Mediterranean coast. As the plane approaches, a large sapphire bay appears with an immense mountain range thrust steeply from the

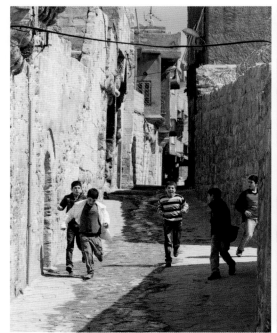

Boys at play along one of the narrow mountainside streets of Mardin

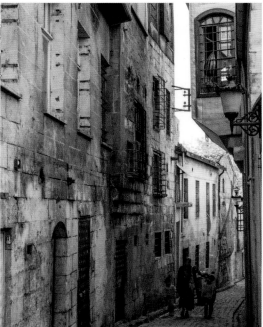

Beautifully restored Ottoman architecture of Gaziantep's hilly old quarter, a labyrinth of narrow streets

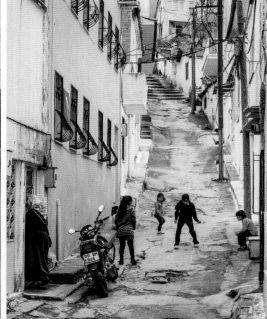

Playing hopscotch in the narrow streets of the old section of Kuşadası

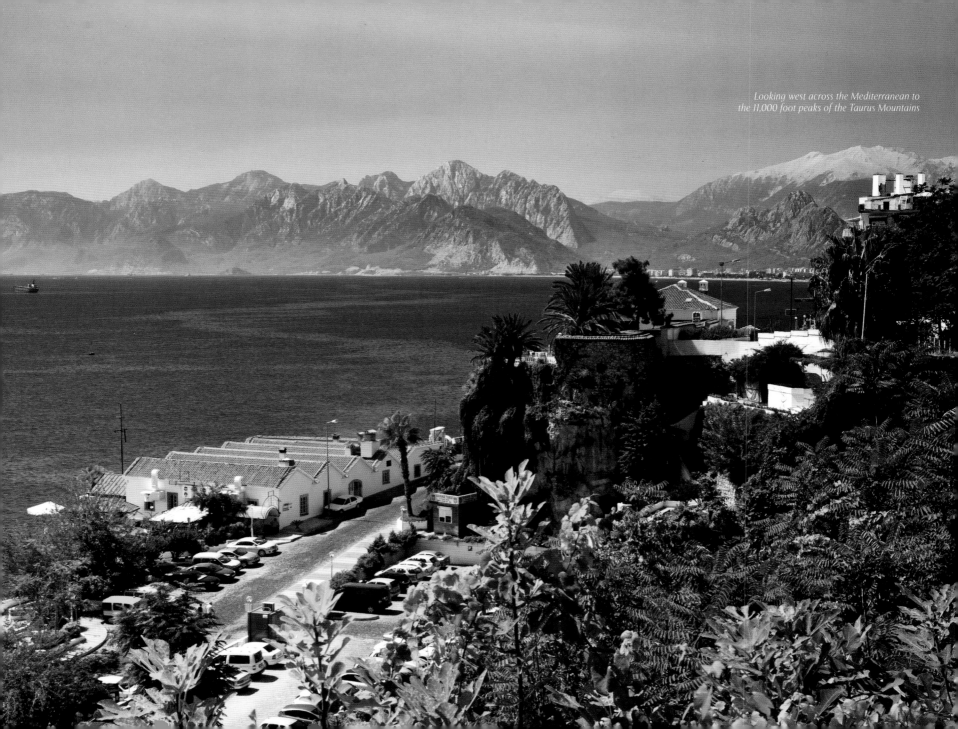

Looking west across the Mediterranean to the 11,000 foot peaks of the Taurus Mountains

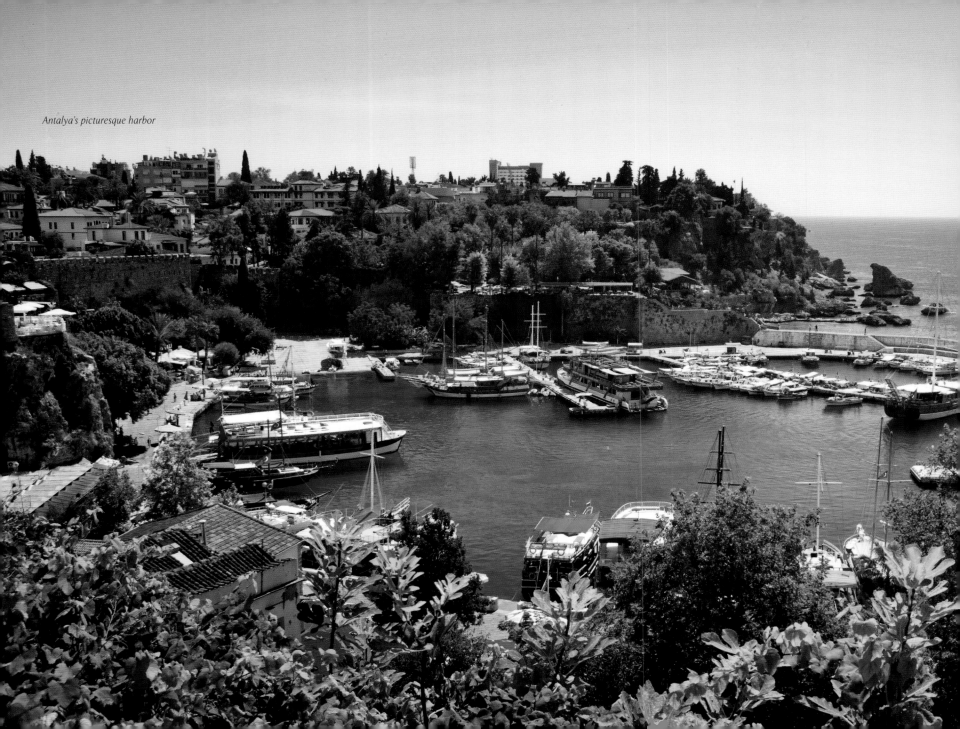

Antalya's picturesque harbor

sea—a western barrier disappearing into the southern haze. The Taurus Mountains are one of Turkey's important ranges. Around Antalya, its tree-less peaks rise abruptly to over 11,000 feet.

Antalya is a postcard of Mediterranean beauty. Beneath a clear, blue sky red-roofed, stone houses tumble down the hillsides to an azure sea. Small harbors dot the coast along with broad beaches extending to the mountains in the west. The covered terraces of restaurants provide welcome relief from the heat, along with awe inspiring, coastal views.

We stop for lunch at one of Antalya's wonders: the Düden Waterfalls. Spring-fed waterfalls cascade through a narrow defile amidst a series of rock grottos. Copious trees shade outdoor restaurants along the river, while the rushing water serves as natural air conditioning.

A leisurely lunch ensues—delicious, grilled fish fresh from the Mediterranean. To our regret, we must forego exploring Antalya's Mediterranean beauty and ancient wonders. Local leaders await us for dinner in Konya, a mountainous, four-hour drive north and the former home of Rumi, Islam's most revered poet.

Despite the valuable insights Turkey's historical sites provide into its history and culture, the privileged meetings with the people of today's Turkey round out our experience in ways not accessible to the average tourist. We leave Antalya anticipating another fascinating evening.

Shopping along the narrow streets leading to Antalya's lovely harbor

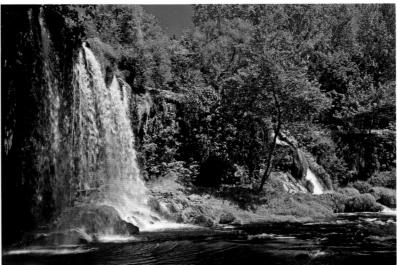

Duden Waterfall descends into the gorgeous, restaurant-lined gorge along the Duden River

RUMI'S KONYA AND AN EVENING OF OVERWHELMING HOSPITALITY

It's a lovely evening. The air is comfortably warm, the hospitality warmer still. We arrive in Konya from Antalya after dark, finding two host families waiting at an outdoor restaurant which is flanked by brightly lit 900 year-old tombs. Three teenage girls, one wearing a headscarf, all shyly giggling, practice their English with us. We share interesting conversations about life, education, and religion with our hosts.

Konya, the heart of Turkey's "bread basket," was the capital of the Seljuk Empire during the 12th and 13th centuries CE. Konya's history goes back thousands of years, to the Hittite days and beyond. The neolithic archeological site of Çatalhüyük, from 6500 BCE, is forty-five minutes to the southeast.

The region was an important center during Roman times. St. Paul, St. Timothy, and St. Barnabas made forays through the region in the early Christian era. The Seljuk Turks lost power after about 150 years when Crusaders, and finally the Mongols, stormed through, fragmenting the empire. What did persist, and is perhaps the Seljuks' greatest legacy outside of their many fine architectural works around Anatolia, is the spiritualism of the Mevlevi Order of Sufism.

Konya is where the great poet, theologian, and mystic, Mevlana Jalaluddin Rumi, better known in the west as Rumi, lived eight hundred years ago. Sufism is the spiritual aspect of Islam. The famous Whirling Dervishes grew out of the Mevlana's

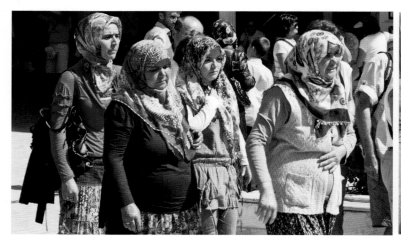

Women wearing traditional dress in Konya

Entrance to Rumi's tomb, Konya

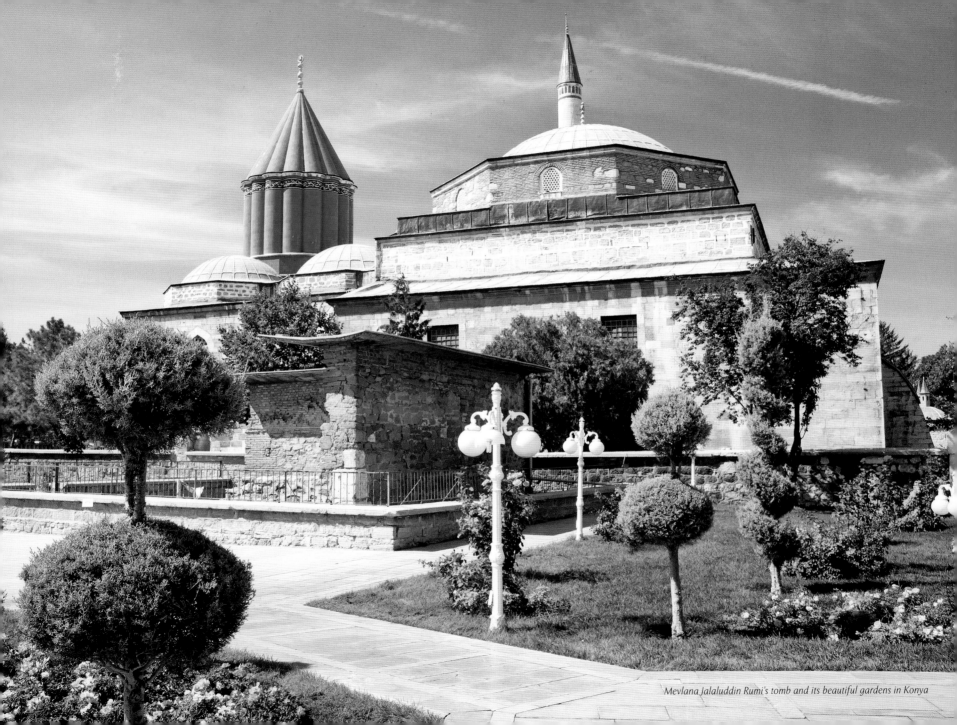

Mevlana Jalaluddin Rumi's tomb and its beautiful gardens in Konya

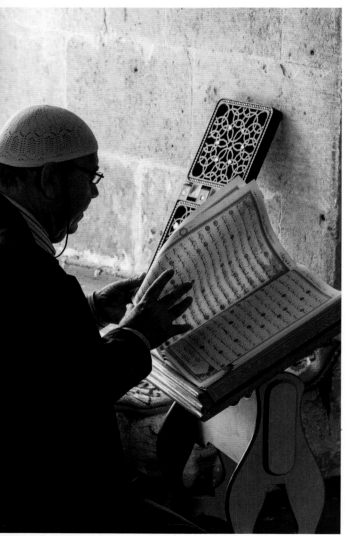

*A gentleman studies the Qur'an
in a window of a Seljuk period mosque*

teachings. The Mevlevi Way is an ascetic, spiritual life. Rumi believed passionately in utilizing music and whirling as a path to God. This evolved into the ritual dance, the Sema, what we know as whirling. Apprenticeship entailed 1001 days of disciplined training, learning kindness, grace, discretion, and equanimity in one's behavior and speech.

Rumi taught unlimited tolerance, positive reasoning, goodness, charity, and awareness through love. To him, all religions were more or less truth:

Come, come, whoever you are,
Wanderer, idolater, worshiper of fire,
Come even though you have broken your vows
a thousand times,
Come, and come yet again. Ours is not a caravan of despair.

While he extended his arms to people from all walks of life and embraced them all, Rumi always pursued Muhammed's teachings and practices and thus conformed to God's commandments. He opposed all kinds of extremism, and he further complained about the harsh and fanatical attitudes of fundamentalists and their destructive influence in the society. Compassion and love are at the heart of his teachings.

As I spend more time in Turkey and become more familiar with the culture and people, I begin to feel that Rumi's teachings have deeply influenced Turkish lives. I sense that how they practice Islam and live their lives is closer to the compassion taught by Rumi than the brutal strictness of religious practice too frequently portrayed in the western press.

Now, Konya covers the largest area of any city in Turkey. It has grown from around 250,000 people several decades ago to a fully modern city with over a million inhabitants. It is evident from the women's dress that Konya is the most traditional of the places we've visited thus far. Here, many more women wear headscarves than elsewhere. Most wear a shapeless, full-length overcoat too, and those that don't tend to wear multi-colored, flowery scarves and skirts.

As we approach Rumi's tomb, its green dome marks it as different from other mosques. The colorful gardens surrounding the complex are immaculately maintained. Sculpted rose bushes and topiary set amidst lush, green lawns add color and style to the sanctuary.

I would love to have photographed inside the tomb. The marble walls are covered with flowing Arabic script and, like most mosques, the ceiling is a delight of design. On display are many elaborately illuminated Qur'ans. The beauty of their calligraphy and the wealth and creativity of their gilt illustrations captivate me.

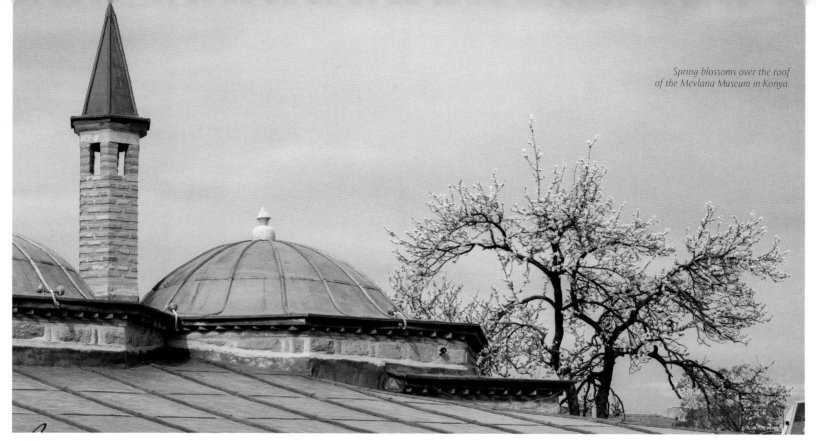

Unfortunately, no photography is allowed, something, as a professional, I always respect.

Rumi's epitaph reads: "When we are dead, seek not our tomb in the earth, but find it in the hearts of men." He told his disciples, "When I die, do not cry after me. Because when I die I am returning to my Creator. So celebrate that night like my wedding night."

Lunch is at a primary school built by a local businessman and supporter of the Hizmet Movement, or the Gülen Movement as it is popularly known in the West. This is the first day of school. Garlands of balloons welcome the students. We eat with one of the teachers who is peppered by questions from our inquisitive group. We learn that English is taught from the primary level and that the success rate in the Gülen-inspired schools is exceptionally high. The vast majority of students pass the national college entrance test and graduate from university.

Music sounds in the hallway. It's the end of a period and the corridors fill with happy voices and laughter. Our group wades out amongst the excited throngs, cameras in hand. We are met with many greetings and questions.

"Hello! What is your name? Where are you from?"

For a quick five minutes, the smiling faces of beautiful, happy children besiege us. They make the most of this strange group of visitors who enhance their first-day-of-school enthusiasm.

49

ANOTHER EVENING AND A VISIT TO ANOTHER SCHOOL

Little do we know what we are in for and nothing yet prepares us for the unbelievable hospitality our little group is about to experience. A few hours on the bus and we arrive, again after dark, in the small town of Niğde. Here, instead of staying in a hotel, we are being accommodated by host families.

Our hosts greet us warmly, taking our bags to their respective cars. Climbing the steps to the school, we are ushered into a large, comfortable office for the obligatory greetings. After this Turkish tradition, the founder of the school, Mr. Celal Afşar, a spitting image of Sigmund Freud, leads us into a spacious assembly hall where the surprises begin.

Eleven, beautiful young girls, aged around 8-11, wearing traditional folk dress, bouquets in hand, flank the entry. Smiling and laughing, they hand each of us a bouquet while welcoming us in English. A mouthwatering aroma wafts through the room as we are shown to our tables surrounding the central floor space.

Suddenly, the girls are lined up beneath a tapestry of the omnipresent image of Atatürk, the founder of modern Turkey. Music begins and the young girls perform a charming folk dance. We're delighted!

More introductions follow, along with an invitation to line up and be served dinner. Following the meal—again an abundance of delicious regional food!—a tray is wheeled out to the floor and the local master painter treats us to a demonstration of traditional Turkish water painting.

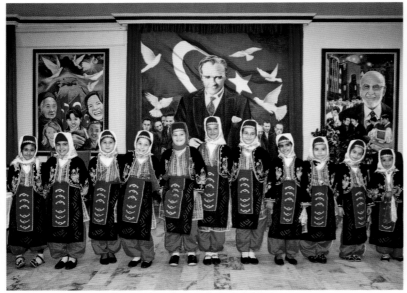

Young girls performing the Turkish folk dance

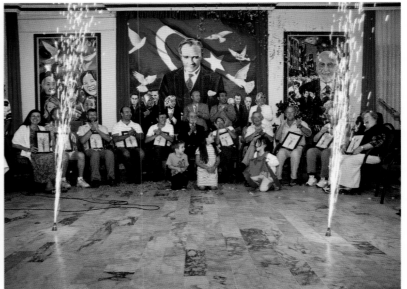

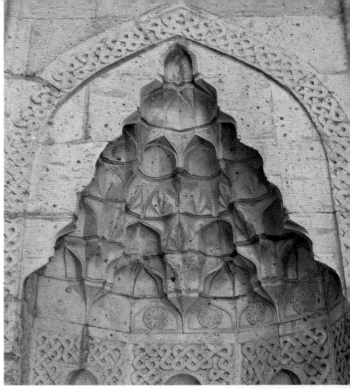

In a tray of water, special oil paints are dripped onto the surface. The artist uses unusual implements to shape the drops, adding more and shaping them. Within five minutes, a lovely image of carnations floats upon the water. Placing a piece of watercolor paper on the surface, the artist smoothly draws the paper from the tray, transferring the painting to the paper and revealing a lovely painting of life-like carnations.

We are asked to take seats in a row at the front of the room and are called upon in turn to receive a framed water painting done by the students and to say a few words. With the last gift given, music swells, in front of us twin fountains of sparks erupt, while cannons on both sides engulf us in confetti. I am beyond words!

As we each depart for our respective host's home, a late night ensues. Yolanda and I, our guide Serkan, along with another Turkish couple now living in London, go to the home of a young doctor, his wife, and infant daughter. We talk about everything, learning about each other's cultures and religions. No question is off limits. For the first time this entire trip, Serkan is fading.

Breakfast is late for a change. We gather, along with our hosts, at the home of a family with a large, fecund garden. Long tables are arranged beneath the grape arbor planted by the host's grandfather's grandfather. Copious clusters of ripe fruit dangle temptingly from above.

Once again, we are treated to incredible graciousness as we partake of the bounty of the garden. Conversation ranges over a myriad of topics, always penetrating and pertinent to today's world. It is difficult to express how fortunate I feel to be able to meet people of the Muslim faith on this level. We experience nothing but respect, warm hospitality, dialogue, interest, and polite acceptance of our differences.

As we reluctantly take our leave, handshakes, hugs and traditional kisses on both cheeks abound. I feel a glimmer of understanding, not through words, but through direct experience, of the philosophy and Islamic teachings of Fethullah Gülen, the inspiration behind the Hizmet Movement that brought us to Turkey: that through education, building bridges between countries and by holding open conversations between peoples, we can overcome our differences and gain an appreciation and understanding of each other's cultures. If our experience reflects some basic principles of Islam, then the world is a less dangerous place and the future brighter still.

Detail of a wood-carved Minbar (pulpit) of the Alaeddin Mosque

THE AWESOME, OTHERWORLDLY LANDSCAPE OF CAPPADOCIA

Next on the agenda is the incredible, in the truest sense of the word, fairytale landscape of Cappadocia, in central Anatolia. First though, on the road from Niğde to Cappadocia, we take a tour of the subterranean world of Kaymaklı.

The Kaymaklı underground city is a labyrinth of rooms, stables, kitchens, wine cellars, passageways, and churches extending eight erratic levels below the surface of the earth. It was cleverly excavated to allow airflow from the surface. Smoke from the cooking fires was absorbed by the soft rock, hindering detection. Up to 3,000 people took refuge here for months at a time.

According to the Turkish Department of Culture, the Phrygians began the complex of underground cities, carving them from the regions' soft, volcanic rock in the 8th–7th centuries BCE. Throughout the second century and into the third centuries CE, these underground cities sheltered the early Christians from the pagan Roman persecution. They were greatly enlarged in later eras. More than 200 underground cities, many connected through miles of tunnels, have been discovered between the towns of Kayseri and Nevşehir. Only a few are excavated and open to tourists.

Another nearby underground city, Derinkuyu, an eleven level complex, is believed to have housed as many as 50,000! It must have been a cramped, uncomfortable and desperate existence with little privacy.

A short drive takes us to Göreme where, even though prepared, I am astounded by the amazing, honeycombed, rock pinnacles of the small town. Doors, windows, and porches are sculpted into the volcanic tuft. Signs adorn the bizarre formations, as small shops are carved into the stone.

I yearn to stop as we drive by one amazing town after another. Finally, the bus pulls up in front of a large complex of stalls selling every conceivable trinket and rug. Walking between them takes us to a long cliff overlooking a panorama, the likes of which I have only seen in a few of America's western national parks and monuments.

The valley stretching beneath is a complicated panoply of erosion which sculpted fantastic white and gray hoodoos. The hulking pyramid of an extinct volcano, the likely source of all this tuft, lurks in the distance beneath a bright, blue sky. Interspersed amidst this bizarre landscape are houses, shops, mosques, and large hotels. Homes have been hewn from most of the rock formations. I can only imagine their interiors. Many pinnacles

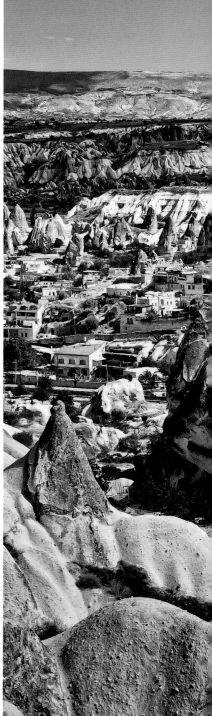

The other-worldly Cappodocian landscape with Mt Erciyes in the distance

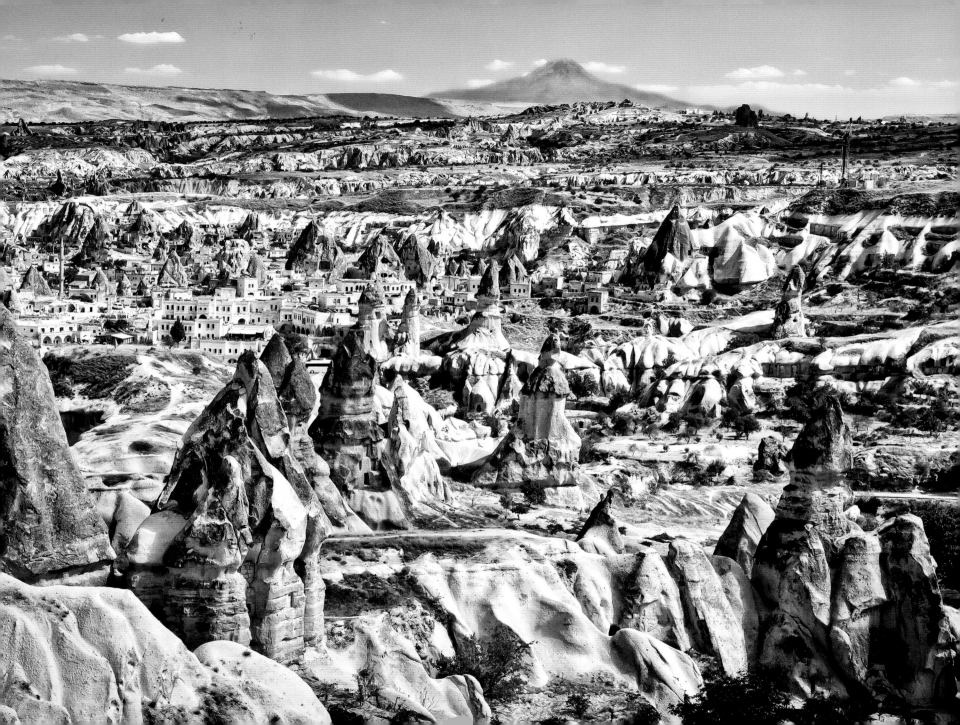

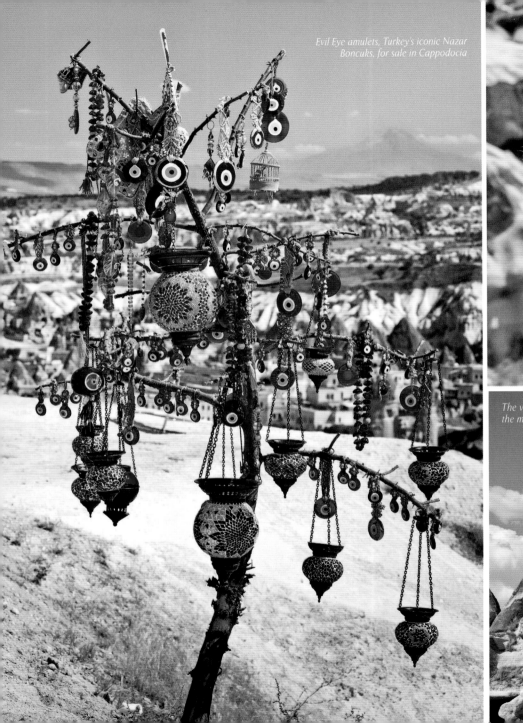

Evil Eye amulets, Turkey's iconic Nazar Boncuks, for sale in Cappodocia

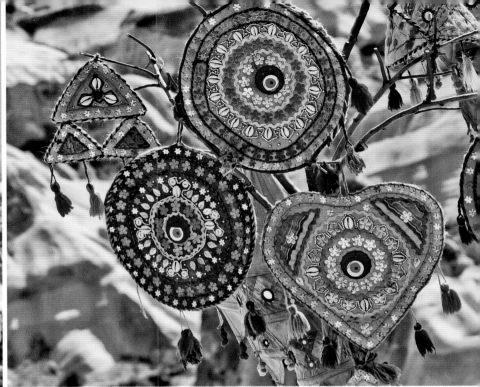

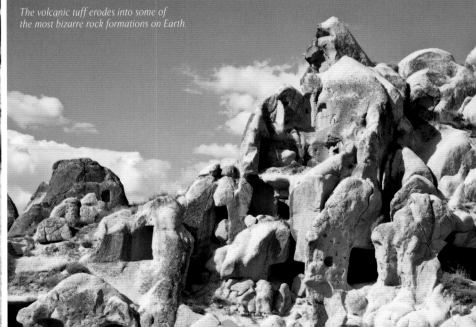

The volcanic tuff erodes into some of the most bizarre rock formations on Earth.

are hotels. Rooms can be had for as little as $50 a night, with rooms in the higher-end hotels going for hundreds of dollars.

We are allowed an all too brief stop and sadly, no chance to descend and walk amongst the incredible formations of this fairyland-like town.

Reluctantly climbing aboard the small bus, we head to our next destination, a restaurant for lunch. Once again, nothing could have prepared us for what we are to experience.

As we pull into the large parking lot, all we can see is a brown ridge covered with dried grasses and low bushes—it is fall, after all. Rounding a corner, we encounter a spacious, stone courtyard flanked by two stone eagles leading to the finely carved, columned entrance to Uranos Sarıkaya, where we are to eat.

A wide, dimly lit hallway, perhaps fifty yards long, leads deep into the hillside. Passing through the archway at its end, we enter a high, round chamber beautifully carved from the living rock—the restaurant itself. Sitting within a mosaic of elaborate, geometric designs at its center, a lone musician plays a zither in the subdued light. Five spaces, each with six stone tables seating ten diners, extend like spokes of a wheel from the mosaic hub. Everything—the tables, benches, railings, columns and doorways—are carved from the stone of the mountain and exhibit truly beautiful craftsmanship. This provides a taste of what the homes and hotels must be like.

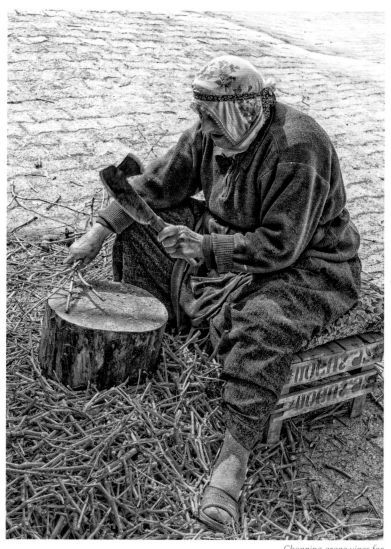

Chopping grape vines for firewood, Nar, Cappodocia

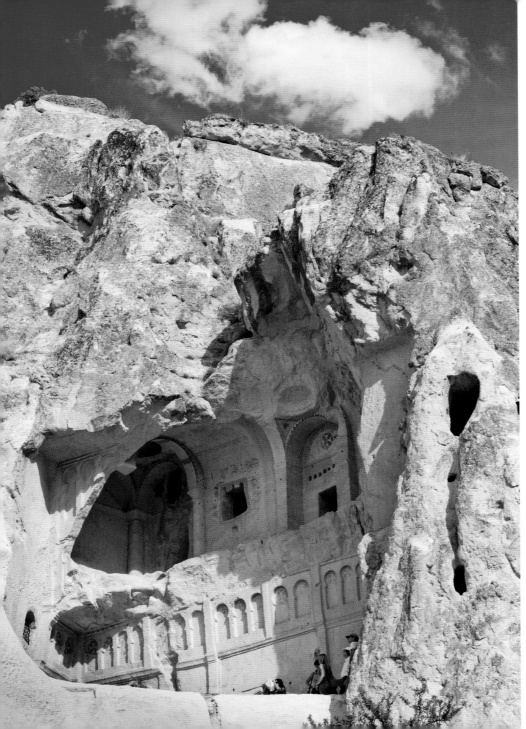

One of the many stunning 12ᵗʰ and 13ᵗʰ century chapels carved from the rocks in the Göreme Open Air Museum

The cooks arrive with, once again, an overabundance of delicious food, and any frustration over the short time spent viewing the valley is forgotten.

Following lunch, we return to the area of Göreme for what, according to the guide books, is an imperative. The Göreme Open-Air Museum is a monastic complex of Byzantine refectories and churches carved into the rock between the 9ᵗʰ and 12ᵗʰ centuries CE. It was named a UNESCO World Heritage Site in 1984.

Once again, fantastic shapes abound. We have time to enter only a few of the eleven or so tiny, 12ᵗʰ century churches. Vivid, colorful frescoes, most in exceptional condition, adorn the walls and ceilings. The love, talent, and stupendous time and effort it must have taken to create these churches is humbling and awe-inspiring.

Unfortunately, again, I am not allowed to photograph inside the churches. Even though with my cameras, I wouldn't need to use flash, it is understandable. If allowed, thousands of flashes would go off every day. This continual assault would degrade these thousand year-old treasures in no time. Here are links to some photos of the frescos taken without flash. They give a taste of the beauty of the work as well as more history: http://www.goreme.com/goreme-open-air-museum.php and http://www.sacred-destinations.com/turkey/cappadocia-goreme-cave-churches.

Sadly, our itinerary doesn't include a night here. I have to be satisfied with a morsel of what Cappadocia offers. Truly, this region of Turkey is so phenomenally otherworldly that I must return and spend days wandering its valleys, exploring its ancient wonders, and photographing its bizarre, fairyland-like formations.

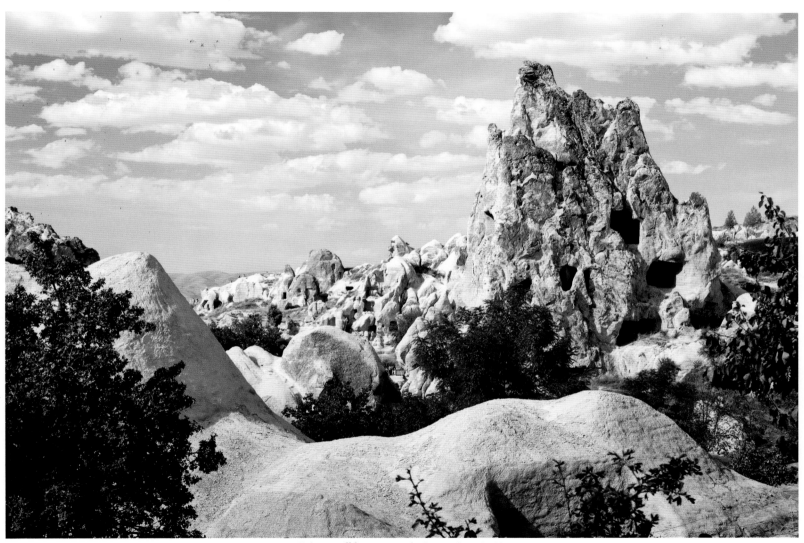

Volcanic tuff formations in the Göreme Open Air Museum

BACK TO ISTANBUL AND SAD FAREWELLS

We have to "beat feet" to Ankara. Our plane leaves for Istanbul at nine and it's a four hour drive from Cappadocia. Unfortunately we arrive after dark in Turkey's capital city. I can't see much. It appears from the highways that it's a very modern capital. The freeway to the airport is broad with blue, neon decorations every kilometer or so. The airport itself, with its architecturally stunning and spacious marbled public areas, is worthy of any capital city in the world.

We arrive at the Sabiha Gökçen Airport south of Istanbul, in Asia, rather than Atatürk International, in Europe. On the bus from the plane to the terminal, I meet a Turk who speaks excellent English. He's a colonel in the Turkish army and a graduate of West Point. We chat only briefly, but after reading several books on Turkish politics, I yearn for a real conversation to gain his unique perspective.

It takes another hour-and-a half to reach the Grand Anka Hotel, where we will spend our last three nights. At this late hour, the trip is long and uneventful other than crossing the beautiful Bosphorus Bridge as the tens of thousands of colored lights ringing its cables and towers put on an ever changing light show.

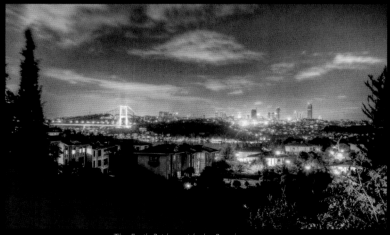

The Fatih Bridge with the Bosphorus and part of Istanbul's skyline

Sweeping architecture shapes form the interior of a Turkish newspaper building, Istanbul

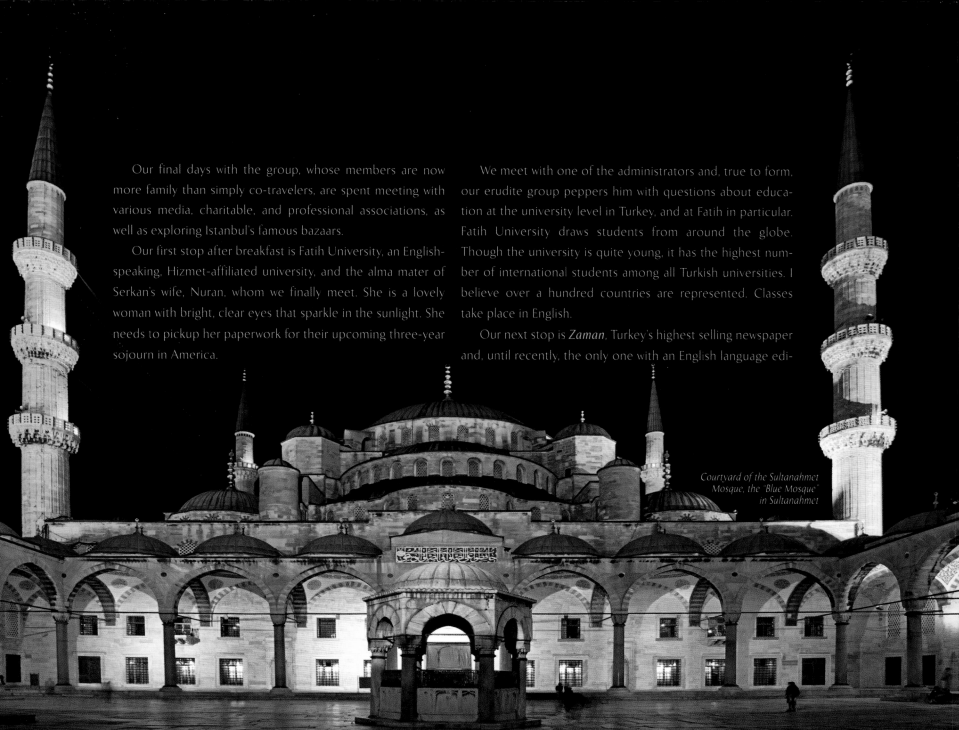

Our final days with the group, whose members are now more family than simply co-travelers, are spent meeting with various media, charitable, and professional associations, as well as exploring Istanbul's famous bazaars.

Our first stop after breakfast is Fatih University, an English-speaking, Hizmet-affiliated university, and the alma mater of Serkan's wife, Nuran, whom we finally meet. She is a lovely woman with bright, clear eyes that sparkle in the sunlight. She needs to pickup her paperwork for their upcoming three-year sojourn in America.

We meet with one of the administrators and, true to form, our erudite group peppers him with questions about education at the university level in Turkey, and at Fatih in particular. Fatih University draws students from around the globe. Though the university is quite young, it has the highest number of international students among all Turkish universities. I believe over a hundred countries are represented. Classes take place in English.

Our next stop is *Zaman*, Turkey's highest selling newspaper and, until recently, the only one with an English language edi-

Courtyard of the Sultanahmet Mosque, the "Blue Mosque" in Sultanahmet

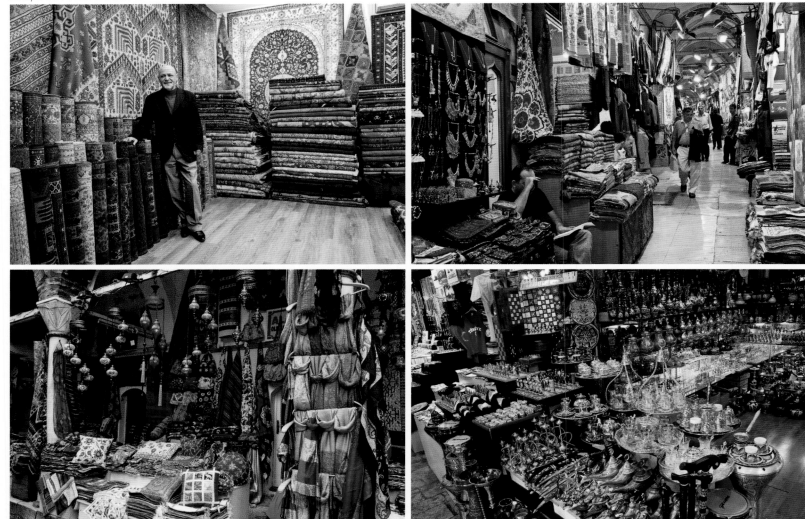

A carpet store owner in a restored Madrasa outside the Grand Bazaar

In the labyrinth of the Kapalı Çarşi, the Grand Bazaar in Istanbul

A shop in the Grand Bazaar

One of the over 4,000 shops in the Kapalı Çarşi, the Grand Bazaar in Istanbul

tion, called *Today's Zaman*. It is also the first Turkish daily to set up an online version, way back in 1995. *Zaman*'s modern building is architecturally interesting with a visually stunning interior atrium rising seven stories to an open skylight. Offices circle the brightly lit interior while floor to ceiling windows allow a view into the bustle of the newsrooms.

In our conversation with the editor, we learn an interesting point that opens my eyes to the danger Al-Qaeda poses beyond the US. Because of *Zaman*'s stance as a newspaper operated by moderate Muslims, and its vocal condemnation of terrorism, the military recommended that security measures be taken. *Zaman*'s building is now surrounded by high fences, cameras and guards, and its underground parking lot is protected from car bombs by moveable barriers.

Amazingly, we have a free afternoon to spend in the Grand Bazaar and the Spice Bazaar—the age-old covered bazaars built by the Ottomans after the conquest of the city. Several of us spend hours wandering the maze of over 4,000 shops lining the crowded, noisy corridors and narrow alleys of the ancient bazaar. Certainly it's touristy, with trinkets and baubles alongside finely-made leather jackets, quality silks, beautiful hand-made carpets, and exquisite fabrics. If you can't find something inside, then it's likely sold in the warren of streets we encounter while trying to find the Spice Bazaar. Thousands more shops bustle with activity—Turks shop here instead of tourists.

The two bazaars located inside the city walls of the historic peninsula appear much closer on the map than in reality and after a few wrongs turns, we stumble upon the entrance and unmistakable aromas of the Spice Bazaar. It is a delight to the senses, even more than its larger cousin. Elaborate displays of colorful spices, nuts, and

Interior of a carpet store, Istanbul

candies line the aisles, each stall competing for eyeballs and noses. Signs proclaiming "Iranian Saffron" and "Turkish Viagra" vie for our attention.

One of my architectural clients in Vail, Colorado, told me I must look up a friend with a shop here. I find it without much trouble, opening its door (one of only a few stores with doors) we step from the noise and crowds into the quiet, lightly-scented interior; this store sells much higher quality merchandise than most.

I ask for Tahir but am introduced to his brother Ibrahim instead. Tahir is out of town, he tells me, visiting their family's home town of Niğde. Niğde, of all places—the small town in central Anatolia where we received such an overwhelming reception only two nights before! Talk about coincidences!

Ibrahim invites us downstairs into a basement world of fine carpets and fabrics where, true to form, we share tea and customary Turkish hospitality.

Our last day together begins with a visit to a Gülen-inspired charity, Kimse Yok Mu, (literally, "Is anybody there?")—the name based upon a cry from a victim trapped in Turkey's devastating 1999 earthquake. Afterward we stop at Samanyolu, one of Turkey's TV networks. Here we are told they strive to provide quality programming that is in some way uplifting or family oriented. As well, they over-dub popular shows from other countries, including America: no gratuitous violence, certainly no profanity.

A brief tour finds us in the kitchen of Yeşil Elma, Turkey's Emeril, just prior to broadcast. We receive a quick lesson in Turkish cooking from the gracious host, who indulges our questions. Cem, our guide from LA, phones his wife, a big fan, handing the phone to the chef; she is thrilled.

It's now lunchtime. Being in Asia, Serkan directs us to a restaurant

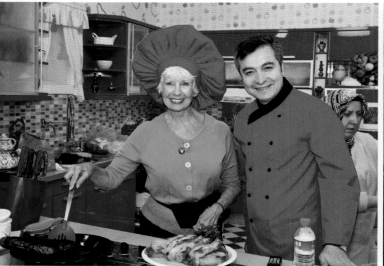
Yolanda poses with Yesil Elma,
Turkey's Emeril, just prior to broadcast.

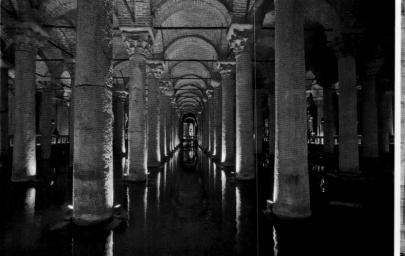

The Roman emperor Justinian built the astounding Basilica Cistern
in 532 CE. It was lost to history for almost 1,000 years.

owned by a friend in Üsküdar, which is south, across the Bosphorus from the Golden Horn and Istanbul's prime historical attractions. The restaurant has been around for ages and specializes in dishes from the Ottoman Era. During lunch, smoke rises from the upper floor of a bakery across the street! Fire has always been a severe threat in Istanbul due to the crowding of the wooden buildings—many very old. The city has suffered huge conflagrations in the past.

Fire trucks arrive promptly, the smoke diminishes and all is well in Üsküdar.

The rest of the afternoon is spent on the Asian side of the city. We visit BAKIAD, the Atlantic Association of Cultural Cooperation and Friendship, one of the sponsors of our trip. Their mission statement reads, "Our ultimate goal is to serve and maintain global peace and harmony by building bridges towards a long lasting friendship between the peoples of Turkey and North America, including transatlantic countries, through educational, social, artistic, and cultural activities."

I must say, and I believe I speak for the other members of our group, they achieved their goal with us. We have learned so much about Turkey's history, people, and culture. We have experienced unparalleled hospitality. We have engaged in deep, rewarding dialogue, gained insights into Islam and its unique practice in Turkey's culture. I believe we also provided those we met with a tiny window into our culture, beliefs, values, and lifestyle. Clearly, the goal of building bridges was achieved. We hope that lasting friendships were formed as well.

Our final meeting is with members of the Journalists and Writers Foundation (GYV). Our group is ushered into a bright spacious meeting room whose broad windows open to a lush terraced garden. The de

Fountain of Sultan Ahmet III,
Sultanahmet, Istanbul

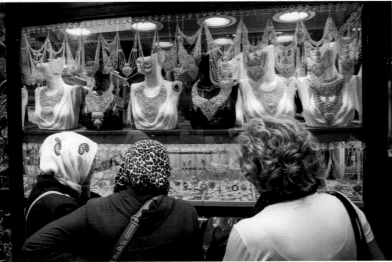

Looking to add to the family wealth, the "Bank of Mama",
in the Kapalı Çarşi, the Grand Bazaar in Istanbul

The minarets of the Sultanahmet Mosque rise behind
the ancient Byzantine walls in the Historic Peninsula

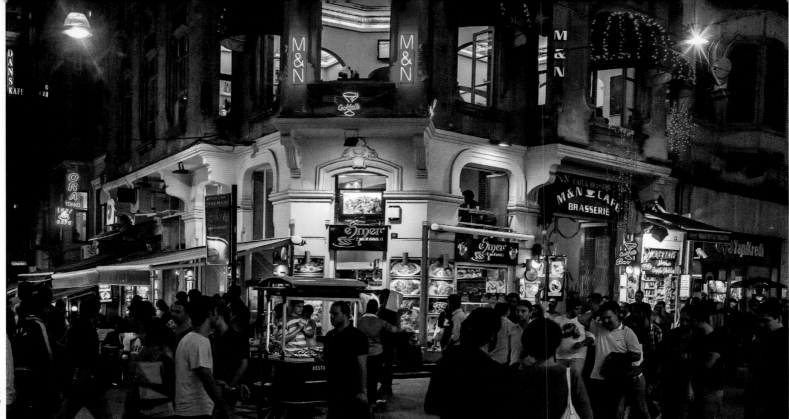

Crowds and lights along Istiklal Avenue in Beyoğlu

rigueur tea is served and our dialogue with two well-dressed gentlemen, one a former Imam (both writers) begins.

Much of what is discussed focuses around their interest in ways to get the message of the moderate Hizmet Movement out, especially to the US, and who to invite on these cultural exchanges. Our ideas surround inviting Buddhists and Hindus, in addition to Jews. We also suggest inviting artists, ministers of mega-churches, and young people, so that they might live with an understanding of the warmth and love we experienced and that this understanding might influence their future.

Additionally, we talked about Wahhabism and the power it exerts over America's perception of Islam. Succinctly, the former Imam described it in these terms: sipping a cup of tea, he said "This is tea and this is sugar. Sugar is spirituality. Tea needs sugar. When you take the sugar out of the tea, you have Wahhabism. No profound spirituality, just mere emphasis on observing the rituals without having much spiritual insight behind them, dry knowledge."

Later, in summing up the purpose of these cultural exchanges, he cites a story about Rumi. "One day Rumi was asked the meaning of love. He struggled, but couldn't define it. Instead, he said this: 'I can't express to you the meaning of love, just taste it.' You came here, we've been to America and we tasted. Our duty is to say 'just taste it.'"

Dusk is now descending. Still in Asia, Serkan has one last surprise.

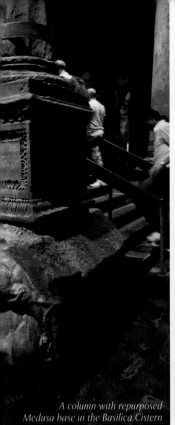

A column with repurposed Medusa base in the Basilica Cistern

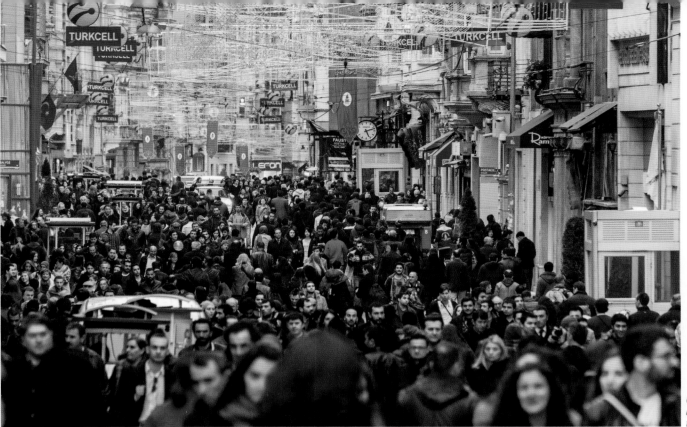

Unceasing parade of massive crowds along the Istiklal Avenue

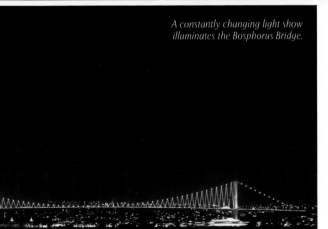

A constantly changing light show illuminates the Bosphorus Bridge.

We find ourselves in a park, high above the Bosphorus, the colorful lights of Istanbul's two famous bridges shining far to the west. A large, palace-like structure looms in the gathering twilight, floodlights playing across its ornate facade. We enter the high-ceilinged, tasteful yet ostentatious rooms for our last dinner together. This is a restaurant few tourists would ever find.

Capping our meal as well as our trip, we each attempt to share our feelings about Turkey, each other, and especially our warm feelings toward Serkan. Little do we suspect that Serkan has a final surprise up his sleeve. Cem's wife, Nur, joined us at lunch and spent the afternoon with us. It's her birthday and Serkan has ordered a birthday cake complete with sparklers shooting into the air.

We all sing happy birthday and Nur is overcome with tears. Such a fitting ending to not only a wonderful day, but to an incredible journey filled with warmth and surprises!

DEEP IN THE MOUNTAINOUS EDENS
OF EASTERN TURKEY

Why do we always end up in the mountains? We live in them after all. Yet somehow, we're always drawn to them wherever we are. After leaving our group, we decide to catch a plane to the northeastern city of Erzurum. The mountain range to its north, with their thousand year-old Seljuk madrasas, Georgian monasteries and churches, beckons. A quick, two-hour flight finds us circling over a broad mountain-ringed valley. The city lies at over 6,000 feet and happens to be at the foot of Mt. Palandöken, Turkey's premiere ski area—though it's too early for skiing.

Even though Erzurum was an ancient stop on the Silk Road and contains over 320 cultural landmarks, it is quite modern, with broad, tree-lined avenues and colorful apartment buildings. Atatürk University provides a youthful air. The streets are filled with students. We are approached several times by students wishing to help us, and to practice their English.

Something that surprises me are the pedestrian crossing lights. They're snowboarders! What fun! I also notice a huge, ski jumping venue under construction close to the university. It seems that Erzurum is to host this year's Universiade, the winter university games: the winter "Olympics" for college students from around the world.

I'm surprised that headscarves aren't more in evidence in the metropolitan area of the city. This is eastern Turkey after all—a very traditional region. Two reasons may account for this: first, Erzurum is where

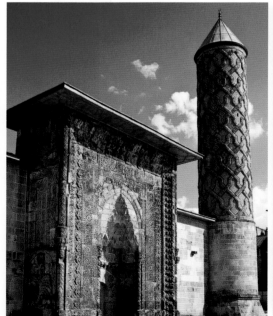 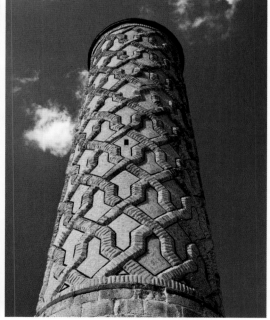

The elegant facade and minaret of the Yakutiye Madrasa built in 1310 *Detail of Yakutiye Madrasa decoration* *Minaret of the Yakutiye Madrasa*

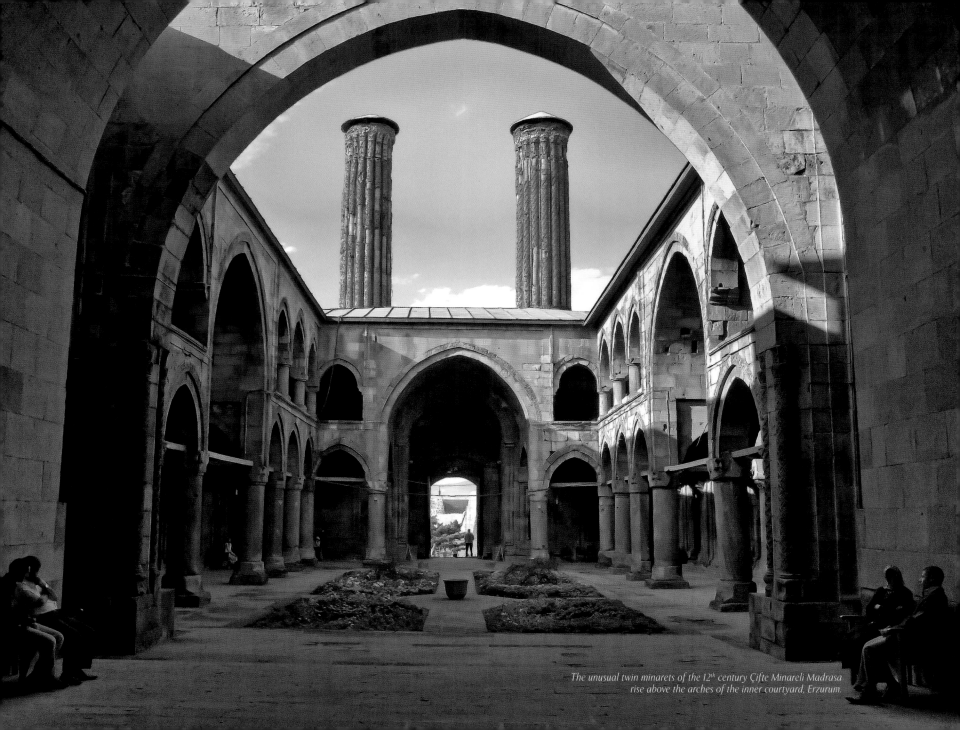

The unusual twin minarets of the 12th century Çifte Minareli Madrasa rise above the arches of the inner courtyard, Erzurum.

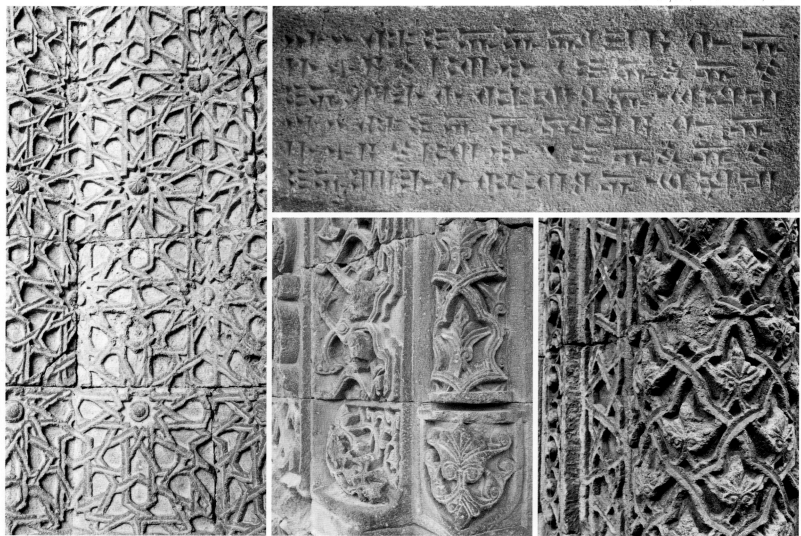

Intricate carvings adorn the columns of the Çifte Minareli Madrasa, Erzurum

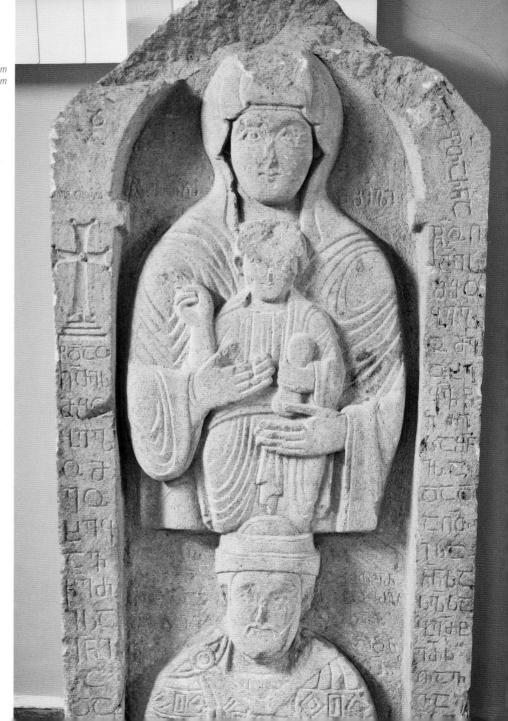

Atatürk, in 1919, laid the foundations for national unity and a modern Turkey, and second, the city has one of the largest universities in the country, and thus a very large population of university students. After Atatürk, for a long time, the secular state banned the wearing of headscarves in government buildings and universities, despite the fact that there was no law that expressly banned wearing a headscarf in public spaces.

While the law was in effect, devout students wearing headscarves had to remove them before entering the gates. This was a cause of much anger within the Muslim community, and also denied government employment and an education to women who felt it their duty, as devout Muslims, to cover their heads. This issue was addressed through a referendum process that took place just prior to our arrival in Turkey, and the ban was widely abolished in late 2013.

Erzurum and the surrounding region have played a significant role throughout history. It is situated at the eastern end of an open plain bordered by steep, rounded mountains. Not only was the valley a main artery on the Silk Road, but archeologists have found evidence of occupation going back 8,000 years. Many civilizations controlled the area over the millennia: Urartian, Hittite, Persian, Roman, Byzantine, Seljuk, Mongol, Russian, and of course, Ottoman.

The Erzurum Museum of Archeology has impressive displays of artifacts and pottery from prehistoric through Byzantine times. A side room displays a number of carvings and a beautiful, decorated bell from one of the Georgian churches we hope to visit in the mountain valleys.

We spend two nights in Erzurum before heading north to the town of Yusufeli, which is deep in the northeastern mountains, on the bank of Çoruh River in Artvin province. I want to rent a car. That makes

Astoundingly huge cabbages in Erzurum

Yolanda nervous, so we opt for a three-hour trip on a thirty-passenger bus, which is overcrowded with at least forty-five people.

Once again, I'm surprised at the treeless slopes. Ancient, tectonic activity is obvious and everywhere. The mountains are a tortuous jumble of volcanic rock cut deeply by water-worn valleys. I meet a mountain guide on the bus who speaks excellent English. He describes his life guiding groups of trekkers from around the world. He guides in the Kaçkar Mountains where we're headed, and up the Kaçkar mount, the highest peak, at 12,917 ft. And he leads multi-day treks up Turkey's most famous mountain, 16,854 foot, biblical Mt. Ararat, of Noah's ark fame, ten miles from the Iranian border.

Our ultimate destination is Barhal, a tiny village the guidebook describes as a jumping off point for trekking, rafting, kayaking and hunting. Arriving in Yusufeli, we catch a minibus to Barhal. Bumping along the one lane, gravel road, barely attached to the mountain with precipitous drops to the river, Yolanda is terrified as the driver races to pass a car. Fortunately, this lasts only a few minutes and the driver slows to a rea-

sonable speed for the rest of the hour and a half trip.

I swear this must be the Garden of Eden. Lush orchards and terraced gardens rise steeply up the mountainsides and line the river. Every type of fruit, vegetable and nut grow in profusion. Perhaps this is the source of the enormous, three-foot diameter cabbages we encountered in Erzurum.

These rich valleys have been occupied for thousands of years. Sadly, a dam is slated for construction in the next few years, shutting off this Eden and displacing the tens of thousands living in these spectacular, mountain valleys.

It's getting dark as the van deposits us at Karakan Pension. The owner's nephew puts our bags on a flying-fox type of contraption, bangs on the cable, and they disappear up the mountain into the dense foliage. He leads us through the gathering gloom up a steep series of paths and stairways to the terrace of the farm/pension.

Climbing even more steep flights from the terrace restaurant, we are shown a clean, sparse, perfectly adequate room. Dinner that evening is one of the best of our trip: fresh, organic vegetables, fruits,

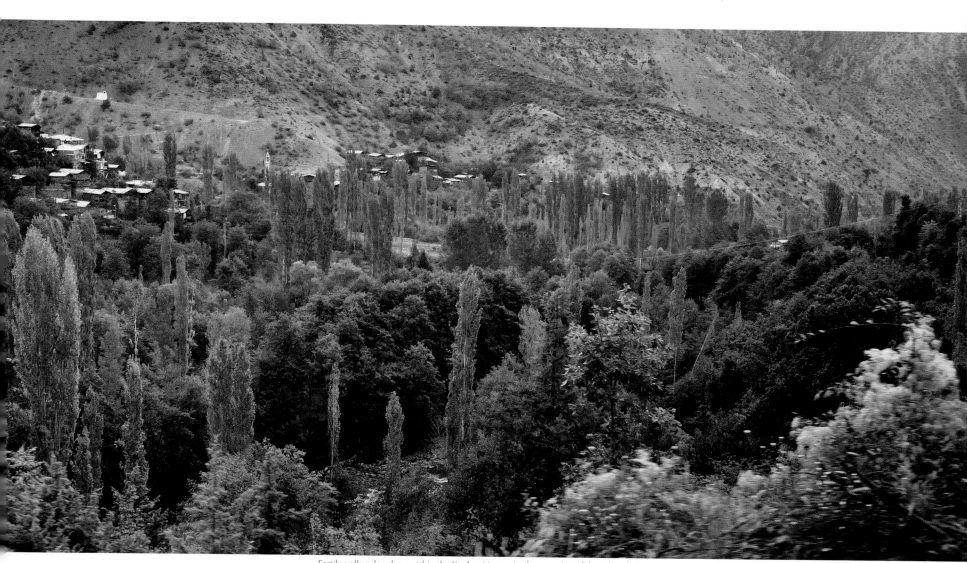

Fertile valleys lay deep within the Kaçkar Mountains between Yusufeli and Barhal.

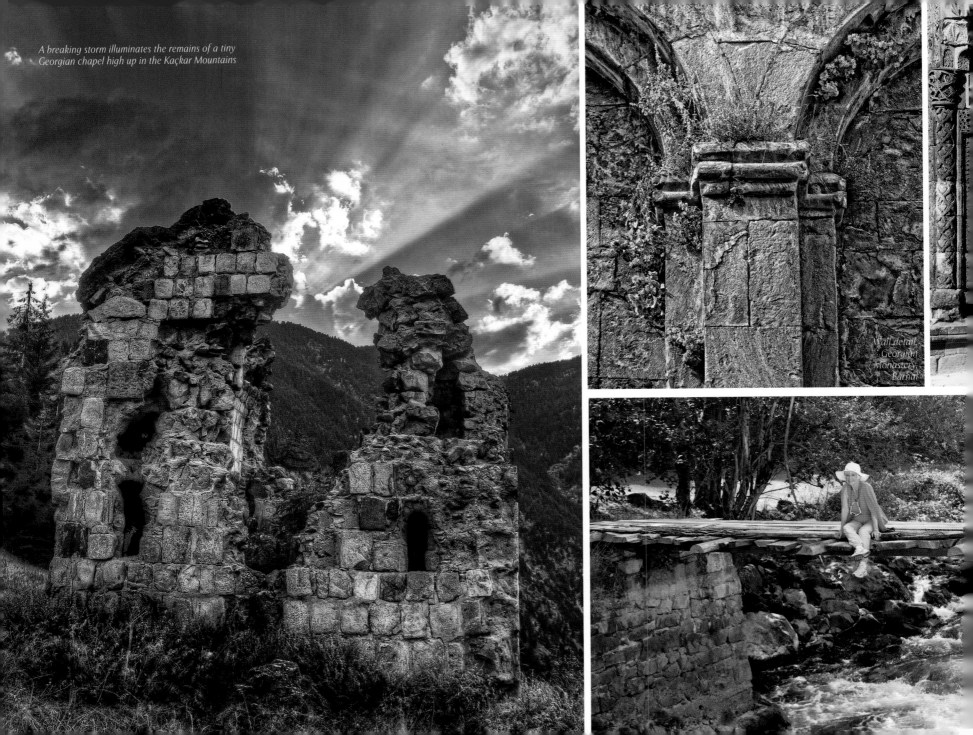

A breaking storm illuminates the remains of a tiny Georgian chapel high up in the Kaçkar Mountains

Wall detail, Georgian Monastery, Barhal

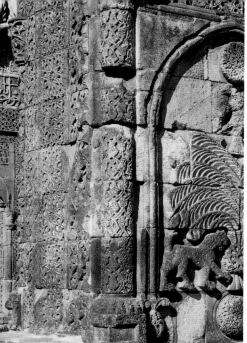

rice, delicious grilled fish, and baskets overflowing with bread.

Morning brings another huge breakfast and we're off to explore. Adjacent to the pension is a deserted, thousand year-old Georgian monastery. Across the valley on a high ridge, the ruins of a small church sit starkly against the sky. Here, finally, coniferous trees fill the mountainsides.

It's a beautiful, late summer day. Yolanda and I spend hours walking the deserted roads, down one valley and up another. In the afternoon, we relax in the village and enjoy tea on a tiny veranda restaurant situated over a small brook. The owner insists on showing me the hunting licenses of people from around the world. He is a hunting guide and shares photos of his clients posed with the animals they've bagged: a few bear and several ibex, one with horns so large they tower over the hunter standing beside his kill.

Late in the day, even though tired, I'm determined to hike to the ruins high up on the ridge. The owner describes the path and I'm off.

It's steep, but the trail is obvious. The views get better the higher I go. The long, steep valley in which the pension lays comes into focus and is more populated than I realized. It is a bit disconcerting to run across fresh bear scat in the middle of the trail. I'm used to this at our cabin in

Colorado and take my precautions, but I am alone and way out there.

The ruins sit on a broad, cleared point at the conjunction of three valleys with 360-degree views. Higher mountains surround me. It has clouded up. Rain and lighting cross a range not unlike the Gore Range above Vail at home. The sun briefly breaks through, allowing me a few decent photographs. As it sets behind a peak, I descend in the gathering twilight to marvel at the opportunities I've been afforded.

In these remote, ancient mountains, surrounded by such deep, rich history, and so far from the intense bustle of one of the world's most venerable cities, I recall the warm, selfless hospitality of the people we've met. I am so fortunate to have been able to converse with people from such an age-old culture and whose religion is at the heart of some of the world's conflicts.

What is evident is that, on a personal level, the Turks' hopes and aspirations for their much-beloved children and their country are no different than ours. They long for peace—desire it intensely. Their wish is that the succeeding generations may grow up in a world that fosters their abilities and provides ample opportunities to achieve their human and spiritual potential.

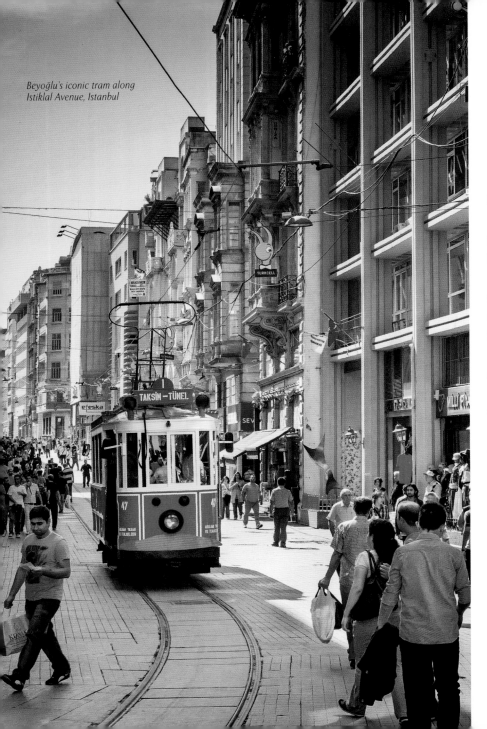

Beyoğlu's iconic tram along Istiklal Avenue, Istanbul

FINAL DAYS IN ISTANBUL

Returning to the cosmopolitan bustle of Istanbul, we are astounded that no reasonably priced hotel room is available in the city. We end up on the fifth floor of a hostel, ninety steps up (I counted them) in Beyoğlu, Istanbul's most fashionable area.

Beyoğlu is a different world. The crowded, narrow streets below our rooftop terrace are wall to wall with restaurants and cafés. It's Friday and they bustle with life.

We enjoy a delicious shrimp dinner at one of the hundreds of sidewalk cafes—people watching throughout the meal. Afterwards, we set out to explore the area, wandering without much knowledge, stumbling headlong into the teeming hoards promenading Istiklal Avenue.

The cramped café-lined alleys contrast dramatically with Istiklal Caddesi (Independence Avenue), probably the busiest pedestrian street in the world. Istiklal is a broad cosmopolitan avenue, several miles long. It is flanked, wall to wall, by architecture from the Ottoman era: Neo-Classical, Neo-Gothic, Beaux-Arts, and later, Art Noveau. Brightly lit fashionable stores, theaters, boutiques, and restaurants occupy the beautiful buildings.

Apparently, Istiklal Avenue is visited by as many as six million people over a weekend. I can believe it! Day or night, people throng its length. Night though, brings out the masses, a constant, unceasing parade between Galata Tower and Taksim Square. A quaint historical tram, an icon of Istiklal, plows daringly through the crowd, passengers hanging out its doors.

Things really don't get started in Beyoğlu before nine and don't stop until sometime around four or five in the morning. Music and conversation fills the streets. Upon returning to our fifth floor walk-up, amazingly we sleep, waking only briefly to the loud weekend festivities below.

Selling fish sandwiches next to the Galata Bridge in Eminönü

A beautiful Sunday afternoon along the Sea of Marmara in Sultanahmet

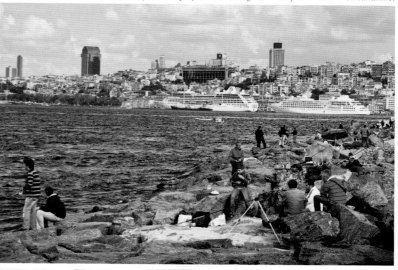

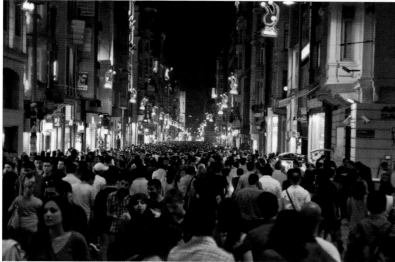

Istiklal Avenue on a Friday night, likely the busiest street in the world

A typical Ottoman Yalı in Sultanahmet

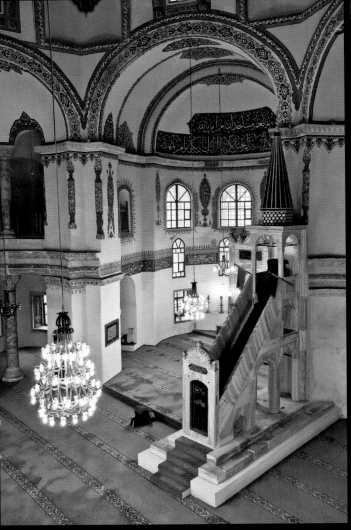

The lovely recently restored interior of the 6th century Little Aya Sophia in Sultanahmet

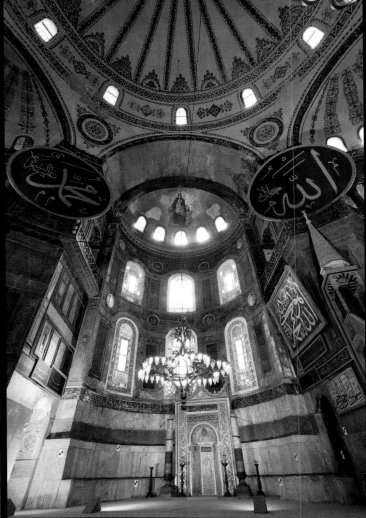

Apse and mihrab inside the Aya Sophia

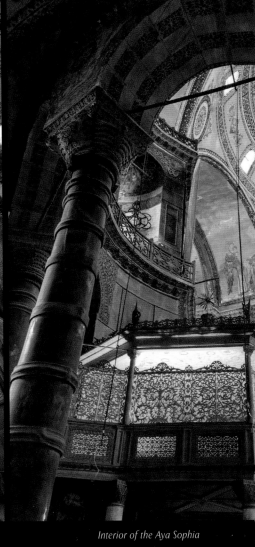

Interior of the Aya Sophia

Yolanda and I choose to forgo our Beyoğlu hostel a second night, not to mention the weekend crowds and pre-dawn partiers. A room at the Turquaz Hotel, where we stayed upon our initial arrival, becomes available. Our final days in Turkey are spent aimlessly wandering the streets of Sultanahmet and Eminönü. We spend a leisurely Sunday afternoon picnicking and walking along the Sea of Marmara, watching the constant boat traffic as Istanbullus fish, cook their catch, and enjoy their friends and families.

I discover an architectural wonder only blocks away from the hotel. It's in every guide book but for some reason the Little Aya Sophia escaped me. Built as a church by the Emperor Justinian between 532 and 537 CE, it preceded its much larger sister, the more famous Aya Sophia. What it lacks in size, it more than makes up for in exquisite beauty. Recently reopened after a several year restoration, it's difficult to believe that the UNESCO World Heritage Site was built almost 1,500 years ago. It is one of the oldest cathedrals in the world and has seen religious worship for over fifteen centuries.

Since we have not yet visited an art museum, we take the tram to the Istanbul Museum of Contemporary Art along the Bosphorus in Beşiktaş. We are blown away with the interesting and thought-provoking work. Not only is Istanbul and Turkey a growing powerhouse in the economic and political spheres, but its artistic life is vibrant and very much an expression of Turkey's self-confidence.

Our final night, we return to our favorite restaurant, Tarihi Çeşme, for our last taste of delectable Turkish cuisine. Afterwards, we have reservations to experience the ceremony of the famed Whirling Dervishes. Though clearly for tourists, the music and trance-like dancing is nonetheless steeped in the ancient ritual of Islam's most spiritual religious order. The broad, white, twirling robe symbolizes the shroud, and their tall light brown hats, the tombstone. This ritual whirling, the Sema, focuses the mind so intensely that the soul is at once destroyed and resurrected.

Walking back through the dark quiet streets of Sultanahmet is reminiscent of our first night in Turkey. And again, forming a perfect symmetry with that magical evening a month before, the stillness is pierced by the Adhan as it peals forth. Its musical phrases once more echo between the neighboring mosques, calling the faithful to prayer: "*Allahu Akbar, Allahu Akbar*—God is Great, God is Great."

Along the Asian shore of the Bosphorus

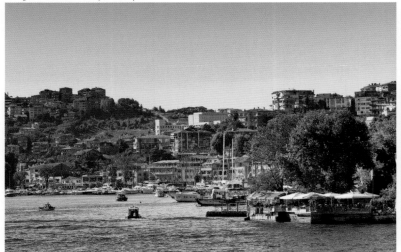

In front of the Aya Sophia

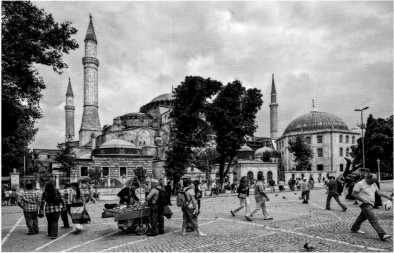

RETURN TO ISTANBUL

The melodic chanting of the Adhan, the call to prayer, pierces my jet-lagged sleep. "*Allahu Akbar! Allahu Akbar!*", "God is great! God is great!", recites the amplified muezzin in a high tenor. Quickly, a second muezzin follows in a resonant baritone. Before the first begins his next phrase, a third chimes, another tenor but with a faster tempo.

Somewhere more distant, a fourth Adhan sounds, and maybe a fifth. I can't tell as the melodious call to prayer reverberates along the dark narrow streets and alleys of Sultanahmet, Istanbul's old city. The sounds echo off walls and buildings, rising to a glorious cacophony until each muezzin finishes in his turn and once again quiet rules the dawning day.

I have returned to Turkey with a contract for this book. My previous trip laid a foundation of understanding, but slightly less than a month inside a country as geographically, culturally, and historically diverse as Turkey is hardly sufficient for a book.

This time, Yolanda and I will spend a couple months, still insufficient to fully capture the diversity of this county. But with the freedom to visit many new places, gather more experiences and impressions—not to mention many more images—I believe I can do a credible job.

Lunch today is with my editors. I have the address and directions. Their office is somewhere in Asia—that is, on the opposite side of the legendary Bosphorus, dividing not just Istanbul, but Europe and Asia as well.

"Take a ferry from Eminönü to Üsküdar, then a taxi to my office," I'm told.

Praying inside the Süleymaniye Mosque

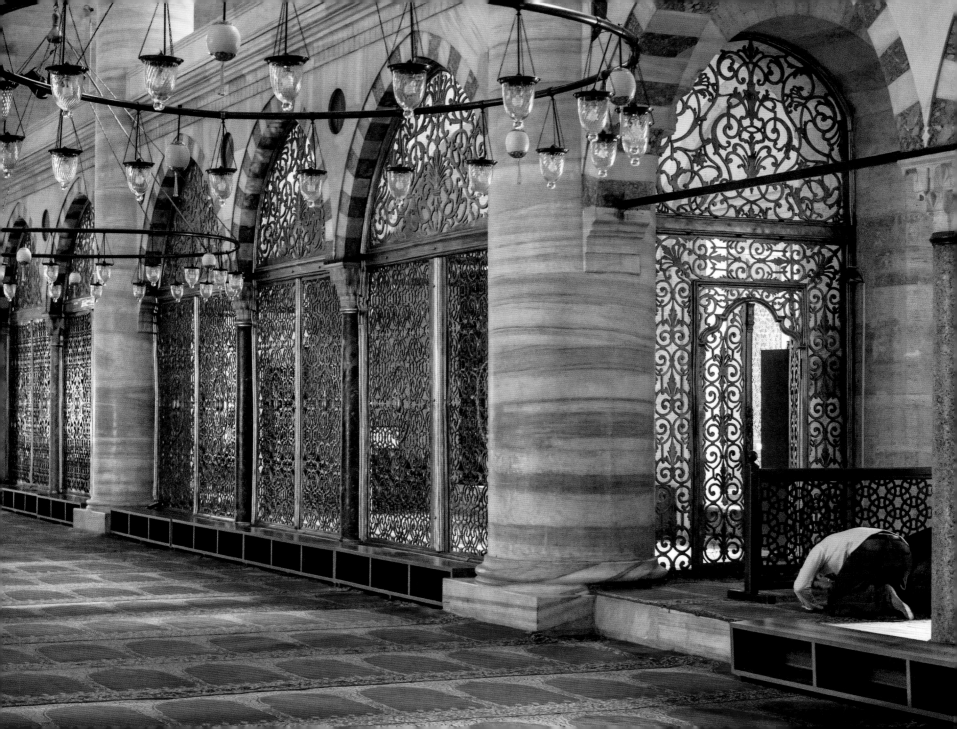

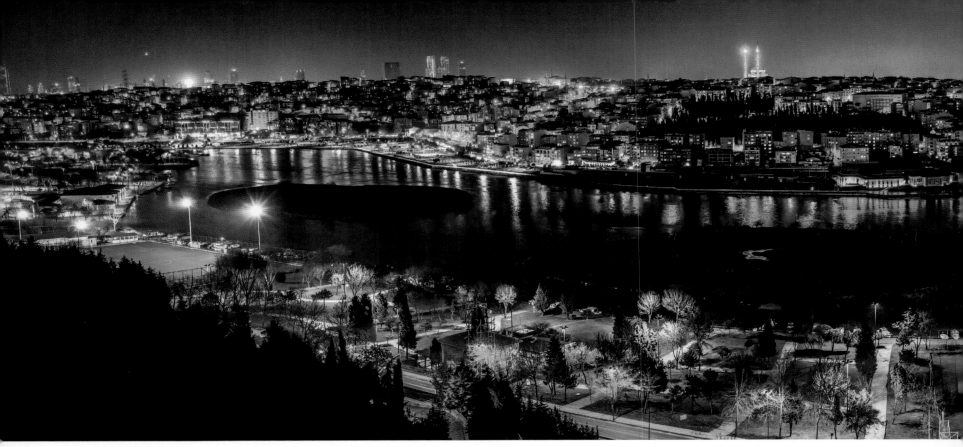

The Golden Horn from Pierre Loti

This is fine, until on the ferry, I meet a kindly, English-speaking Turkish gentleman who takes us under his wing, telling me, "Don't take a taxi. You don't know where you're going and they'll drive you all over the place, running up the fare." He finds me the right bus, even pays the fare, hands me his phone number saying, "Call me when you're done and I'll show you the fantastic view from the Çamlıca hill."

Following my course on Google maps, I know where to get off. Two blocks now to the office, but when I get to the location shown on the app it's not there! Quizzical gestures with the address to a passerby points me to the building two more blocks away.

My meeting goes well. The editors show me typically warm Turkish hospitality and the impressive variety and quality of books they publish.

When we have finished, the editor calls our new friend. We agree to meet at the ferry. Now though, I can't find the right bus or a place to purchase a pass. Knowing the way, more or less, I can't be ripped off too badly, so a cab will have to do. Traffic is terrible. Traffic in Istanbul is always terrible—too many people, some 15 million, and way too many cars, taxis, and buses.

We arrive late; no new friend. I fear we have missed him and am thinking about just catching the ferry back when he shows up. How can one pass up such serendipitous hospitality! To me, travel is all about synchronicity: the more you follow where the universe leads, the more interesting your experience.

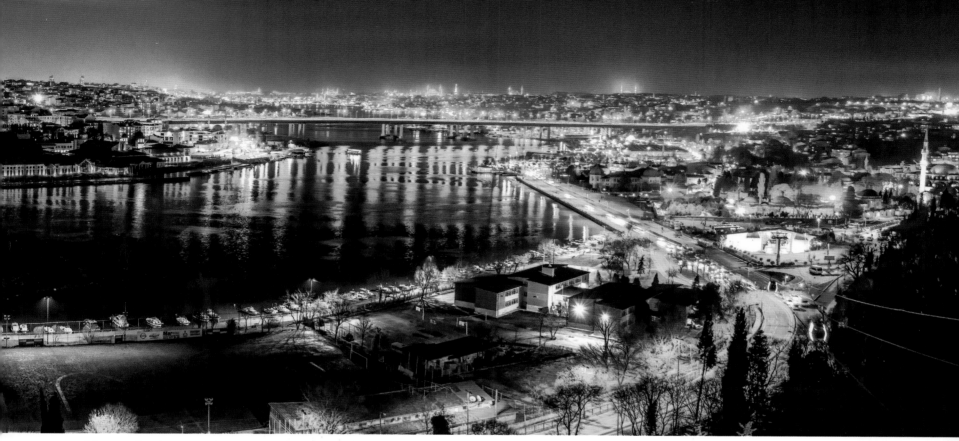

The weather has turned; it's overcast—not an afternoon to photograph a spectacular view. He suggests we take the ferry through the Golden Horn (the horn-shaped body of water splitting western and eastern European Istanbul).

After passing beneath the Galata Bridge, which separates old Istanbul from the more cosmopolitan Beyoğlu district, the ferry zig-zags from one shore to the other, dropping people off, picking others up. Dusk descends. A glorious sunset spreads behind the city, silhouetting mosques and their minarets against the crimson fire.

In the gloom, a long high hill appears above the shore. It appears to be faced with trees and rock cliffs. This is our destination, Pierre Loti—an ancient, Ottoman cemetery whose steep hillside is littered with thousands of stone monuments and tombs.

After passing through an enormous plaza of white marble with a mosque and many shops selling religious objects, a gondola takes us to the top.

The Golden Horn and the lights of Istanbul spread out in a panorama before us. With little time before the last ferry, I take a few shots to turn into a panoramic photo and head down. Exhausted from the day and cold—it is winter, after all—our friend sees us off in Eminönü, promising to meet another day for the view from Çamlıca hill. He continues back to his home in Asia, we get something to eat, and head back to our hotel for much needed sleep.

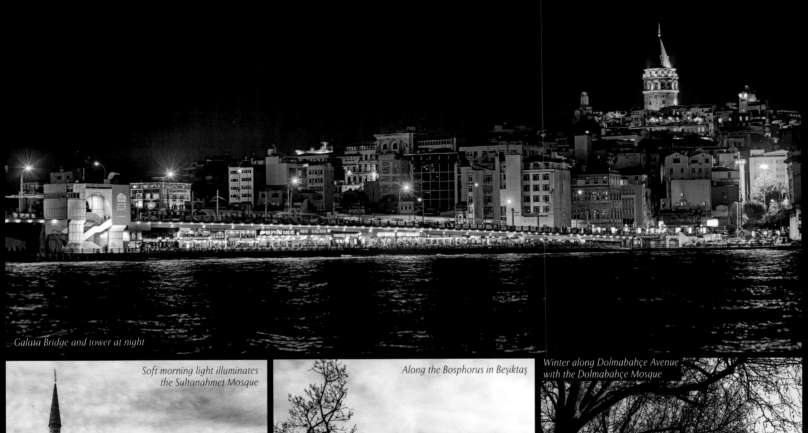
Galata Bridge and tower at night

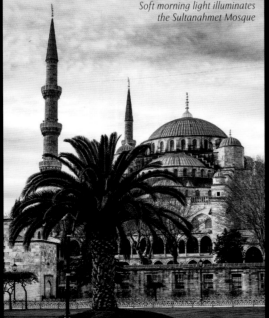
Soft morning light illuminates the Sultanahmet Mosque

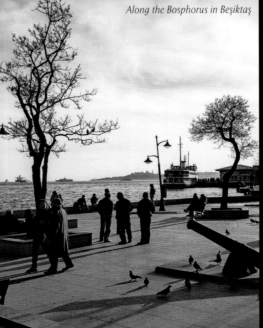
Along the Bosphorus in Beşiktaş

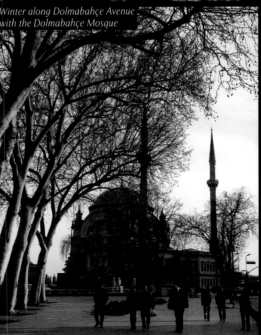
Winter along Dolmabahçe Avenue with the Dolmabahçe Mosque

The next day we try to sleep in to get some jet-lagged rest from the activity of the day before. After wandering the streets of Sultanahmet, mid-day finds us at Istanbul's excellent archeological museum where millennia of human habitation and creativity are on display.

If there is one thing that dominates your awareness in Turkey, it is history. Vast expanses of human history pervade the Anatolian landscape. Those two rivers of legend that cradled civilization, the Tigris and the Euphrates, have their source in the high mountain ranges of Eastern Turkey.

Evidence of humanity extends back as far as 65,000 years! Things really didn't get going though until the Neolithic period, around 8,000 BCE, when humankind evolved from their hunter/gatherer lifestyle and learned to cultivate crops and domesticate animals. The Anatolian Peninsula, which makes up the ninety-seven percent of Turkey not in Europe, is chock full of Neolithic sites, many not yet excavated. Humankind is a prolific animal and every stage of its development is clearly documented in Turkey.

The Neolithic was the beginning: cities sprang up, bronze replaced stone, iron replaced bronze, armies conquered, and empires grew, clashed, and disappeared over the thousands of years before the Greek roots of western civilization appeared.

Turkey has it all: the entire panoply of early civilization and much of the history of the past two millennia. It has always been a crossroads for the world.

In our first three days, we have good, long conversations with three people from very different backgrounds, all Muslims, all very friendly and open. They truly liked Americans.

First was a man from Sudan working in the oil business. He was educated in the old Soviet Union and spent nine years there. Talk about a different perspective! Then we met a couple at the Archeological Museum from Pakistan. They had gotten married over the telephone while he was working as a banker in London. She was at home in Islamabad, after getting her master's in England. This was their honeymoon. They were returning to Pakistan for their formal wedding and invited us to come!

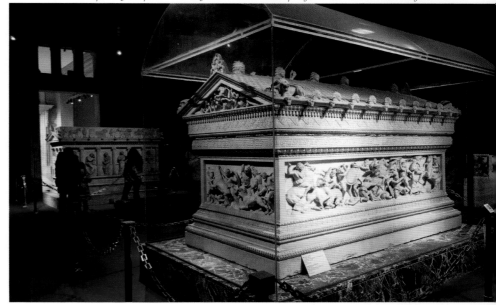

The exquisitely sculpted 4th century BCE Alexander Sarcophagus in the Istanbul Archeological Museum

While catching a bus to the airport—we were taking a several week "winter escape" to southern Turkey, beginning in Bodrum—we had a long talk with a young Muslim couple of Moroccan descent, though both were born in the Netherlands to immigrants. Both are still in university studying social work and are keenly aware of the problems encountered by Muslims in Western countries.

This is why I love traveling: for the opportunity to meet people from different countries and cultures; to gain an understanding of who they are, how they live, how similar we are, and to demonstrate to them that the negatives about Americans they might see and hear are untrue. I want them to understand that the violence our pervasive shoot-'em-up culture portrays is far from our truth.

So here, in three short days, I experience a summation of my book— the incredible warmth and hospitality of a highly diverse Muslim culture firmly rooted in history.

BODRUM — THE GEM OF TURKEY'S SOUTHWEST AEGEAN COAST

Escaping winter, we fly south to the surprising, spring-like warmth of southwestern Anatolia. I had tried to imagine the Aegean coast of Turkey's southwest: hundreds of miles of empty coastline with isolated beaches punctuated by rocky coves of crystal-line, turquoise water surrounded by lush, Mediterranean vegetation and ancient archeological ruins.

I was not disappointed.

The city of Bodrum, the heart of this region, lies on the southern coast of its eponymous peninsula. With its well-sheltered harbor separated from a sandy-beached bay by an isthmus and the magnificent Bodrum Castle, the city holds charms for both the well-heeled and the backpacker.

Bodrum's spectacular evening skyline from the Manistir Hotel

*Arts and crafts in
a village in Bodrum*

*Bodrum Castle, now an underwater archeological museum,
dominates the peninsula separating Bodrum's bays.*

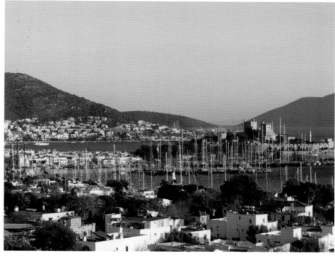

A glance at the harbor tells you unequivocally: there is some very serious money in Bodrum. Yacht after incredible yacht lines the castle-side quay, every one impeccably maintained. Their thick coats of varnish gleam in the generous sunlight.

As for the rest of the harbor, lesser, yet still expensive yachts, clutter the wharfs and quays in a forest of masts.

The bay east of the castle offers a crescent of clean, white sand lined with restaurants, cafes, shops, discos, pensions, and holiday resorts. Everything a tourist could want is found here and in the maze of alleys behind the beach. More facilities are planned as the area is undergoing renovation.

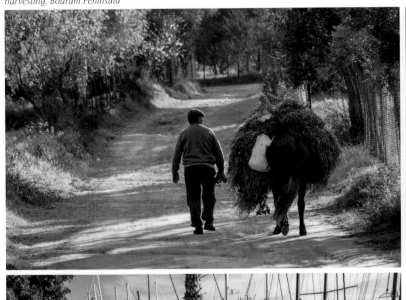

Walking home after a day of harvesting, Bodrum Peninsula

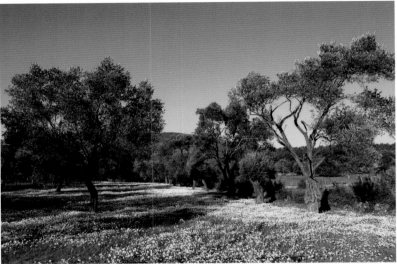

Spring flowers adorn a grove of ancient olive trees on the Bodrum Peninsula

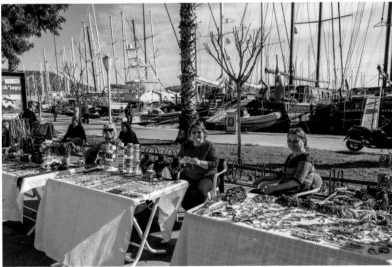

Artisans selling their wares in the weekly market along Bodrum's waterfront

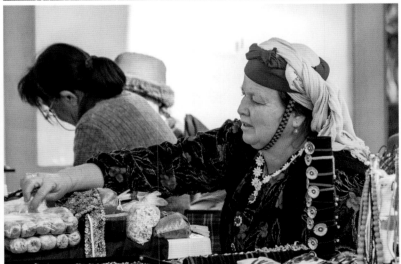

A woman in traditional dress sells her crafts along the Bodrum waterfront.

A broad, pedestrian plaza fronts the bay's eastern end. Yolanda and I spend several gorgeous evenings feasting lazily or sharing drinks at seaside restaurants and cafes while the sun goes down.

Our real find though, is the Manastır Hotel, situated on the eastern hillside above the town. At an amazing $61 a night, our room's balcony has a breathtaking 180 degree view of the town and the Aegean with its many islands, including Grecian Kos, fifteen miles away. Service is superb, the staff well trained and friendly. Plus, they serve the best breakfast buffet we have in all of Turkey. Breakfast is an important meal to the Turks. At home, it is always a shared, family meal, and hotels include it with the room.

Bodrum is the main port from which sailing excursions depart. Everything from day trips to multi-week adventures leave from here to explore the vast coastline of southwestern Turkey and its Aegean islands. The peninsula has become a Mecca for Brits, Germans, and Swedes escaping their northern climes.

This sad circumstance spawned a building boom that has flooded the picturesque coves around the peninsula with all too often ticky-tacky little boxes. Entire hillsides and lovely coves on the western end of the peninsula are awash with developments.

Wheel, pots and cactus, Bodrum Peninsula

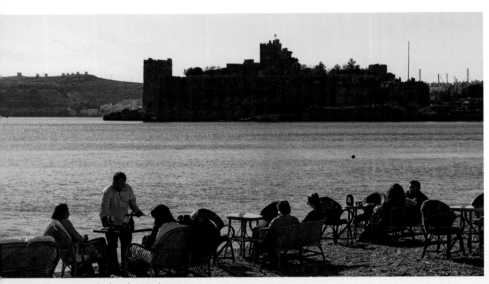

Drinking çay on the beach in Bodrum

As with the rest of Turkey, history extends back thousands of years. Known to the Greeks as Halicarnassus, one of its most famous kings, Mausolus, built his eponymous mausoleum around 350 BCE. It was so beautiful and formidable an architectural masterwork that it was identified as one of the "Seven Wonders of the Ancient World." Its foundation and ruins are now a museum where one can gain a sense of its majesty and artistry.

When the Knights Hospitaller arrived in 1402, they used much of the earthquake ruined structure to construct their castle on the isthmus where Mausolus's palace likely had stood. Over the next 120 years, most of the mausoleum's stones were used to fortify the castle, while its many statues were ground up to produce lime for cement.

The castle fell to the Ottomans in 1522, and after several incarnations over the ensuing centuries, has now been turned into the premier underwater archeological museum in the world.

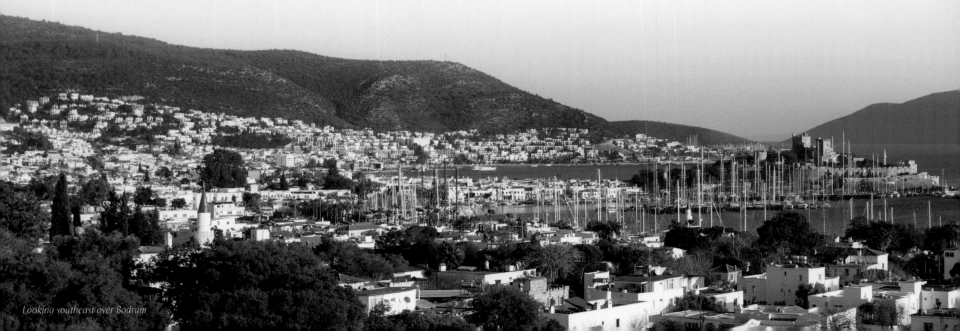

Looking southeast over Bodrum

Despite some rain and cold weather, we're glad to be here in off-season. We have several gorgeous, warm, sunny days without crowds. Come spring, and especially summer, the city is jammed. The party scene goes until dawn.

We rent a car to explore the peninsula for a day. Driving along the coast on the (occasionally) sketchy road offers one great sea view after another. In all the small towns, and nearly every cove, construction is either in full swing or recently completed. You have to wonder when the boom will collapse.

Still, we find much bucolic countryside with horses grazing in fields of wildflowers, little villages stuck in time, and hills thick with evergreen forests.

If you are like most provincial Americans, who possess a distorted and negative image of this extraordinary country, the beautiful, vivacious, modern city of Bodrum will disabuse you of your erroneous illusions.

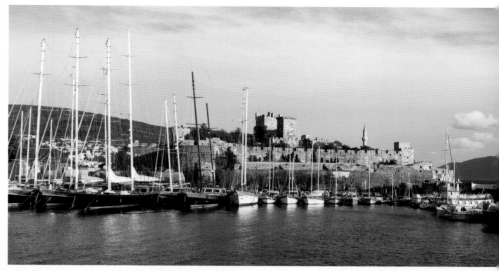

Gorgeously maintained yachts lay at anchor on the quay below Bodrum Castle.

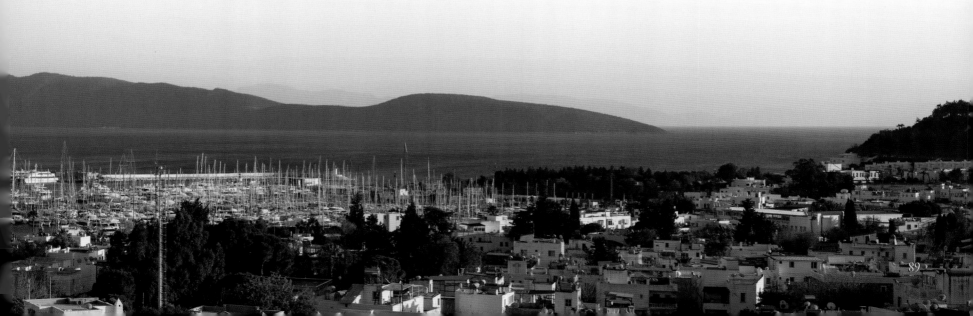

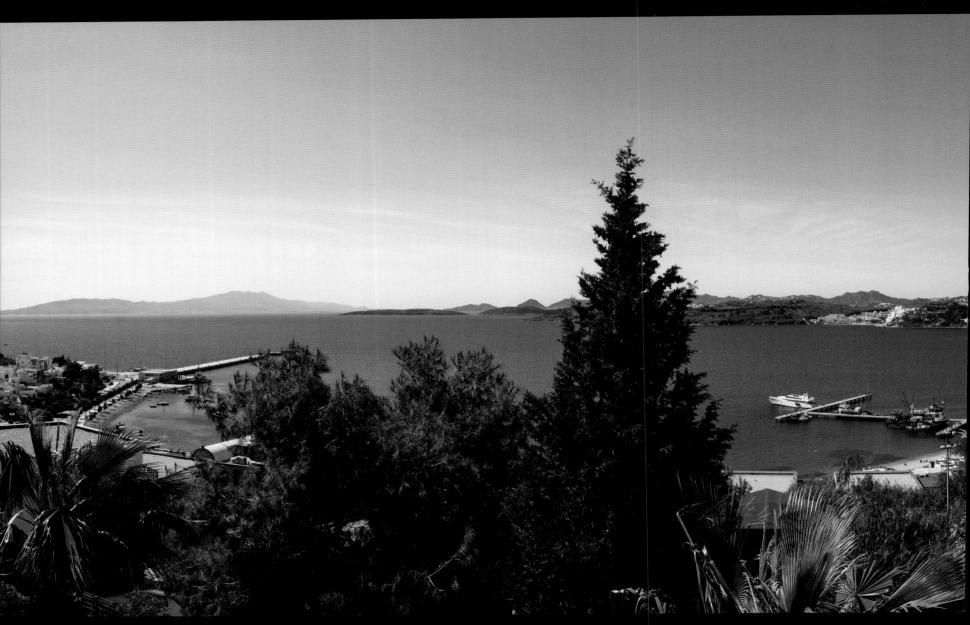

The lovely view from our room at the Manastir Hotel.
The Greek Island of Kos lies far in the distance.

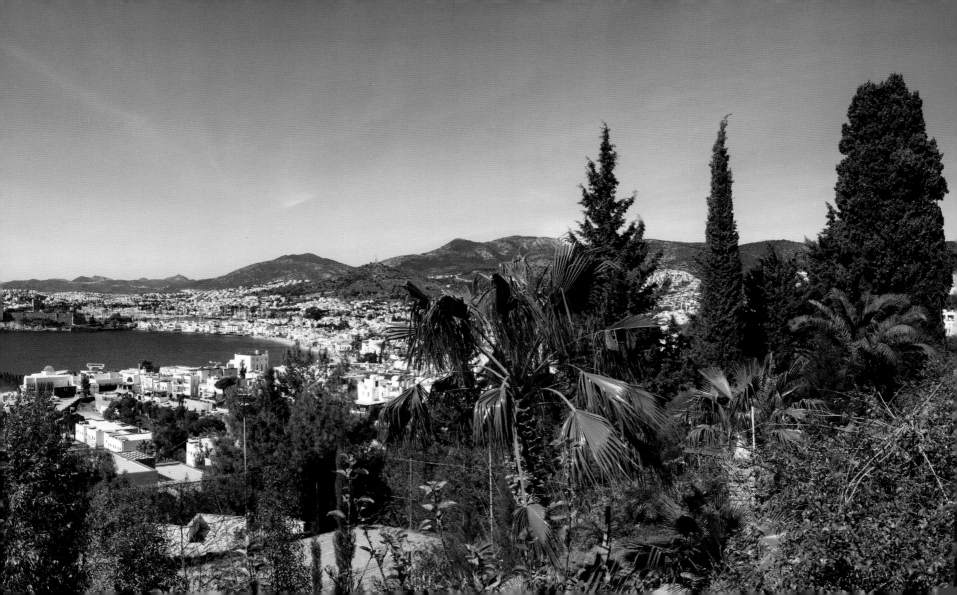

GALLIPOLI AND TROY —
AT THE INTERSECTION OF LEGEND AND HISTORY

Few regions in the world have retained such hold on the collective psyche as the northern stretch of Turkey's Aegean coast. Think Homer's Iliad and the Trojan wars, the Biblical city of Smyrna and more recently, Gallipoli, a name held in reverence by Turks, Aussies, and Kiwis. And what about the dwelling place of Satan?

Returning to Istanbul to join the tour, we find a city transformed with the blossoms of spring. The gardens around Sultanahmet are packed with new flowers. Women in modest topcoats and colorful head scarves take photos of their darling children perched upon the walled terraces, using the multi-colored blossoms as background.

As I mentioned before, we rarely take tours on our travels, much preferring to get around on our own. There are times, though, when it makes sense. What with airfare, hotels, meals, transportation and guide included, the cost for this tour was only slightly more than airfare alone. Plus, we were free to arrive and leave on our own schedule. And once again, it turns out that we were very fortunate in chancing upon our guide, Salih Gök.

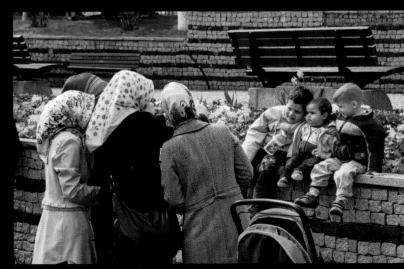
Taking photos in the gardens of Sultanahmet

Flowers, Sultanahmet, Istanbul

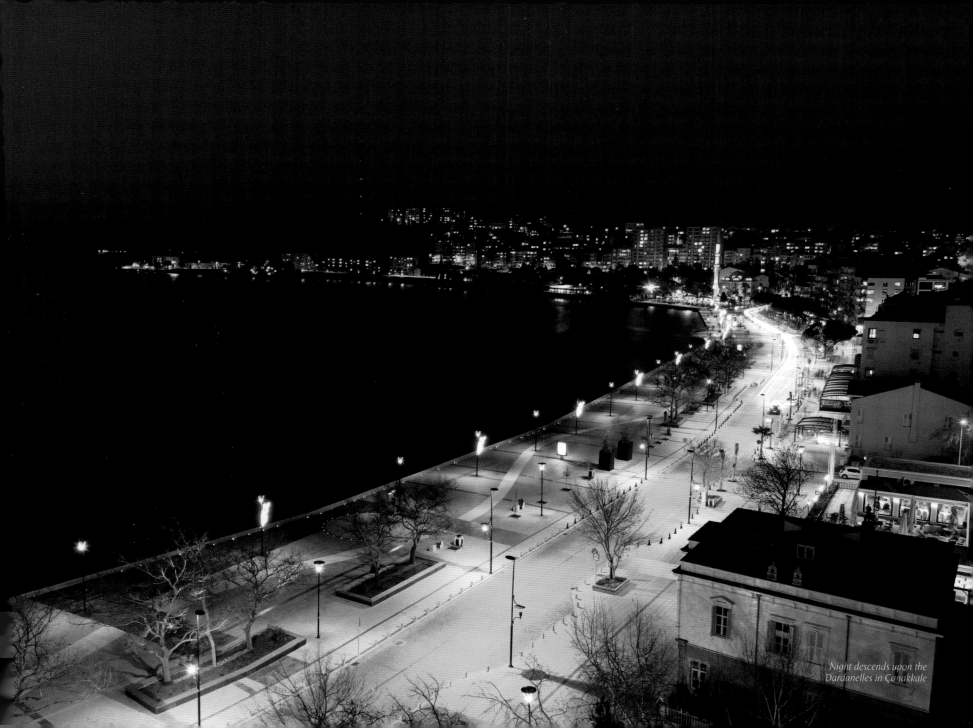

*Night descends upon the
Dardanelles in Çanakkale*

Salih Gök, our irrepressible guide posing among the ruins of Troy

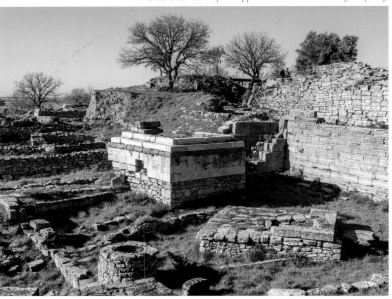

Excavated ruins of the upper-most civilizational layer of Troy

Salih has been a professional tour guide for years. He is of Kurdish descent, and holds not only Turkish and American passports, but Syrian and Greek as well. He speaks fluent English, Turkish, Kurdish, Armenian and Japanese. He loves to talk and is a wealth of information providing insights into the history, culture, religion, and regional influences.

Salih's generous aplomb molded our disparate group of thirty into a cohesive and interesting whole, unerringly respectful and considerate of each other. Yolanda and I, independent travelers that we are, were very pleased. Once again, synchronicity blessed us with amazing providence.

After a day spent in Istanbul we drive west along the Sea of Marmara, away from this megacity. Surprisingly, the environs of Istanbul stretch some two hundred kilometers from east to west. Passing Ataturk International Airport, housing developments thin out and rich, rolling farmland dominates.

Early spring brings a carpet of vibrant green. Isolated farming villages become more frequent, nestled within the verdant hills. Small developments of single family vacation homes and condos appear sporadically amidst the farm land. These we learn, are very expensive and owned by wealthy professionals and businessmen who use them only on weekends or during the summer. An insight into the importance of grilled meat to Turks is that the many chimneys in the complexes are not for heating, but to vent their grills.

After two hours, low mountains appear with quiet, blue lakes resting within their rich valleys. Turning southwest toward Gallipoli, the long,

narrow peninsula protects the legendary Dardanelles Strait from the Aegean. Agriculture continues to dominate. Rolling hills and small plains filled with blossoming orchards are surrounded by rice paddies and fields with emerging artichokes and strawberries.

We arrive at the port of Gelibolu—Gallipoli in English, named after its eponymous peninsula. This is the major transit point south across the narrow and dangerous thirty-eight mile long Dardanelles. Known to history as the Hellespont, it allows passage between the Mediterranean, Istanbul, the Black Sea and all the countries surrounding it. Here, as in Istanbul, the narrow Çanakkale Strait separates Europe from Asia.

For millennia armies have crossed the strait and moved south and east into Anatolia, Persia, and the Middle East. The first to cross were the Persians under Xerxes. Alexander the Great crossed during his three year invasion, which eventually ended in India. The Crusaders crossed in their vain attempts to hold the Holy Land, killing many Christians in Anatolian dress along the way. The Mongols crossed it, and of course the Ottomans crossed, pushing toward the gates of Vienna.

While awaiting the ferry, we wander the small, double harbor, where the fishing fleet lies at anchor. Fisherman patch nets as others recline upon the many large bags of nets strewn about the stone wharf, talking and smoking. A pedestrian street lined with shops, restaurants, and bakeries leads to a small mosque and market. Groups of young boys joke around, watching the few tourists waiting to cross the strait.

Loading the ferry, a blustery breeze stirs the choppy waters. Itinerant perfume sellers are ubiquitous and persistent. Freighters, tankers, and even a floating dry dock pass by. The three mile crossing takes thirty minutes, and after disembarking, we head toward perhaps the most legendary city of ancient history—Troy.

Looking across the strait as we drive the forty-five minutes southwest, mammoth monuments to the WWI battles of Gallipoli (a.k.a. the Çanakkale Campaign) appear on the opposite shore. These battles, between the Ottoman army and the British colonial troops—the ANZAC forces of Australia and New Zealand—have become legend.

Since this is where Colonel Mustafa Kemal—known to history as Atatürk—made his name, it is a good place to pause and tell his story.

On this battlefield, the Ottoman army officer, Mustafa Kemal Pasha, displayed great leadership, and the weakened Ottomans managed to turn back a British-led invasion aimed at Istanbul—the Ottoman capital. This is indeed the story of the emerging modern Turkey. It is safe to say that the most important reason for Atatürk and his colleagues to establish the Turkish Republic in the way they did was the Gallipoli Campaign.

The Ottoman Empire had been shrinking in the decades prior to the First World War. When war came, the Sultan allied his country with Germany and the Austro-Hungarian Empire. The British knew that if they could take the Dardanelles, it would be easy to steam into the Black Sea, supply their Russian allies and move up the Danube in small ships to attack Vienna. They thought it was going to be easy.

As they began penetrating the strait, their "unsinkable" battleships started being sunk by mines that had been hastily laid by the Ottoman navy. The Brits gave up this tactic the next day and decided to use an army to go over the Gallipoli Peninsula and secure the strait.

Meanwhile, young, eager Aussie and Kiwi farm boys and ranch hands, dreaming of glory, were training in Egypt. It was decided to land them on the shore and attack the Turkish troops that were entrenched above the twenty yard-wide beach.

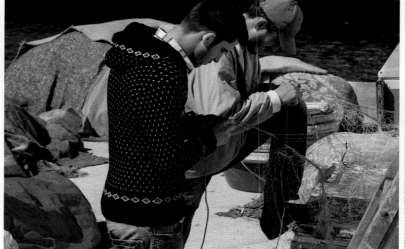

Nets cover the quay in Gallipoli's harbor.

The British and colonial forces persisted in their attacks for nine long months. Unable to break out of their beachhead, the ANZAC forces kept exposing themselves to fire, trying to locate and annihilate the Turkish troops on their well-positioned ridges and trenches. The Turk's machine guns mercilessly mowed them down as they tried to move up hill. Fighting was ferocious. The Turks would yell at them, "Can't you see we're killing you? Why don't you stop? We don't want to keep shooting you."

It was a terrible waste. In nine months, the ANZAC troops were able to advance only nine hundred yards. The Ottoman Army, led by Colonel Mustafa Kemal, held back the intense assault. The brutal fighting cost almost a half million casualties. Of these, Turkish fatalities were around 65,000, while 48,000 were Allied fatalities. When compared with population size, the ANZACs suffered the highest percentage of all Allied fatalities.

When the officers commanded them to fight, each side fought valiantly and fairly. But when the fighting would stop, they would come out of their trenches to play soccer and trade food and water. The ANZAC soldiers even taught the Turks to play cricket and they would cheer each other on. However, when again commanded to, they would return to their respective trenches and recommence the fierce battle.

The trenches were at times only ten yards apart. Richard Casey, an Aussie lieutenant, was shot advancing between them. Before his troops could rush out to get him, a Turk ran out, picked him up and carried him in his arms back to his comrades. Casey later became the 16th Governor General of Australia and an enormous monument depicting this episode has become an icon of these battles.

Another monument at the ANZAC landing point is inscribed with words by Kemal Atatürk. It speaks volumes about the Turkish character:

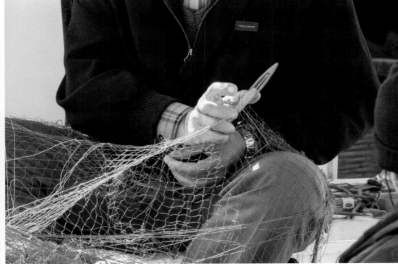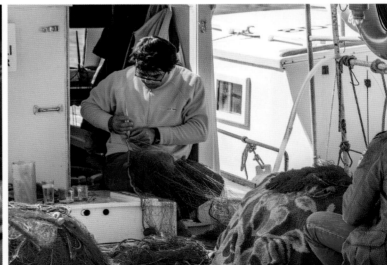

Doing what fisherman always must do and have done for millennia

"Those heroes who shed their blood and lost their lives, you are now lying in the soil of a friendly country. Therefore rest in peace. There is no difference between the Johnnies and the Mehmets to us where they lie side by side in this country of ours. You, the mothers who sent their sons from far away countries wipe away your tears, your sons are now lying in our bosoms and are in peace. After having lost their lives on this land they become our sons as well."

Every April 25th on ANZAC Day, tens of thousands of Aussies and Kiwis travel to Turkey for a special dawn service. Since ANZAC Day is the most important national day of commemoration for them, Australians and New Zealanders descend en masse upon the Historical National Park in Gallipoli. They come at sunrise from the other side of the Earth to honor the memory of their fallen. They return just as quickly, leaving this hallowed Aegean ground to the sounds of the breeze through the grasses and the gentle surf lapping at the shore.

Despite the gallant and successful defense of Gallipoli and the Dardanelles, the Ottoman Turks, who entered the First World War on the side of the Central Powers, lost the war against the Allied Powers. With this defeat, the Allied Powers were able to enter the Dardanelles Strait and sailed into the Bosphorus Strait en route to the Ottoman capital. The six century long Ottoman Era came to a close. The weakened Ottoman Empire was quickly divided up amongst the victors. The Russians took the northeast, with the British, French, and Italians dividing large sections of the country. The Greeks, subjects of the Ottomans until 1832, took all of western Anatolia, land they had held prior to the Romans and once again during Byzantine times, but had lost to the Seljuk Turks in 1071.

The army was disbanded, their weapons surrendered. The once proud Turks, rulers of an empire for centuries, had become a conquered and occupied people. The Ottoman-Turkish Empire lost much of its vast lands, save for the Turkish homeland of Anatolia.

Before the Sultan left Turkey, Mustafa Kemal confronted him asking why he was giving up so easily. He replied that the capital city was occupied by the British and that he was being closely watched and was without an army. If he had resisted, his people would have been massacred.

Mustafa Kemal wasn't being watched though. The last sultan appointed Mustafa Kemal Pasha as an officer-in-charge to save the motherland of Anatolia from invasion and entrusted him with what was left in the

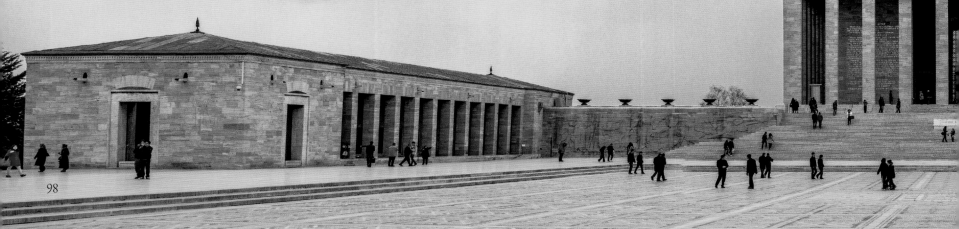

treasury along with an extraordinary authority for giving orders to military, judicial, and administrative bodies in the entire Anatolia. On November 1, 1922, the Turkish Grand National Assembly abolished the Ottoman Sultanate which had existed since 1299. The last Ottoman Sultan Mehmed VI was removed from the throne and exiled to Malta, and later Italy. It took Mustafa Kemal Pasha two years to secretly travel the country organizing the army and the people. On May 19, 1919, he debarked in the city of Samsun on the north coast of Anatolia, thus starting the Turkish War of Independence.

Following the lead of Mustafa Kemal and his colleagues, the Turkish army first defeated the Russians, taking their weapons, and then beat the French. The Italians negotiated their departure and the army now went after the Brits. Eventually, the British pulled out and only the Greeks were left. They put up heavy resistance. Fighting was fierce. Turkish men and women fought together. Over a million lives were lost on both sides. During a year of fighting, the Greeks were slowly pushed to the Aegean. As the last Greeks left from İzmir, they burnt the city, and in Ankara, on October 29, 1923, a republic was proclaimed.

Atatürk governed for fifteen years. He was not just the George Washington of Turkey, but also the Jefferson, Madison, and Lincoln of the new republic. He saw that fundamental changes had to be made to society and the culture in order to drag the country into the modern age.

The Fez, the ubiquitous symbol of the Ottoman male, was banned. He didn't want his people to be influenced by Istanbul and its Ottoman baggage, so he moved the capital to Ankara, then a town of only 20,000. He adopted the crescent and star symbols of the Ottoman flag and changed the national anthem. Scholars invented a new Latin-based alphabet that conformed to the phonetic sounds of Turkish instead of the old Arabic script. He established suffrage for women in 1934, ten years before France. He initiated land reform, taking the Ottoman land and distributing it to those who needed it, and had everyone take a last name. Mustafa Kemal was bestowed the surname Atatürk, the father of modern Turkey, in 1934. No one else, not even his wife or adopted children, can ever use that surname.

Above all else, Atatürk sought to transform the new republic into a secular state. Therefore, laicism became one of the "six principles" of his reforms upon which the republic was established. The Caliphate was

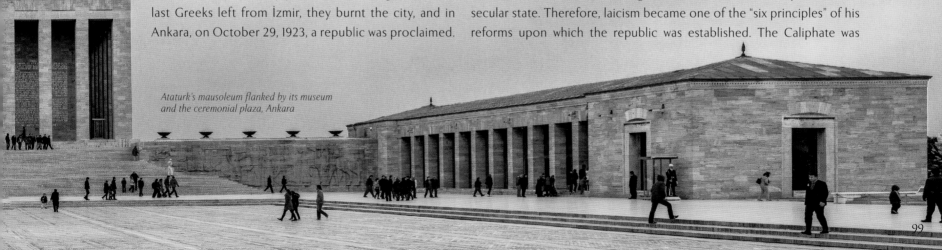

Ataturk's mausoleum flanked by its museum and the ceremonial plaza, Ankara

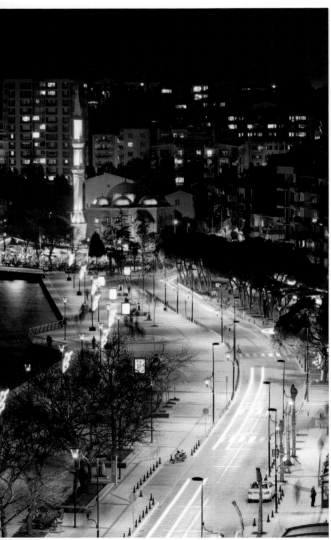

Illuminated a brilliant blue, the minaret and domes of Çannakale's Necip Paşa Mosque dominate the waterfront at night.

established after the death of the Prophet of Islam and the Caliph, or successor to Muhammad, provided leadership over the Muslim world. It was an Islamic institution for 1,400 years. When the Ottoman Sultan Selim I took control of the entire Middle East in 1517, the succeeding Ottoman sultans kept this Caliphal authority for four centuries.

On November 19, 1922—three weeks after the Sultanate was abolished—the provisional Parliament in the new capital proclaimed that Abdülmecid, the senior heir to the throne, was the caliph-elect with no official powers. This last Caliph was the last Ottoman Sultan Vahdeddin's first cousin, and Atatürk warned him that he had a year to behave. Caliph Abdülmecid however, continued his meddling in politics. Consequently, Atatürk abolished the Caliphate and sent all remaining members of the Ottoman family into exile. 1.7 billion Muslims were now leaderless and to this day, Atatürk is thought by many Muslims as the most devious person on Earth, while many others views him as an inspiring political and military figure for gaining the independence of many Muslim nations.

Atatürk saw into the future and knew that religious fundamentalism could rise and a leader like a Khomeini could come to power, causing Turkey to regress from the democratic republic he had established. He worked with the Çelebi, the leader of the Mevlevis, who agreed that when they were both gone, fundamentalist leaders could threaten the secular state. All religious endowments and foundations were put under government control and the lodges of the beloved Sufi orders were shut down. To this day, in spite of all appearances, the Sufi orders (*tariqat*s) don't "officially" exist. The Mevlevi Order however, managed to transform itself into a nonpolitical organization that is still revered, even by the secular state elites.

It is easy to see why Atatürk is revered throughout Turkey. He led the country from defeat and partition to independence and unity, dragging it out of its Ottoman torpor and into the modern era. His memory and his ideas are actively kept alive and the country is constantly on guard that it not deteriorate into a religious state.

～

As we continue our drive southwest along the Asian coast of the Dardanelles, with the hills of European Gallipoli across the narrow waters, we come to the turnoff for Troy, the Hellenistic city of legend. A five kilometer road leads west through fertile, rolling farmland to the archaeological site.

Troy disappeared from history sometime after the 4th century CE. Historians were not even certain whether it had actually existed or was simply a legend. In the 8th century BCE Homer wrote of the Trojan War, 400 years after it occurred. He brought immortality to Helen, King Priam, Paris, Achilles, and the Trojan Horse. The war occurred sometime between 1300–1200 BCE and Homer must have used oral traditions, coupled with his own imagination, to tell the story.

Heinrich Schliemann, a German businessman who had made his money in the gold fields of California, became obsessed with Troy's discovery. He read every account he could find and after determining the likely location dug a long, wide trench down to bedrock. His initial trench revealed at least nine levels of habitation, growth, destruction and renewal until Troy's abandonment, sometime in the early centuries of the Roman Empire.

Troy was situated above a large bay at the mouth of the Dardanelles. It became rich collecting anchorage fees from the ships waiting in their harbor for the infrequent favorable winds that would allow them to pass the strait. The bay has silted up over the centuries. Now, ships passing the strait can be seen from the ruins across several miles of lush, flat farmland—the former bay.

We spend the night in Çanakkale, a vibrant, modern city on the Dardanelles. It is Sunday evening, an hour before sunset. Strolling families, groups of friends and couples fill the wide pedestrian mall lining the waterfront. The huge Trojan horse from the 2004 Hollywood movie stands proudly and appropriately on the promenade.

Cafes line part of the esplanade, while a small harbor is filled with fishing and pleasure boats. At one end of the promenade sits a small mosque and minaret. As the sun goes down, the crowds diminish. The evening darkens and the lights of the city come on. The mosque along the waterfront and lighted decorations on the streetlamps turn neon blue.

The following morning, we head south to the ruins of another ancient Hellenistic city, Pergamon. According to the Book of Revelations, it is the dwelling place of Satan. The acropolis, with its theaters, temples, and the second finest library in the ancient world, rises 1,000 feet above the alluvial plain. The magnificent, reconstructed Altar of Zeus, likely thought of as the throne of Satan, was removed in the late 19th century and has its own room in the Pergamon Museum in Berlin.

Unfortunately the acropolis is closed for major reconstruction. Wandering the Asclepium below it—a major Roman healing center—offers a taste of the architectural splendor of an ancient spa.

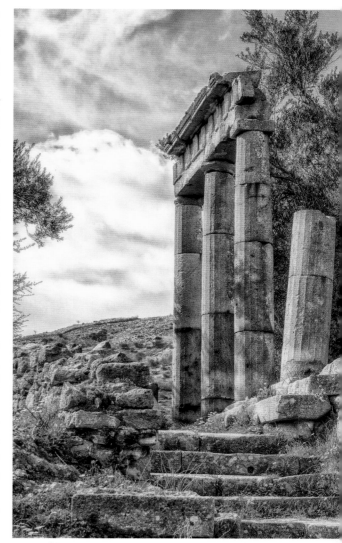

Temple of the Ancients, Pergamon

FROM COASTAL KUŞADASI TO
THE TRAVERTINE TERRACES OF PAMUKKALE

As a photographer, what I love most about traveling is when I can freely wander the old neighborhoods and back alleys of some exotic locale. This is where I often find my most interesting photographs of people and street scenes.

Turkey offers this opportunity in spades, along with the added benefit of safety. There has not been a minute in Turkey when I have felt unsafe.

Fortunately for the slum-dwellers, but not for photography, the government is pushing urban renewal. The old slums of itinerant housing are fast disappearing.

Because of a loophole in Ottoman law, if a house could be built on state land overnight it was a legal residence and owned by those who built it. As people moved to the cities this loophole persisted and has resulted in numerous haphazard neighborhoods, many without basic infrastructure.

In an enlightened approach, and yet another example of the generous Turkish character, developers are given government land near these settlements in exchange for building modern

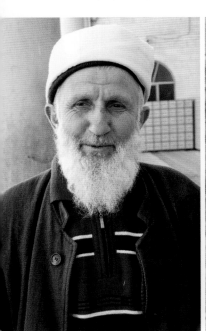

The venerable Imam of the Grand Mosque in Şanlıurfa

One of Gaziantep's residents smiling for the camera

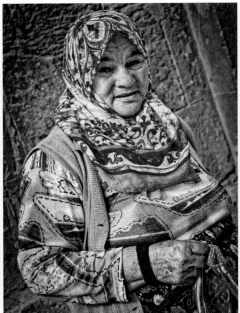

Traditionally dressed woman selling knitted goods in Barhal

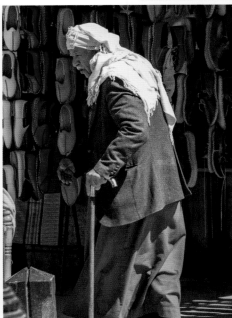

Traditionally garbed man out for a stroll, Gaziantep

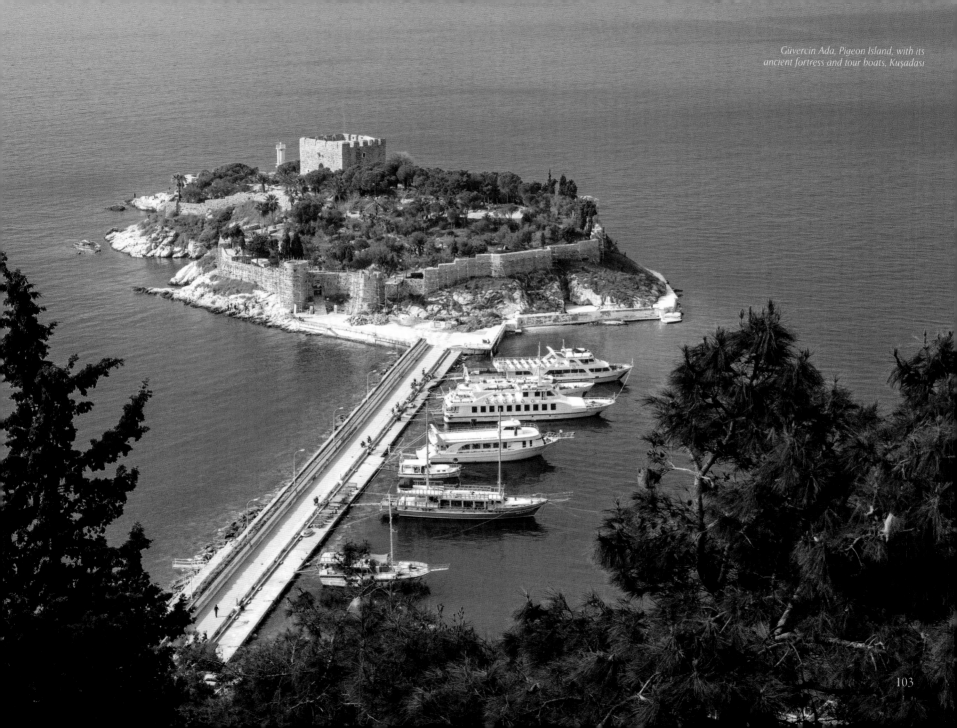

Güvercin Ada, Pigeon Island, with its ancient fortress and tour boats, Kuşadası

apartments, some of which are given to those whose houses are then bulldozed.

Yes, I said *given*. The developers turn their profit on the additional condos in the buildings that can be sold. This broad-minded approach is transforming the cities and towns of Turkey, and improving the lives of the poor.

The coastal Aegean city of Kuşadası—pronounced "Ku-sha'-da-seh" (literally "Bird Island")—is a prime example. Kuşadası is hotel central for tours visiting the ancient, biblical city of Ephesus. Four and five star hotels dominate its headlands and coves. The azure waters of the Aegean washes lazily at their rocky foundations. The panoramic view from our hotel reveals numerous, modern, multi-colored condominiums surrounding the edges of the city, examples of the Turk's open-minded urban renewal.

Ephesus was one of the major sites of the Roman Mediterranean and features in Apostle Paul's letter to the Ephesians. It has been extensively excavated and reconstructed. Having visited and photographed it during our previous trip, my interest lay in exploring Kuşadası.

The city's broad, waterfront pedestrian plaza is more evidence of urban transformation. New sculptures, restaurants and playgrounds follow the sweep of the city's bay, which terminates in a slum encrusted hill at its south end.

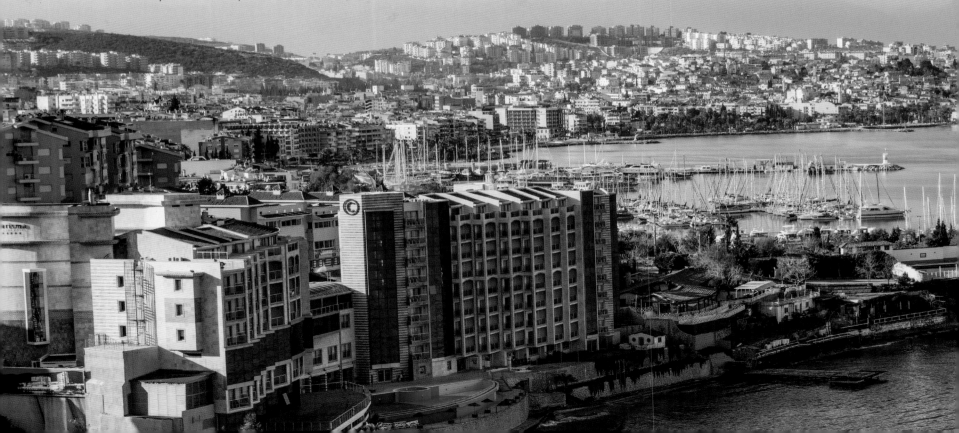

Wandering the steep lanes and narrow alleys of this poor neighborhood, I find old Ottoman houses in various states of decay. Children play hopscotch in the cobblestone lanes while a man on his balcony proudly displays his prize fighting rooster. Observing this is an elderly grandmother safeguarding the neighborhood from her rooftop perch.

Turks are invariably friendly, always eager to help. Several stop to talk as I wander, some offering me cookies and fruit juice.

The tree-filled park crowning the hill provides a panoramic view. The inevitable statue of Atatürk surveys the harbor beneath a huge Turkish flag, and again, urban renewal is evident in the new, multi-colored apartments stacked upon the surrounding hills.

I am impressed with the ubiquitous, rooftop, solar hot water installations. With Turkey's lack of petroleum resources, it only makes sense to take advantage of the abundant sunshine.

Turkey's enlightened attitude influences not just urban renewal and energy use, but extends into infrastructure, education, social security, and health care.

The country is investing in the future with new roads, bridges, and communications infrastructure. Education is mandatory and free. Win entrance to college, and the government picks up the tab. As in almost all industrialized countries (save one very notable exception!), everyone has free access to quality health care. Government retirement benefits

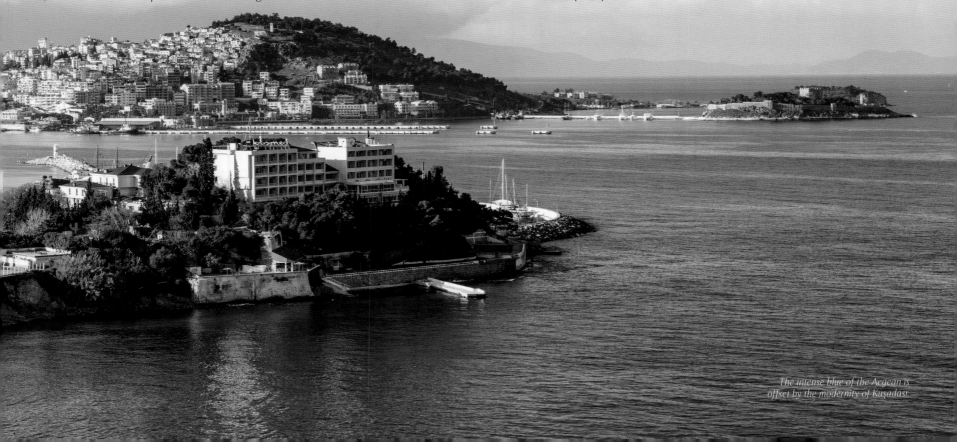

The intense blue of the Aegean is offset by the modernity of Kuşadası.

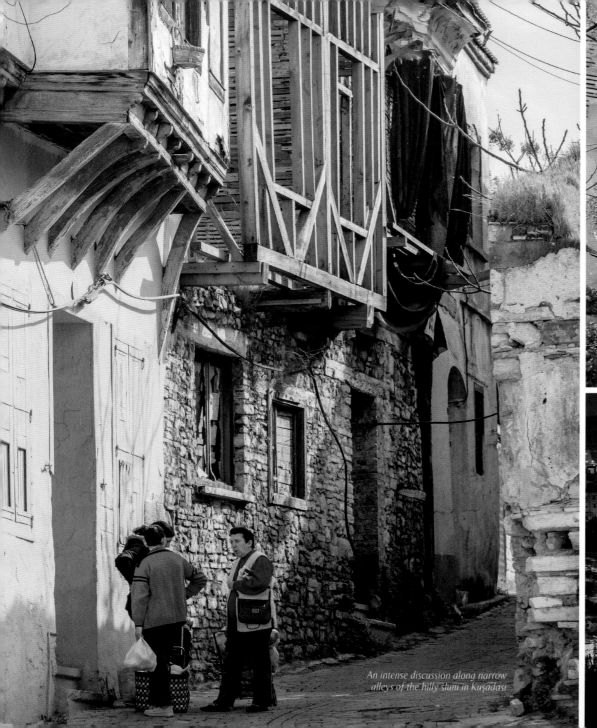

An intense discussion along narrow alleys of the hilly slum in Kuşadası

Hüzün, the depressing feeling of melancholy caused by dilapidation, Kuşadası

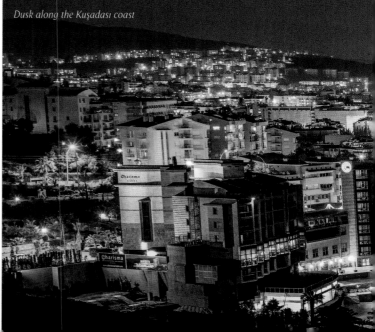

Dusk along the Kuşadası coast

Blue window with yellow wall, Kuşadası

are generous. It is not surprising how happy people can be when they are healthy, well educated, and secure.

This hasn't always been the norm. Upheavals have been frequent since the collapse of the Ottoman Empire after World War I. But, since the Turks embraced democracy and modernization, there has been a steady rise in prosperity and stability. Turkey has become a modern, first world country and is asserting its rightful place in the world.

After a couple of days enjoying the balmy weather of the coast, we move east into Western Anatolia and the fertile agricultural regions of the Menderes (or Meander) River Valley. This area reminds me of California's central valley, though in miniature: a long, broad, agricultural valley bordered on one side by hills and low mountains, and on the other by magnificent, snow-covered peaks. Only here, the valley runs east-west rather than north-south.

The land is fertile and well-watered. Little irrigation is needed but the government has been building dams, particularly in the drier southeast adjacent to Syria. The farmers raise almost every kind of fruit, vegetable, potato, squash, rice, grain—and of course, lots and lots of olives.

Ancient groves of olive trees cover hillsides. Locals extract everything possible from this invaluable fruit. The first pressing yields the highest-quality extra virgin olive oil. They add water to the leavings and press it again for more oil. Then they make soap from what's left, and finally drying the last bits into bricks, they

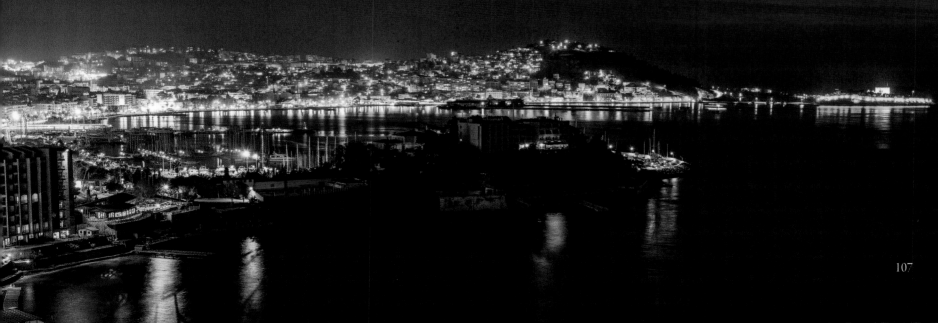

burn them for fuel. Another ubiquitous food is eggplant. Turk's have over 254 official recipes for eggplant. Every year, chefs from the best hotels and restaurants compete in a country-wide eggplant cook off.

Cotton, however, is the primary crop, and textiles are Turkey's number one industry and main export. Whether you're aware of it or not, you probably own clothes made in Turkey or more likely, made with Turkish fabrics.

The agricultural share in the Turkish economy accounts for about 10 percent of gross national product (GNP). While the growth in the industry and services sectors outpaces agricultural growth, the agricultural sector still has big potential in the Turkish economy, contributing to the national income and exports. Turkey is self-sufficient when it comes to food, and it is one of the world's largest producers of hard-shell nuts, fresh vegetables and fruits. For instance, Turkey is the leading producer of figs and apricots, and it dominates the world hazelnut industry, producing about 75 percent of the world's total.

Farms are typically fragmented; they are individually owned but cooperatively run with the machinery owned in cooperation with the other villagers. There are no "farm houses" in the American sense. Farmers live in small villages surrounded by their fields without fences or borders. Their income from agricultural activities is subject to the income tax, but self-employed, small farmers pay no taxes if a farmer's gross revenue is less than the amount specified by the tax law. These small farmers often work together, helping each other. If a villager sends his son to the army, the sons of the other villagers help out.

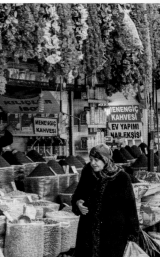

Fishmonger's display

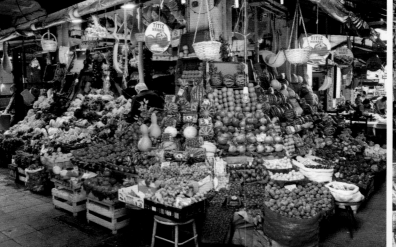
Beautifully displayed fruits and vegetables

Spice shops in Şanlıurfa's bazaar.

Wildflowers in an ancient olive grove, Bodrum Peninsula

These predominantly rural areas account for less than 30 percent of the economically active population. But here, women play a greater role in the labor force of the rural areas. They perform much if not most of the farm labor. Five million Turkish women work the land. You see them in the fields stooped over under the hot sun planting seeds, hoeing weeds, harvesting crops, and carrying bales. They look after the animals and shear the sheep, make butter and cheese and of course, tend to their children and families.

About three out of ten Turks live in rural areas, and the urban-rural gap in the GNP is significant. Migrant labor, especially from the Southeast, moves around during harvest time. Entire families move together, setting up tents near the fields where they work for a few weeks, or a month, before returning home with their money.

There are no cowboys in Turkey. Large cattle herds like in the U.S. don't exist. Villagers may own a few head of cattle, but the main source of protein is lamb. Small flocks are everywhere along the roads and highways herded along by Turkey's world-famous Kangal sheep dogs, who do most of the work. They have an instinctive sense and require very little supervision. A shepherd from the village is with them, but does little more than ride around on his mount, playing his flute.

After several hours traversing the valley, a white scar becomes evident along a bench on the northern mountains. This is the national park and UNESCO World Heritage Site of Pamukkale, or Cotton Castle, one of Turkey's major tourist destinations.

Drawing closer, the enormous size of the majestic, travertine cliffs becomes apparent. Think Mammoth Hot Springs in

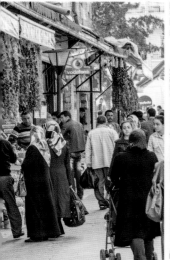

Dried condiments used in the local cuisine hangs outside a spice shop.

A wealth of late summer fruits and vegetables adorn a roadside stand

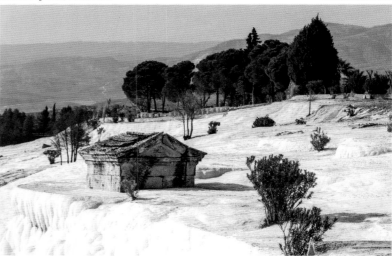

Yellowstone, but on a truly massive scale. The brilliant, white formation is an elaborate complex of terraces a mile and half long and over five hundred feet high. Humans have bathed in its hot pools for thousands of years.

The ruins of the Greco-Roman city of Hierapolis lay on a broad bench of ancient travertine behind the cliffs. Green hills sprinkled with crimson poppies rise behind the ruins. Hierapolis must have been a magnificent city. The setting is spectacular, perched as it is above the verdant valley posing as the foreground to the majestic peaks of the Taurus Mountains.

For 1,500 years Hierapolis was inhabited. The enormous size of the city denotes its importance in the Roman world. The quality of its architecture must have been stunning. Perhaps as many as 100,000 people lived in here at its height.

The apostle Philip walked its streets and was martyred here by the Romans in 80 CE.

People from all over the Roman world came to take the cure from the hot springs—and many to die. A vast Necropolis of tombs and sarcophagi lie scattered and pilfered west of the partially reconstructed ruins. I have never before had such a sense of "Walking on the bones of history" as while traversing this vast city of the dead.

Racked by frequent earthquakes, destroyed and rebuilt several times, it was abandoned for good in 1354 CE, when the entire city was destroyed by a major tremor.

Now, a modern spa and hot springs allow visitors to partake of the ancient waters amid an oasis of palm trees, lush greenery and cafes. Columns and pedestals of the long dead city lie

Tourists wander the travertine terraces of Pamukkale.

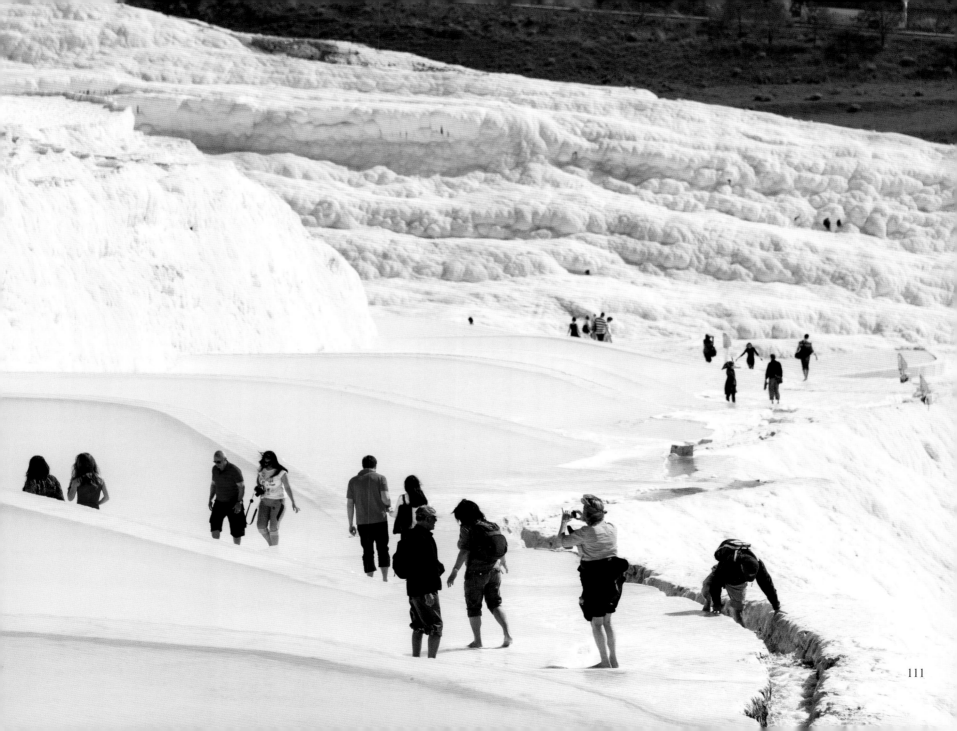

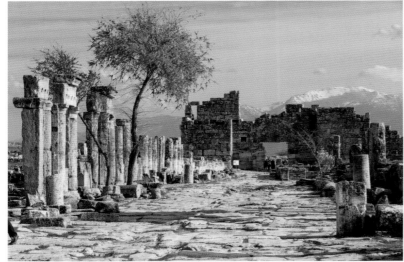

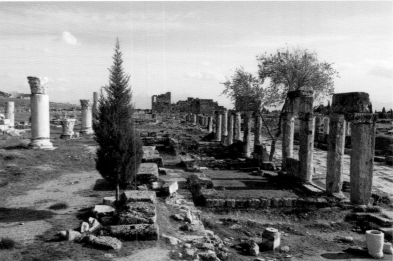

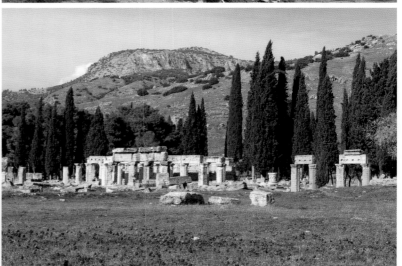

*One of the many tombs surrounded
by sarcophagi in Hierapolis*

*A profusion of wild flowers grow amidst the ruins of
the ancient Roman city of Hierapolis*

beneath the pool's surface, providing resting places for those enjoying the healing waters.

We spend the night in Pamukkale, a town groaning under the construction needed to accommodate the flood of visitors. Germans, Italians, Koreans, Japanese and of course, we Americans and Canadians, fill the hotel's large restaurant. The sumptuous buffet of fresh fruits, hot vegetable casseroles, breads and meat dishes come, no doubt, from the fertility of the Meander Valley below.

The Qur'an says it is better to pray than to sleep. The next morning, I wake all too early. Unable to get back to sleep, I begin writing. Unexpectedly, the soft, distant sound of a choir filters into my consciousness. Listening closely, I realize it to be the 5:22 call to prayer from a distant mosque. Sung as always, by a single muezzin with his own unique style and melody, this one, filtered by distance and perhaps the strange acoustics of the forested mountains, manifests in an ethereal, heavenly chorus unlike any Adhan I've heard before. It is entrancing.

A minute or two later, another muezzin much closer begins. His clearer, unique style carries none of the choral sense. But in this moment of pre-dawn quiet, the ethereal effects of the previous call lend itself to this more direct rendering.

What must it have been like in the days prior to electronic amplification? Is there somewhere in the Muslim world where one can still hear the Adhan as it has sounded for over 1,300 years—sung by a muezzin alone at the top of a minaret high above his village, using only the power of his vocal chords to call the faithful to prayer? Could it have been something akin to what I just experienced? Could the ancient call have reverberated in this same, uncanny way through the stone walls and narrow alleys of a thousand-year-old village, without the volume and strident timbre imposed by today's inexpensive loudspeakers?

The more I explore Turkey, the deeper my sense of it becomes. Coming from a country with a historical perspective of only a few hundred years, it is difficult to imagine the viewpoint of a Turk.

America has known only two civilizations in say, 1,000 years of history. The Anatolian Peninsula recently knew 623 years of Ottoman heritage. And before that, the rise and fall of numerous civilizations, over some 8,000 years, date back to the very dawn of history. It has to influence their outlook.

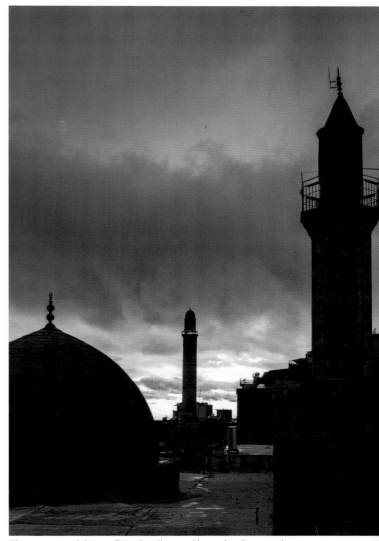

The minarets and domes of Mardin silhouetted beneath a dramatic sky

CAPPADOCIA — FACILITATING BUSINESS AND HOSPITALITY FOR OVER 1,000 YEARS

The Silk Road conjures images of camel caravans, exotic spices and very slow travel between China and Europe. It was not a single route but a network that changed over time. The Anatolian Peninsula was a focus of travel along the route's western provinces, with branches leading throughout the peninsula to Constantinople, the Black Sea and Aegean coasts.

East–West trade flourished for centuries. Long before the west became aware of the "Middle Kingdom" through the chronicles of Marco Polo, caravans of traders made the months-long journey.

During the empire of the Seljuks of Anatolia, which is also known as the Seljuk Sultanate of Rum, 1077–1307 CE, and especially at the beginning of the 13th century, the hospitality for which Turkey is famous rose to new heights. Seljuk Turks used the term Rum (meaning "Roman") for the Anatolian Peninsula even after their conquest of the Byzantine Roman Empire, and they established a network of 250 large caravansaries (or *han*s) in order to facilitate trade.

Building the infrastructure of caravansaries, as with building any infrastructure, was good for business.

A dust-defined sunbeam penetrating the building's oculus illuminates the winter quarters of the Sultan Han, Aksaray

Interior portal of the Sultan Han, Aksaray

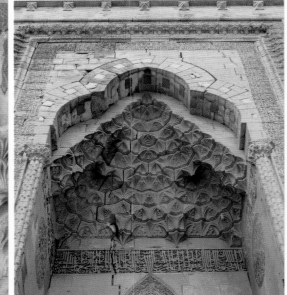

The massive portal of the Zinciriye Madrasa in Mardin is another dramatic example of 14th century Seljuk architecture.

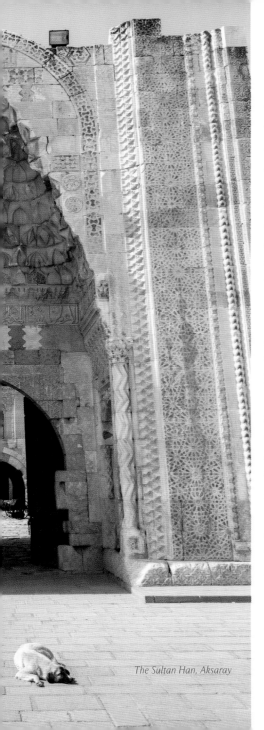

The Sultan Han, Aksaray

Travel for caravans, consisting mostly of companies of traders journeying together, became more secure, making Anatolia a desirable place to do business. The empire prospered along with the flourishing trade.

For three days, any traveler could find free food, water, shelter and fodder for their animals, not to mention safety. Caravansaries, also known in Turkish as *han*s, were built 18-25 miles apart, a day's journey by camel. Many of these ancient *han*s are still in existence and several have been restored to give the modern traveler a glimpse into 13th century travel.

The highway we've been traveling from the coastal city of Kuşadası to the other-worldly landscape of Cappadocia, follows one of these trade routes. The Sultan Han, in the Aksaray province, is a beautifully restored example. Built in 1229 CE, its forty foot high stone walls must have been an imposing and welcome sight for ancient businessmen. Its ornate, carved, and decorated portal and massive gates would have signaled to all travelers that within lay security and hospitality.

The *han* operated year-round. It was run like a small city, providing every service to the caravan travelers. The large interior courtyard, with a mosque at the center and surrounding storerooms, accommodated fair-weather travelers while the enormous enclosed space behind the courtyard provided shelter in the winter months.

Some researchers believe that part of the open courtyard was used for the animals in summer time, but during the winter months, people slept in the side cells while their animals were kept in the enclosed hall. Other researchers, however, say that travelers stayed inside this winter enclosure with their animals. With both humans and animals housed within the high, vaulted ceilings of this winter enclosure, and with cooking fires burning along with lord knows what else, the stench must have been unbelievable. Still, it beat the alternative of being in the open spaces of this high, windy plateau. On the day we visit, dust is being blown by a strong, southerly wind. Our visit would have been a bit unpleasant, but the photographic possibilities in a dust-defined shaft of sunlight beaming through the single ventilation hole in the soot-blackened ceiling which more than made up for the wind and dust.

Continuing farther east, the tawny plains give rise to rolling hills dominated by a snow-capped volcanic peak, Mt. Hasan, rising from the Central Anatolian plateau. It offers a wonderful view of the plateau, including distant Cappadocia. This volcano, along with Mt. Erciyes farther east, is the source of the soft, volcanic tuff that has eroded into the fairy chimneys and other-worldly landscape for which Cappadocia is famous. For thousands of years—back to the days of the Hittites and earlier—people have carved their homes, sta-

bles, and churches from the fantastic hills and canyons of the region.

Our travels take us to the city of Nevşehir, and then into the unforeseen warmth and hospitality of a resident of the tiny village of Nar.

The day begins with the idea of wandering the streets of this ancient village, its homes carved from the tuff. Afterwards, we had planned to take a bus to one of the valleys near the outdoor museum of rock-hewn churches in Göreme to explore an area not visited on our previous trip to Cappadocia.

Little did we know that things would not go according to plan, and that in the true spirit of synchronicity, we would spend the day in the warm embrace of Turkish hospitality.

As we walk the twisting lanes, people invariably say "Merhaba," which means hello in Turkish. A women helped by her son squats on the cob-

blestones in front of her house, sorting home-dried raisins, offering us a handful. A man leaving the town's tiny mosque calls after us, motioning us to follow him. He leads us to some stairs and pointing through the opening at the top, shows us an ancient, stone mill where donkeys had driven the huge grinding stone for generations.

Leading us around the town he points out various things. Our non-existent Turkish sadly inhibits communication. Then, coming up the street from the post office is a colorfully dressed gentleman with salt and pepper hair and an infectious laugh.

He introduces us to Mehmet and we quickly find that we can communicate in German. Our plans for the day evaporate.

Mehmet Bilgin is a retired art teacher from Kayseri, a Central Anatolian city to the east of Cappadocia. Born in Nar, he returned, buy-

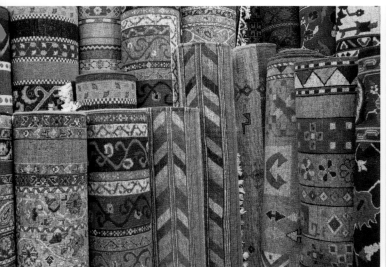

Carpets, Cappodocia

Carpets and bags on display

Silk cocoons, Cappodocia

ing the cave house his grandfather grew up in. He is now turning it into an artist's retreat. He wonders if we would like to see it. Without hesitation we accept the invitation.

Climbing the hill, we stop in front of a large, hand-made wooden door. Pushing it open, we enter Mehmet's world, a series of hand-hewn caves set in the cliff. Some are ancient, others not, as he has carted off 2,500 pickup loads of rock to date. There are caves behind caves, two-story rooms with wooden floors, stairs and handrails all made by him. He's made the cabinets and shelves as well. This is obviously a labor of love and the dream of his life.

Climbing the cliff reveals more caves, one half-filled with rubble yet to be hauled away, 50-60 trucks loads he says. At the highest level is a cave used in the past as a stable. The waist-high feed troughs are still

there along with indentations for the hitches. How many generations have lived here?

Mehmet plies us with tea, the symbol of Turkish hospitality, and a plate of homemade bread appears. We sit on his terrace overlooking the town sheltered from the sun by the porch of the cave above. Here is a truly happy man building his unique dream. No endless games of backgammon or hours spent "philosophizing" with other retirees. He says people in Nar think he's crazy. I have to agree. But this kind of crazy is a good thing. I doubt few people in this provincial town can understand his intellect and expansive world view.

Mehmet invites us to go hiking with him. There are some ancient, rock-hewn churches he wants to show us. How could we refuse? We set off through the town. He stops occasionally to talk with elderly villagers,

Busy hands, Cappodocia

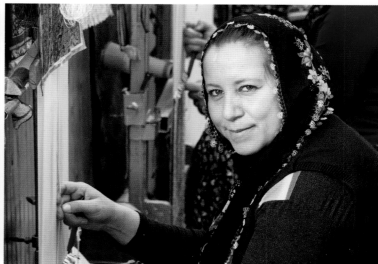

An artist happily at work in Turkey's iconic industry, Cappodocia

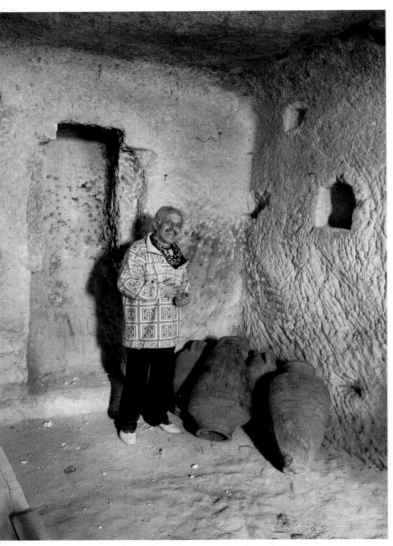

Mehmet Bilgin in his cave in Nar, Cappadocia

friends of his father, he says. He again shows us the mill, telling us how as a boy of twelve, he ran this mill.

Mehmet points out the ruins of a Seljuk castle now mostly destroyed or built over. Rooms still exist. One contains an old wine making niche in which the grapes were stomped. The juice flowed from it through a hole into a circular bowl, all carved from the rock. He figures these to be around 1,000 years old.

Leaving the town behind, we walk along a dirt road through a narrow valley of small farms—hobby farms of the retired he tells us. The occasional tractor or pickup truck passes. The blossoming almond trees are a soft purple in the warm, spring sun. People plant potatoes in terraces thousands of years old, while other crops are poking up through the ground.

Unprepared, and after several miles, we are thirsty and hungry; mid-afternoon has arrived and we've had nothing to eat. There is no town or market, and we have no real idea how much farther the churches are. Four kilometers Mehmet says; just around that curve way ahead in the valley. Yolanda is getting tired, much in need of water and something to eat.

Mehmet takes out his cell phone, makes a call, and leads us across a field and into a small dwelling where we are greeted by friends of his, a retired commissar and his wife from Samsun, along the Black Sea coast.

She prepares tea and produces bowls of nuts, dried fruits, and cookies. We're saved! Unfortunately it's difficult to communicate. They speak only Turkish, so going through Mehmet in German and then me to Yolanda in English doesn't work well. But there are smiles and thank yous, and they know we appreciate their hospitality.

The weather is changing and we decide that we should return via a different way, up and over some hills, through vineyards and past an old Ottoman cemetery. Mehmet leads us back to our hotel. We say our goodbyes, thanking Mehmet for a truly memorable day. Once again, we are blown away with the graciousness of Turks, a culture of sharing hospitality that goes far back in time.

Seljuk-Turkish style tombstone, Cappadocia

Ottoman cemetary, Şanlıurfa

119

From Capital to Commerce: Ankara to Istanbul

Approaching the capital city, Ankara, from the south provides a lesson in reforestation and climate. As we rise in elevation from the central plains and the 650 desolate square miles of Tuzgölü, the enormous "Lake of Salt" situated in the dead center of the Anatolian Peninsula, the landscape turns mountainous once again. Swaths of what had been bare, rolling hills are now covered in cultivated rows of small evergreen trees. In not too many years, immense forests will cover the barren hills with a healthy green cloak.

The climate is changing, too. Winter has returned. Distant mountains sport a shroud of newly fallen snow. As we cross a divide, the two-lane highway becomes a modern, multi-lane super-highway. We descend into the capital, nestled within a broad bowl of hills surrounded by snow-covered mountains.

Innumerable high-rises blanket the hills in multiple shades of color. With lush parks, broad and clean streets, huge shopping centers, a modern metro system, sleek corporate headquarters, and majestic government buildings—Ankara has all the accoutrements of a major, capital city, and yet is barely eighty-five years old. This combination creates an air of first world modernity. When Atatürk declared Ankara the new capital in 1923, it had a population of only 35,000. In four years, the population rose to 44,553 and it had boomed all the way to 286,781 by 1950. Now it is a metropolis of 4.5 million.

The beautiful symmetry of the corridor fronting the museum holding Atatürk's personal items and diplomatic gifts.

Detail of one of the military honor guards at Anıtkabir

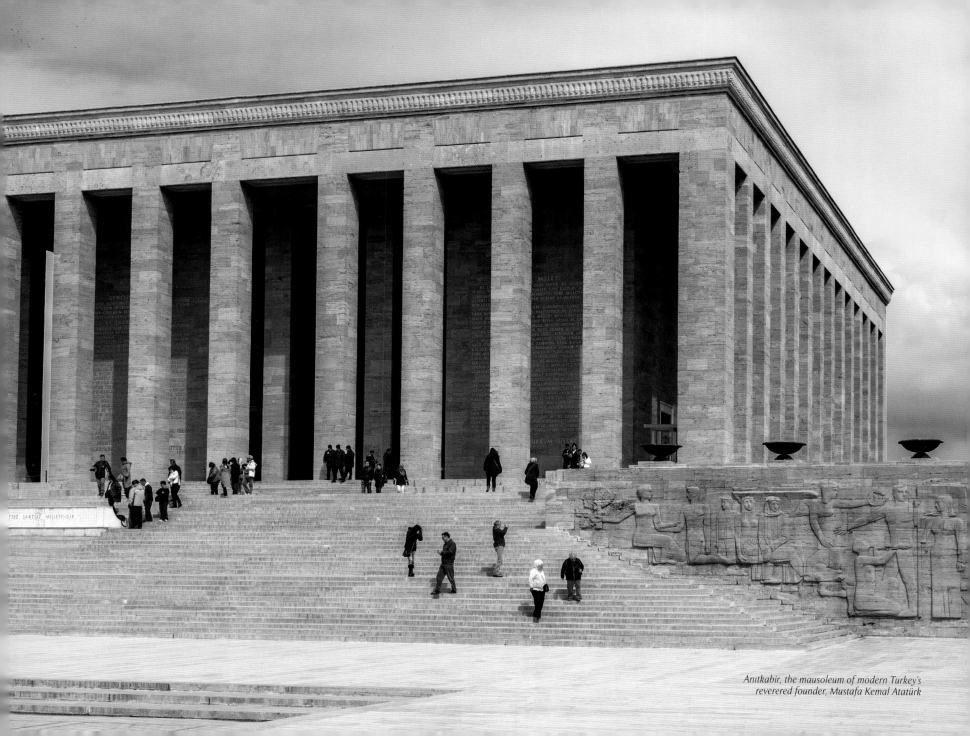

Anıtkabir, the mausoleum of modern Turkey's reverered founder, Mustafa Kemal Atatürk

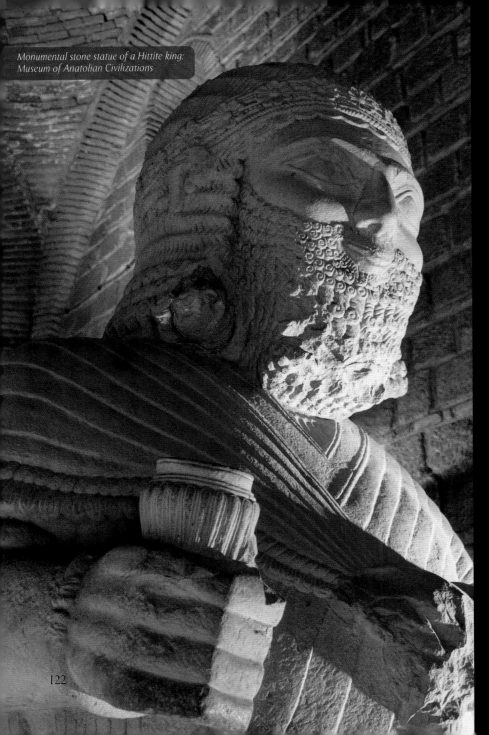

Monumental stone statue of a Hittite king: Museum of Anatolian Civilizations

An exquisite bronze head of a Roman man: Museum of Anatolian Civilizations

Anıtkabir, the formidable mausoleum and memorial to Atatürk, is sited atop a high hill in the center of the city, surrounded by an evergreen forest. After going through a security checkpoint and metal detectors, we follow Lion Road, which is flanked by twenty-four stone lions, Hittite symbols of power.

Marble is everywhere. A broad, stone staircase leads to a vast, monumental, marble-tiled plaza flanked by colonnaded buildings containing museums. One contains memorabilia from Atatürk's life: his huge, multilingual library, along with many of his possessions and honors. Another holds a collection of his cars, and even his yacht. His imposing mausoleum rises from the northeast end of the plaza. A colossal staircase leads to the grand, columned entry. The veneration held by the Turkish people for the founder of modern Turkey is palpable. This is a site of "pilgrimage" and is open to visitors every day. Military honor guards from each of the services stand guard around the mausoleum, patiently tolerating the many cameras aimed at them.

In a museum beneath the mausoleum are three extensive, multi-media dioramas depicting Atatürk's greatest victories: one of the Gallipoli battle during World War I and two famous battles against the Greeks during the War of Independence. Each diorama is connected by galleries of paintings featuring the generals and other military staff important to the war effort.

A long, marbled hallway continues beneath the mausoleum. Multiple alcoves branch off of it, each dedicated to one of the important radical

reforms made during Atatürk's presidency: latinizing the alphabet, women's rights, the Name Law, education, modernization of dress, and so on.

Next we visit the Museum of Anatolian Civilizations in the citadel above the city. Driving uphill, we pass a hillside covered with the last section of "illegal" houses in a hodgepodge of alleys and lanes. These people will soon be beneficiaries of the enlightened government program replacing slums with new, multi-level apartments elsewhere in the city. Some are even now in the process of being torn down to make room for new developments.

The collection of the museum is housed in a restored 15th century Ottoman-style covered bazaar. Unfortunately, it is undergoing remodeling and much of the extensive collection is in storage. Since Ankara is the capital, the museum directors have had the luxury of acquiring many of the finest artifacts from the extensive archeological sites around Anatolia.

Two rooms were open. The high, vaulted main room dedicated primarily to the Hittites contains massive stone statuary of kings and animals. The walls are covered with beautifully preserved stone reliefs depicting scenes of Hittite deities and royalty from the 2nd millennium BCE, along with monumental friezes from the epic of Gilgamesh on the Mesopotamian Plain. Huge amphorae, pottery vessels, exquisite figurines and goddess objects are tastefully exhibited in glass cases throughout the room.

The lower floor contains objects from later Anatolian civilizations: Greek, Roman, and Byzantine. Hundreds of Roman and Greek coins are on display, along with glass objects, gold Hellenistic diadems and innumerable figurines in pottery, bronze, stone, and clay.

That evening we eat dinner in the massive food court of the shopping center behind our hotel. All the major international brands are represented in this upscale mall. The three shopping levels are bustling with activity. Groups of teenagers are hanging out, laughing and poking fun at one another. Parents

A very small section of the beautiful Hittite bas-reliefs lining the walls of the Museum of Anatolian Civilizations

123

Istanbul's iconic Bosphorus Bridge spanning Europe and Asia

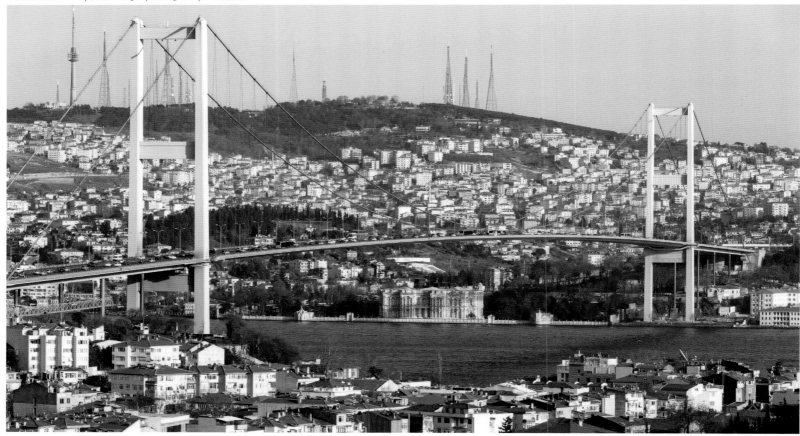

dotingly watch their children run around the playgrounds beneath the escalators. Lovers walk arm-in-arm, eyes only for each other, while packs of boys preen and flirt with groups of girls strolling by.

Another cold, early March day greets us the following morning as we drive northeast from Ankara to Istanbul. Climbing higher into a mountainous region, we find the forests blanketed with six inches of new snow. It looks so much like our familiar mountains in Colorado.

Small villages with wooden, Ottoman houses are covered with fresh snow. The minarets of mosques project prominently from the small towns and villages set amidst this mountainous, winter wonderland. Broad agricultural valleys appear, their orchards and fields shrouded with fresh snow. Distant peaks rise above the valleys, their bare snow-covered summits shining brightly in the morning sun, stark against the cloudless, blue sky.

Descending in elevation, we reach a large lake set in a basin of low mountains, its sky blue surface empty but for the reflections of clouds. Lake Sapanca is one of Istanbul's reservoirs and here we stop for lunch at a popular restaurant/tourist stop. Large lawns and pavilions are scattered along the shore. Again, we notice that the climate changes. It is a glorious, spring day.

We approach Istanbul from the south via the seaport city of İzmit, famous for its beautiful, handmade carpets and embroidery as well as historic houses from the Ottoman period. Traffic becomes more congested. The sleek, modern skyscrapers of Asian Istanbul come into view. As we approach the Bosphorus Bridge, beautiful designs filled with colorful tulips, Turkey's beloved flower, fill the steep, grass-covered hills on either side of the highway.

Once again we return to Istanbul via the most dramatic way possible—the majestic Bosphorus Bridge. The Bosphorus below sparkles in the springtime sun as the distinctive panorama of European Istanbul is spread before us. To the west lies Sultanahmet. The minarets of the Blue Mosque and the massive bulk of Aya Sophia rise behind the towers of the Topkapı Palace. The glorious Süleymaniye Mosque sits as a stately backdrop to the Galata Bridge and the Golden Horn. The modern skyscrapers of Beyoğlu and Levent rise behind the 19th century glory of the Dolmabahçe Palace. Directly below, innumerable ferries and boats scuttle about the strait, ferrying their human cargo as they move between continents.

Tonight we will say goodbye to the friends we have made on our tour and to our incomparable guide, Salih, whose erudite commentaries provided invaluable background to our experiences.

Tomorrow we fly south into the unknown, into Salih's Kurdish southeast, and into a new and deeper perspective of the complexity of Turkish culture.

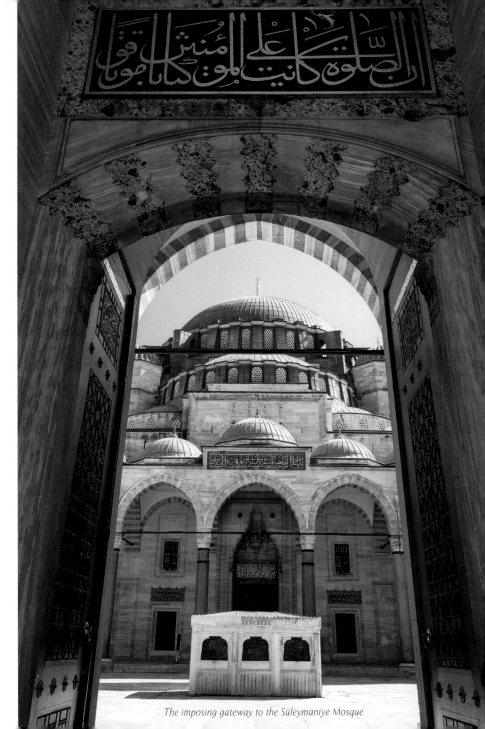

The imposing gateway to the Süleymaniye Mosque

The Rizvaniye Madrasa, Şanlıurfa

URFA — PIETY ALONG THE MESOPOTAMIAN PLAIN

It took some convincing to get Yolanda to travel to Southeastern Turkey. Kurdish terrorists have been active there in the recent past, and the towns I wanted to visit were within sight of the Syrian border—not the most stable of countries at the moment.

Syrian refugees continue to seek shelter in Turkey and there has been military activity along the border. Still, the US State Department's website has no travel warnings for Southeastern Turkey. For only $50 roundtrip, I found flights on Turkey's Pegasus Airlines to Şanlıurfa, which is simply known as Urfa. Şanlıurfa, "Glorious Urfa," is the most pious city in the region and the reputed home of Abraham, the patriarch of Judaism, Christianity, and Islam.

Arriving late at night and with the airport miles out of the city, I had arranged a shuttle with our hotel. The driver was there as we exited the airport and whisked us through the darkness into what seemed a disappointingly modern city. However, what the light of day reveals is a far different reality.

Our hotel balcony opens onto the massive ramparts of Urfa Castle. The beautiful gardens of Gölbaşı are spread between us and the ramparts. The glorious architecture of the early 13th century Halilur Rahman Mosque stands in contrast to

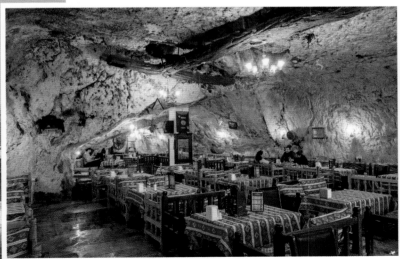

Interior of the cave restaurant overlooking Gölbaşı, Şanlıurfa

Dusk descends upon Gölbaşı and the city of Şanlıurfa

127

the high cliffs behind. This is one of the most hallowed places in Turkey.

Tradition tells that, around 1800 BCE, the Prophet Abraham was born in a cave in the cliffs below the castle. It also speaks of him opposing the tyrant King Nimrod with his monotheistic teachings. For this, he was thrown from the lofty battlements onto a blazing pyre of rose bushes, the flames of which turned to water, the ashes to carp. His life was miraculously saved. So the story goes. And thus, the thousands of rose bushes in the gardens, and the lakes of sacred carp that grow fat with the constant feeding by the tens of thousands of pilgrims.

Walking the tree-lined paths winding among the rose bushes and carp-filled lakes of the park, we are struck by the colorful dress of the women. We've seen nothing this colorful elsewhere. Many women wear identical, purple headscarves—likely a Kurdish tradition—and brilliant dresses of sequined fabrics that dazzle the eye.

A laughing group of school girls—judging from their T-shirts, they are fans of some western boy-band—stop us to practice their English. They insist on being photographed by me and to take photographs with us as well. This is one of the delights of traveling in Turkey on your own. It's not the first time groups of students practiced their English on us and wanted their pictures taken—and we know it won't be the last, either.

While exploring the bazaar that afternoon, I find the majority of the ethnic Arab and Kurdish men and women clothed much differently than elsewhere. The men wear a type of pant called a Şalvar. It is baggy well below the butt, with the crotch almost down to the knees. Many men sport black and white checkered head scarves, others red and white checked.

The women are even more colorful than those we noticed in the park. And there seems to be several different styles present, likely representing different tribes or nationalities. What I see leads me to the conclusion, confirmed later, that Şanlıurfa is a marketplace to the Middle East. The population is made up of a rich diversity of Kurdish, Turkish, and Arabic people. The Kurdish tribes have been around for two to three thousand years, long before the Turks arrived in the region. Along with the various ethnic Arab and Turkic tribes, the Kurds here are overwhelmingly of ethnic Zaza origin.

Our second morning is again spent meandering aimlessly along the tree-shaded paths and countless rose bushes of beguiling Gölbaşı. We visit the Rızvaniye Madrasa, a Quranic school, where we meet one of the teachers, Mehmet

Pilgrims feeding the sacred carp in Balıklı Göl, Şanlıurfa

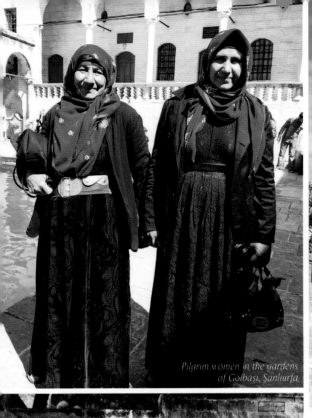

Pilgrim women in the gardens of Gölbaşı, Şanlıurfa

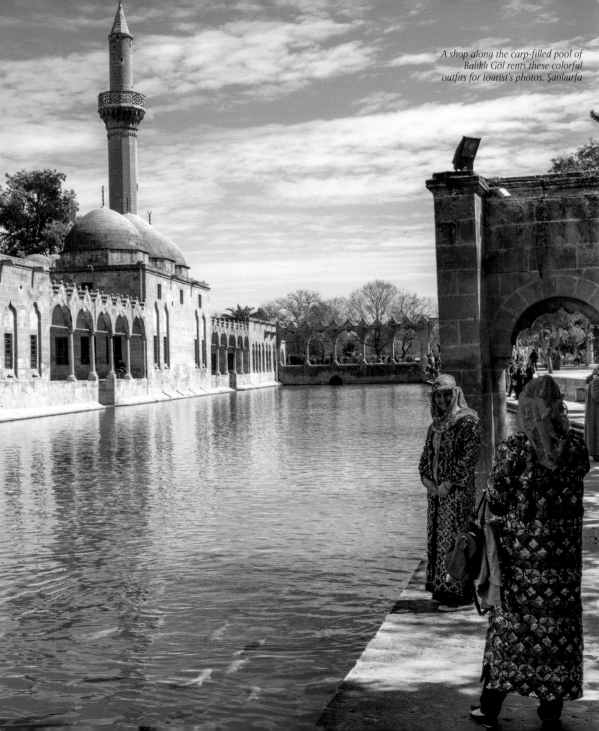

A shop along the carp-filled pool of Balıklı Göl rents these colorful outfits for tourist's photos, Şanlıurfa

Polat. In excellent English, he spends a half hour warmly sharing his world view and the story of Abraham with us. We learn as well of another of Urfa's pilgrimage sites: the cave to which long suffering Job, the Biblical Prophet, retreated during his seven years of travail, never losing his faith in the Almighty.

Continuing our wandering, we are again stopped often by families, kids, and groups of school girls, all with smiles, eager for us to take their picture and be photographed with us.

Then, once again, it happens. A kindly gentleman in a black and white checkered headscarf stops us, inquiring in excellent English where we are from. I tell him America and his response is immediate, "Oh, I love America." And so we meet İzzet Torunlar. He invites us to share tea at one of the cafes under the trees and later ends up showing us around for the next several hours.

İzzet's story is unique to us. He was born into a Kurdish bedouin family with 200 sheep, 100 goats, 60 camels and some horses. There were about 100 people in his extended family and his own family lived in an enormous, black tent along with their animals. In the summer they would move together to the cooler highlands in the northeast around Mt. Ararat, of Noah's flood fame. After six weeks, they would move southwest through Diyarbakır, Van, Bingöl, and Batman—wherever the

Carp-filled Balıklı Göl next to the Rızvaniye Madrasa, Şanlıurfa

The rose gardens of Gölbaşı along with the Ulu Mosque and King Nemrod's Kale in Şanlıurfa

Bed, Bath and Beyond in Şanlıurfa's bazaar

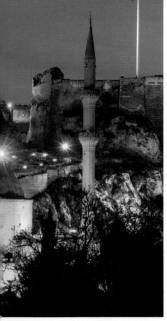

grazing was good. They sold milk, cheese and lamb to the villagers. In October, they would return to Urfa.

The story of his wedding is classic, and one I've vaguely heard before: İzzet was 17, his bride-to-be, 15. He went to her camp, "kidnapped" her on his camel, and stole her back to his tent. During the "escape," he was "pursued" by her relatives. When they got to his tent they made all kinds of angry noises, playing like they were going to beat him up and kill him. His mother interceded, giving the bride's family sweets to "placate" them. With the farce played out, they were married on his camel.

At 54, İzzet taught himself English and has graduated from selling underwear on the street to owning a B&B in town. He says his family is everywhere in the world. Two thousand people are in his *aşiret*, or tribe. They are a very old, Mesopotamian family.

While we are chatting over tea, a middle-aged woman approaches us. She is clothed in a loose fitting black robe which covers her entire body; only her mouth, nose and eyes are visible. She and her 12-year-old son had been sitting at the next table. We invite her to take a seat. She speaks only Arabic, which İzzet barely understands. He attempts to translate and

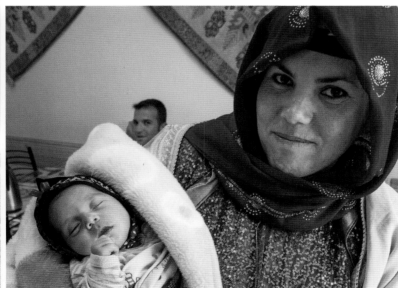

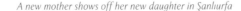
A new mother shows off her new daughter in Şanlıurfa

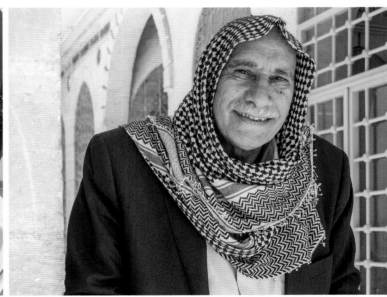
İzzet Torunlar, our bedouin friend in Şanlıurfa

we learn that she was a kindergarten teacher in Syria until she had to flee. She and her son had been in Urfa three weeks after her school was bombed, killing many of her students.

We are sad, not only because of her tragedy, but also because of the language barrier. We would have loved to learn more about her life and her view on the situation in Syria. Yolanda and I tell her we are Americans, and receive nothing but positive feelings from this Syrian refugee.

That afternoon, I find my way to the Urfa Museum. Though small, the archeological holdings are astounding. Many stone statues of animals are some of the oldest known. The oldest human statue ever found is here: a 4-foot-high carving dating back to between 8,000–9,000 BCE.

Prior to 1990, when the Atatürk Dam was being built on the Euphrates River north of Şanlıurfa, there was a scramble by archeologists from around the world to excavate and study at least a few of the numerous ancient sites that would be inundated. Several display cases in the muse-um are dedicated to individual sites and contain artifacts from their neolithic beginnings.

But there are two sites near Şanlıurfa that are truly significant to mankind's archeological and cultural record: Harran, and the astounding find of Göbeklitepe.

Harran is one of the oldest continuously habited places on the planet. The book of Genesis mentions it, and for a few years, Abraham called it home. Its adobe beehive houses are the only ones of their kind in Turkey.

Stone-age Göbeklitepe though, is older still. This religious site was built literally at the dawn of civilization, 11,600 years ago, seven millennia before the pyramids of Egypt, and six millennia before the invention of writing. Göbeklitepe contains the oldest temple complex ever found. Its carved, limestone megaliths are covered with elegant bas-reliefs of lions, wild boars, gazelles, vultures, snakes and scorpions. It has overturned long-held ideas about the earliest beginnings of human civilization.

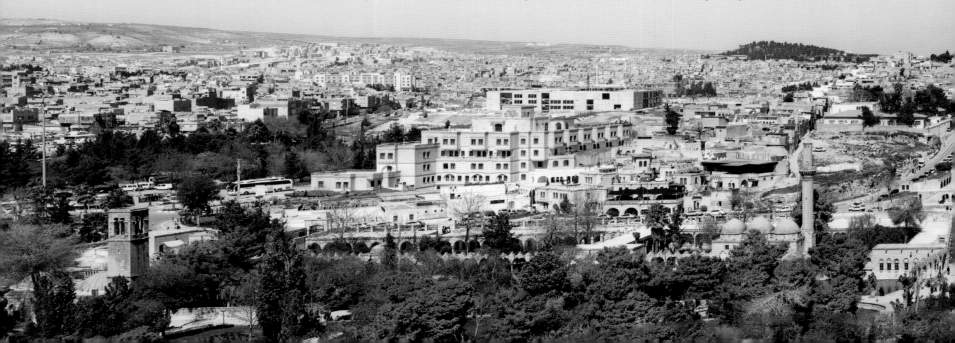

Scholars had thought that the Neolithic revolution occurred suddenly in southern Iraq and spread from there. New findings like Göbeklitepe suggest that Neolithic mankind's leap from hunting and gathering to communal agriculture was as monumental as the mastery of fire—it happened in many places over millennia.

But there are mysteries here. Why is there no evidence of habitation? Where are the tombs? Where are the hearths or evidence of cooking fires? What some archeologists are surmising is that Göbeklitepe was possibly a religious center that pre-dates the Neolithic; that the hunter-gatherers of the area worked together to create this monumental temple complex as a place to gather and worship before they mastered agriculture. Some believe that the need to provide the builders, worshippers, and priests with sufficient food caused the development of agriculture.

To bolster these ideas, evidence of the world's oldest domesticated wheat was found at a prehistoric village only twenty miles from Göbeklitepe. Carbon dating suggests agriculture was developed there 500 years after Göbeklitepe was built.

As I mentioned in this book's introduction, the Neolithic in the southwestern United States occurred nine to ten thousand years after the Neolithic in Mesopotamia. Yet there may exist a comparable parallel to the Göbeklitepe scenario at Chaco Canyon in New Mexico.

Chaco clearly was a large ceremonial center. Its construction between 900-1150 CE required cooperation by many hunter-gatherers. And yet again, there is no evidence of habitation on a scale that would conclude that it was anything other than a religious center.

Less than 1/10th of Göbeklitepe has been excavated. What will be revealed in the coming years of slow, painstaking work will likely cause theories to be further revised. What I cited above is educated speculation by archeologists and anthropologists—but speculation nonetheless. Perhaps though, the discoveries at Göbeklitepe may shed light on what happened at Chaco.

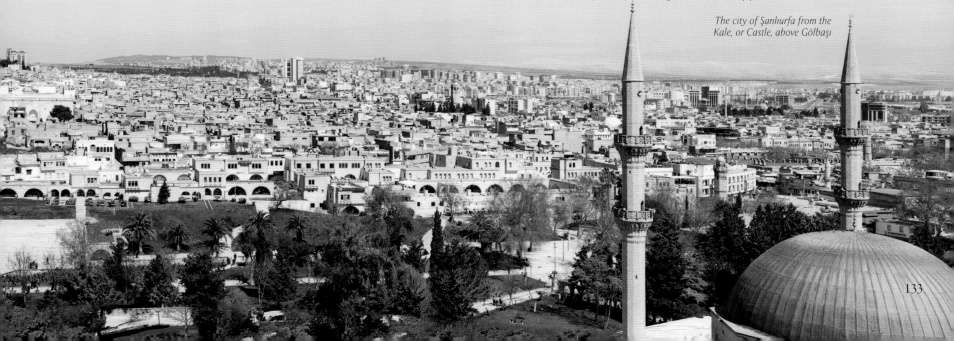

The city of Şanlıurfa from the Kale, or Castle, above Gölbaşı

133

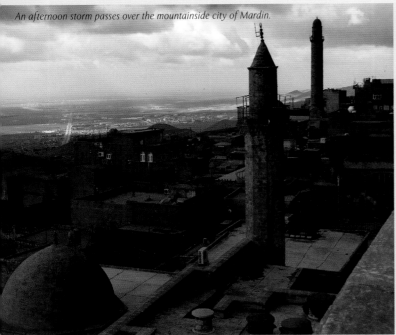
An afternoon storm passes over the mountainside city of Mardin.

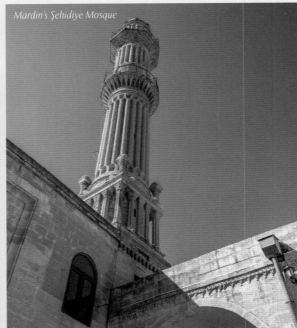
Mardin's Şehidiye Mosque

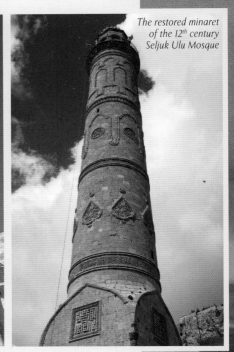
The restored minaret of the 12th century Seljuk Ulu Mosque

Mardin—View from the Mountaintop

We hadn't planned to travel farther east. Salih, our guide, insisted we spend a few days in his home town of Mardin, an ancient, buff-colored Silk Road city whose narrow, cobbled streets zig-zag up a steep mountainside. It is a lovely three hour drive on this bright spring morning. The flat, Mesopotamian plain is a vibrant green. Vast fields of grain extend in all directions. The brilliant yellow of mustard fills the uncultivated spaces through which shepherds lead their flocks.

Occasionally, a tiny village appears perched atop a hill, some higher, others lower. To my untrained eye, I suspect they are tels, ancient accumulations of ruins built up over millennia.

After passing through the 6,000 year-old city of Kızıltepe, an immense industrial facility, miles long, fronts the highway at the base of the mountains that have been moving south to greet us. Numerous grain elevators rise out of the complex and I suspect this to be the major grain depot for the region.

Turning north we begin climbing through a broad valley with enormous, limestone quarries cut into the mountains. A new, modern city surprisingly appears—not the ancient town I've seen in pictures. The bus stops and the driver motions for us to get off. We're a bit confused because there is no bus station to be seen. He motions us to cross the road, points, and says, "Taksi."

134

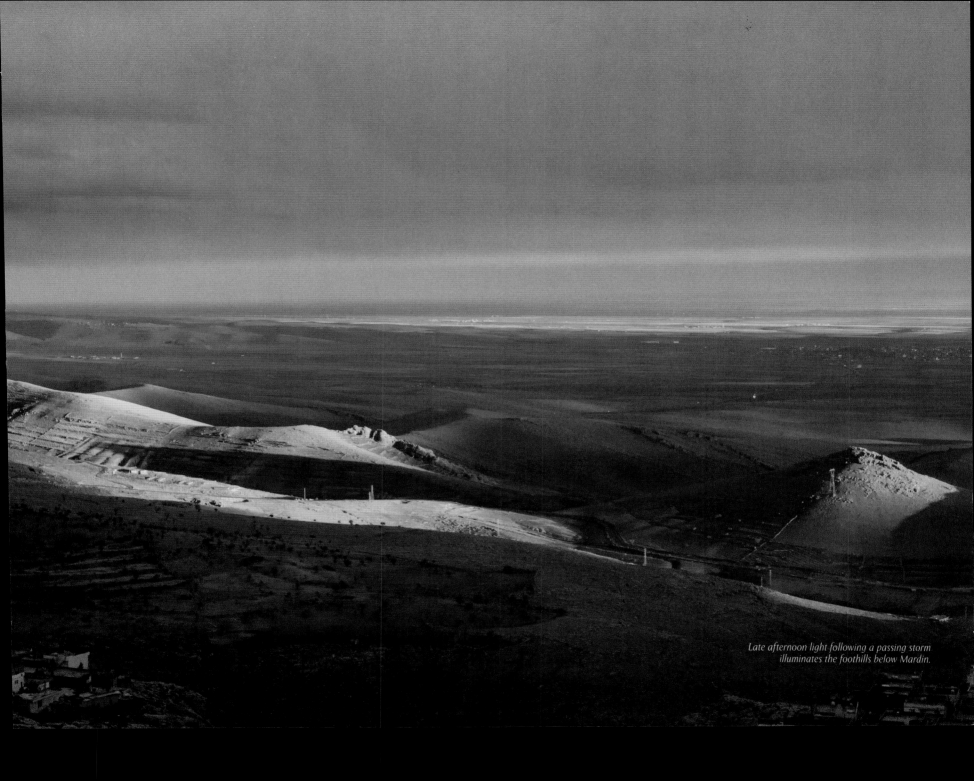

Late afternoon light following a passing storm illuminates the foothills below Mardin.

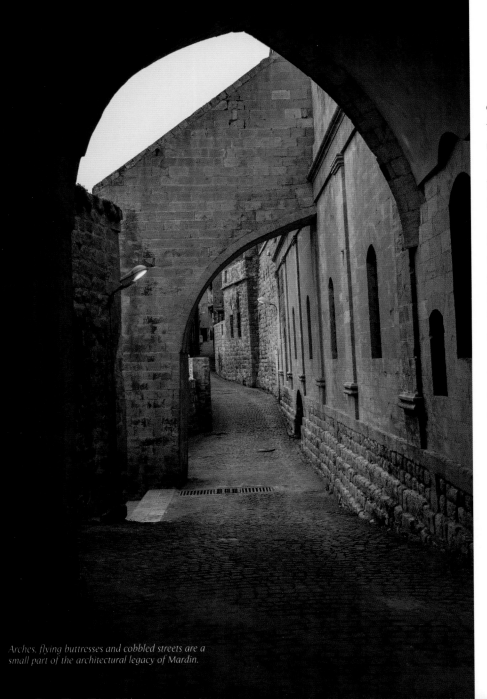

Arches, flying buttresses and cobbled streets are a small part of the architectural legacy of Mardin.

For 20 liras, the taxi driver takes us uphill, below the broad cliffs crowning the mountain and onto old Mardin's main street. We are very fortunate to have found accommodations at the Reyhani Kasrı, a first rate, modern hotel with spectacular views from its terraces. Our room looks down to the emerald green Mesopotamian plain disappearing into the vastness of Syria, whose border lies but five miles away. The tranquility of the scene belies the violent reality further south.

Yet again, we find a unique city. Most of the architecture is Seljuk, from the 12th and 13th centuries. Restoration work has brought much of the past glory back to life. Lovely mosques, old *madrasa*s, large administration buildings, and venerable *hamam*s—the iconic, communal Turkish baths—are scattered up and down the mountainside. Mardin, along with Venice and Jerusalem, are the three cities with the best preserved historical architecture in the world.

The remains of a thousand year-old fortress sit atop the cliffs high up the mountain. Ringed by a tall fence with ominous red signs, it is now a military facility. One couldn't imagine a better place from which to keep an eye on the border.

For centuries, houses were built as terraces, never less than eight feet below the uphill neighbor. Hence, there were unobstructed views to the south for everyone. Salih had mentioned that while growing up here, during the heat of the summer, families slept on the flat rooftops

A warren of stairs and alleys connect the few main streets. Everything ranges in tone from buff to gray. Our hotel is on the one commercial, single-lane street. Shops, restaurants, barbers, and cafes line both sides.

We set out to find two buildings: the post office, said to be an architectural masterpiece and the loveliest in Turkey, and a Seljuk Madrasa, the Sitti Radviyye, from the late 12th century. We are disappointed to find

*The elegant portal to one of
Mardin's old stone houses*

Elegant repetition in a stone balustrade, Şanlıurfa

*The beautifully carved door into the courtyard
of one of the restored stone houses in Şanlıurfa*

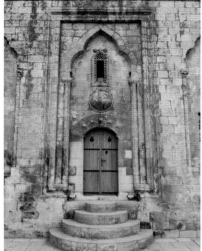
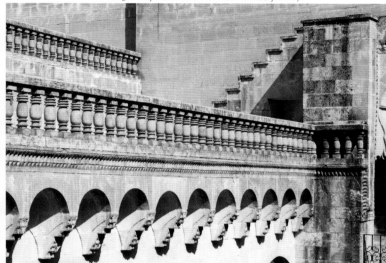

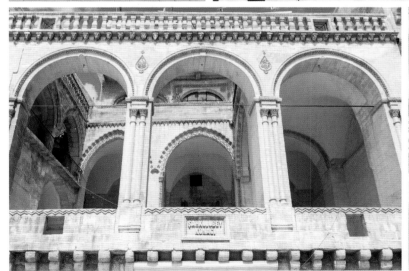
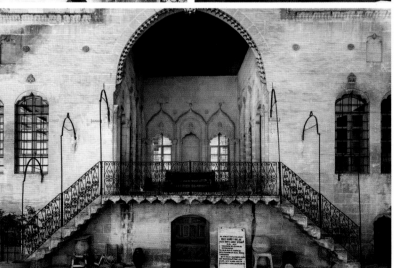

A fine example of the elegant stone architecture of Mardin

Interior courtyard of the State Fine Arts Gallery, Şanlıurfa

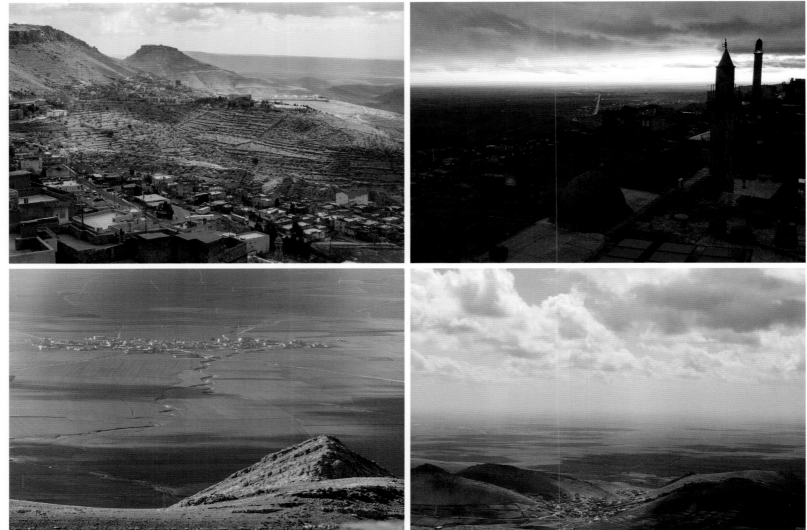

Terraced hills of the eastern suburbs of Mardin

Mardin with the ancient city of Kızıltepe and the highway west toward Sanliurfa

Looking south across the fertile Mesopotamian Plain from Mardin

Syria, only five miles away, and the vast Mesopotamian Plain stretches far beyond the horizon to the south

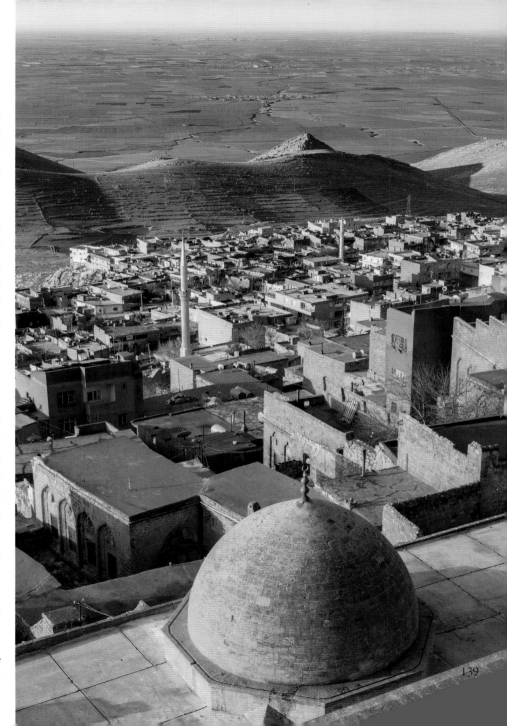

the post office under renovation and the elegant, carved decorations covered with scaffolding. A group of rambunctious boys begin dogging us and after using up their few English words, "Hello, Where are you from? What is your name?" settle upon, "money, money, money..." I'm not about to give them anything and ignore them until they finally get tired of annoying us and leave us in peace.

Finding the *madrasa*, we enter it and encounter a footprint of the Prophet Muhammad embedded in rock and mounted in a case next to the ancient *mihrab*, the prayer niche indicating the direction for the prayers. A boy directs us to smell through a small hole from which a faint fragrance of roses flows. Next to the *madrasa* is an 825 year-old *hamam*, a Turkish bath, which is still in use and that it is open only to women until after 6:00 pm, when it's the men's turn.

Wandering aimlessly along the cobbled streets and alleys eventually leads us back to the main street. We pass stores selling local soap, others with large bins and barrels of nuts, barbers, cafes, a number of architectural treasures and a strip of perhaps a dozen or more shops selling gold jewelry. Eventually, a man standing outside the archway to a courtyard restaurant stops us. He speaks excellent English and invites us inside. Entering the courtyard, I realize this to be an old Seljuk *han*, a caravansarai from the Silk Road days. We peruse the menu and meet the chef who entices us to return that evening with the promise of traditional Kurdish music and dancing. Sounds good to us.

Continuing on, broad, stone steps lead to a beautiful gateway, the symbol of Mardin. Again, restoration and scaffolding prevent entrance.

A couple of women are taking photos of each other. I offer to photograph them with their camera. It turns out they're from Urfa, both teachers—and one is an English teacher! We have a brief conversation,

Morning begins on the Mesopotamian Plain.

139

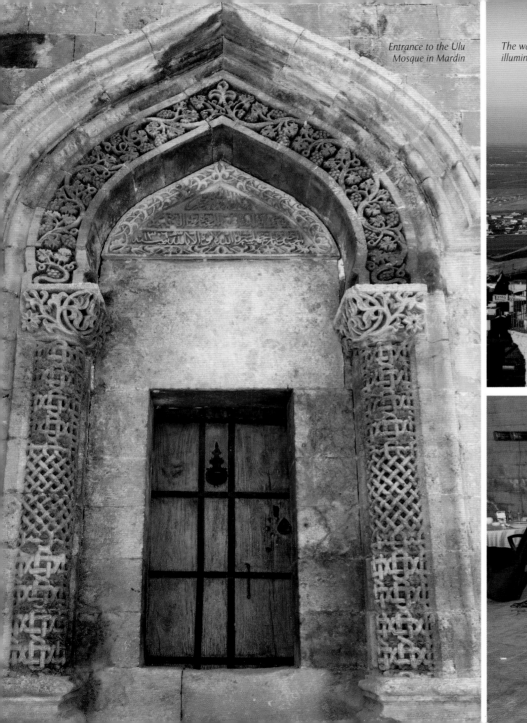

Entrance to the Ulu Mosque in Mardin

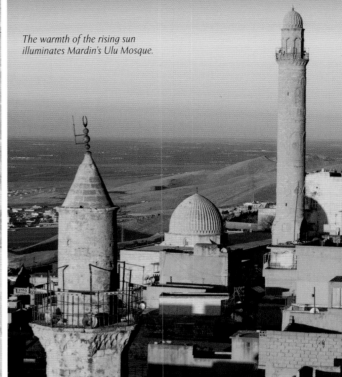

The warmth of the rising sun illuminates Mardin's Ulu Mosque.

but it's getting cold. A wind has come up, dust is blowing, and rain is beginning to fall, so we return to the warmth of the hotel.

The wind is really ripping now. We relax and turn up the heat until sometime after 7 pm, when we return to the restaurant.

Upon entering the archway, the music is already loud with the usual syncopated rhythms of eastern music. The canopy over the large courtyard is being tossed by the wind. The three, large sections rise and fall as they get tossed about. It's a bit scary.

We order a salad, lentil soup, and a somewhat sour yogurt soup along with dessert. We're surprised to see the two teachers walk in with their parents. They see us and wave enthusiastically before sitting down.

The syncopated music is lively and loud. The musicians, dressed in matching black tunics and şalvars with black, pointy-toed boots, are excellent. The three male singers, accompanied by one female, are loud and shrill. A blind midget with a powerful voice is totally consumed by the music. The drummer, using a small, bass drum about three feet across, appears to be the leader. He rests his right hand on the wooden top of the drum, striking it with a long, thin stick in syncopation as he beats the drum with a mallet in his left.

Waiters bring him paper napkins written on by the patrons. Requests? The drummer and blind singer move to a table of men, likely businessmen, where they play several songs. I see one of them slip a 50 lira bill between the cords on the side of the drum, obviously the appropriate way to tip.

People get up and begin dancing. Led by the drummer, they hold hands, moving together. The singer joins them, and then more people join in. The music changes, the line breaks into couples and individuals, and the two teachers come up to us insisting we join them. How can we refuse?

The storm outside is increasing. Yolanda is tired, so we say our goodbyes to the teachers and their parents when suddenly, the lights go out. Making our way outside, we find the entire town in total darkness. With the wind whipping along the narrow street, but thankfully without rain, we find our way back to our hotel, climb the darkened stairs, and quickly fall sleep.

At 4:15 am we are abruptly jolted out of a sound sleep by the Adhan from several neighboring mosques! Why so early? In Urfa, it sounded at 5:30! We're able to get back to sleep, but man!

Breakfast is from 7:30-10 and we awake to find the windows splattered with muddy rain. All the decks, terraces, windows and outside furniture are covered with rust-colored splats. What a mess.

It's partly cloudy. Streaks of sunlight dot the plains below. The breeze is brisk, but nothing like the night before. We head to the bazaar a block away. Steep, slippery steps lined with cheese and vegetable shops lead down into the covered gloom.

Narrow alleys twist and turn, ending in blind corners and pleasant surprises. We happen upon the Seljuk period Ulu (Grand) Mosque from 1176 CE, where Yolanda meets five, thirty-something professionals from Van. They are all Kurds: two psychologists, a violin teacher, an elementary science teacher, and Cemal, who owns a cafe but lived in Russia studying literature and philosophy. They suggest we get some coffee and talk.

The powerful voice of this diminutive blind singer
drives this group of Kurdish musicians.

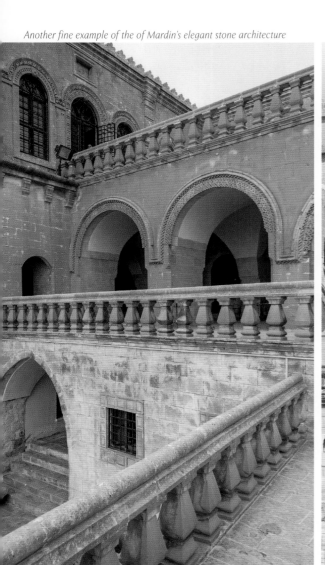

Another fine example of the of Mardin's elegant stone architecture

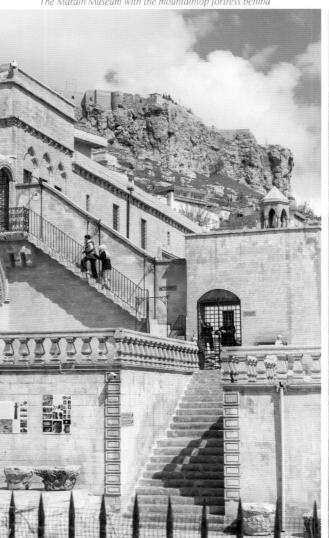

The Mardin Museum with the mountaintop fortress behind

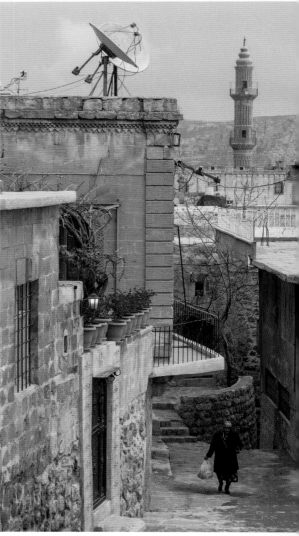

The streets of Mardin

142

While drinking sweet, almond-flavored Suryani coffee, they tell us of their homes, their lives, a bit about politics, and then read our fortunes from the coffee grounds in our cups.

They are fresh from Diyarbakir, a hundred miles north, and the enormous gathering of 1.5 million Kurds celebrating Newruz (aka Nevruz), the first day of spring and the beginning of the year in the Persian calendar. Falling on the March equinox, Newruz has been celebrated for thousands of years by various peoples of diverse ethnic communities, from the Middle East to Central Asia and Pakistan.

Situated on top of a mountain overlooking the Mesopotamian plains right next to the border with Syria, Mardin has a multiethnic and multicultural community. Along with its overwhelmingly Muslim Kurdish, Turkish, and Arab populations, it is also the historic home of Syriac Orthodox Christians, who are locally known as *Suryanis*.

Saying goodbye, we continue our wanderings through the bazaar and stumble upon just about everything one could desire. There are the ubiquitous spice shops. Inside a tiny tailor shop is a single sewing machine amid a chaos of vibrant fabrics and cuttings. Soap appears to be a primary local export and the variety is bewildering—not just the colors but the ingredients and their uses. Apricot is for moisturizing the skin, seaweed is to prevent cellulite and acne, anise combats irregular skin pigmentation, sulphur helps greasy skin etcetera...

Somehow, we once more end up on the main street and we continue our explorations, ending up in the Mardin Museum. It is an architectural delight, originally built as an Assyrian Catholic Patriarchate in 1895. Par for the course, I run into a large, boisterous school group who, to the amusement of their teacher, insist I take their photo and that I pose with them.

I see a number of Syriac Orthodox churches and monasteries scattered around the city. The Christian Suryanis have lived here for over 1600 years, originally retreating to Mardin's Tur Abidin neighborhood in order to escape Byzantine persecution. The Mor Yakup Monastery was constructed on the ruins of a Zoroastrian temple in 328 CE and another, the Deyrul Zafaran (Saffron) Monastery, was the World Syriac Orthodox Patriarchate from 1116 until 1932. The name of the monastery was derived from the warm Saffron color of its limestone.

It's our last morning and I'm up before dawn. The 4:15 am call to prayer awoke me and I'm eager to photograph the city from the rooftop terrace as the sun rises over the eastern hills. It promises to be a glorious day and I'm disappointed only that the dawn light, the sweet light in photographer parlance, doesn't last longer.

With only a week left in our journey, we make the most of our last hours in amazing Mardin before the bus whisks us back west along the Silk Road and across the flat, Mesopotamian plains, the literal Cradle of Civilization, to the Baklava Capital of the World.

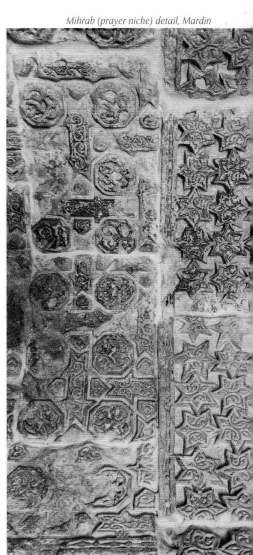

Mihrab (prayer niche) detail, Mardin

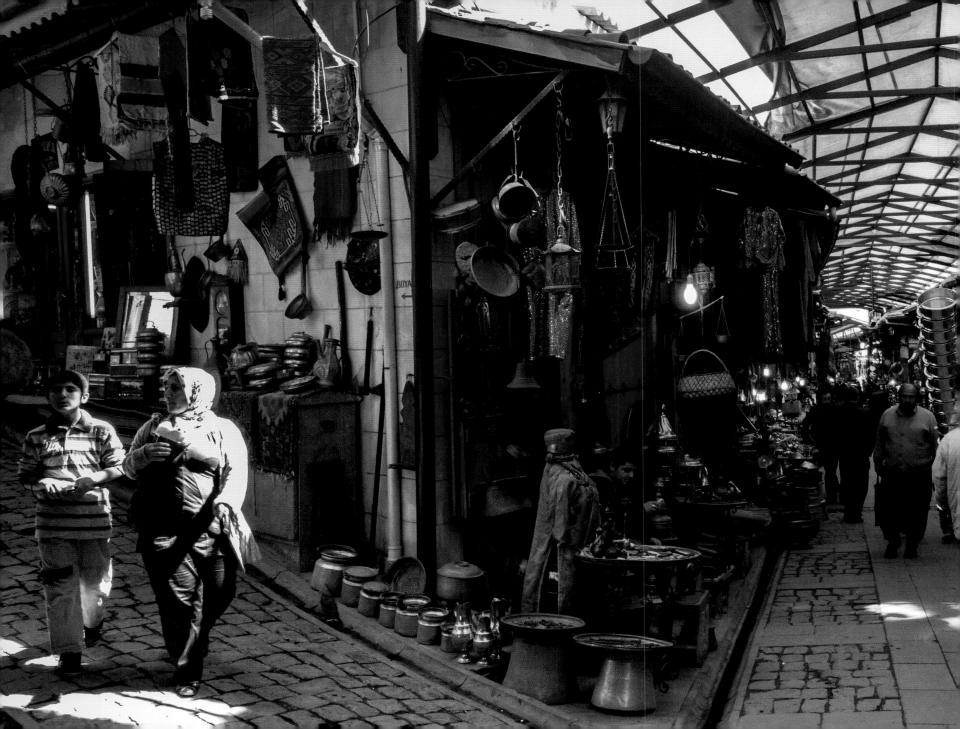

GAZIANTEP—CITY OF CULINARY DELIGHTS

Enormous hand-chased urns for sale along Gaziantep's streets

I find a different Ottoman aesthetic in the minarets and mosques of Gaziantep

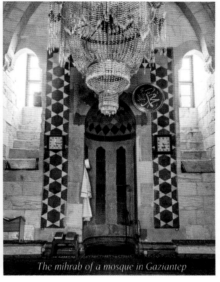

The mihrab of a mosque in Gaziantep

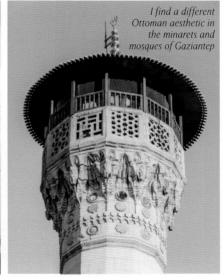

A typical scene in the Zincirli Bedestan, the Coppersmith's Market, Gaziantep

Gaziantep, Heroic Antep, our last stop in Mesopotamian Turkey, offers an architectural esthetic that is yet again different from other places we have visited. There is a distinct Ottoman feel to the narrow streets of the old center of this modern city. Yet, there is a difference I have difficulty putting my finger on. Perhaps it's the rich culinary heritage, especially the baklava.

Gaziantep is the Baklava Capital of the World. This is not to be disputed. With over 180 baklava bakeries and a tradition dating back several hundred years, competition is fierce. The industry is dominated by a few families and simply good baklava could not make it here.

It is the soil, they will tell you. It's imperative that all organic ingredients be grown in the region. The pistachios, the honey, the butter, even the wheat for the flour, must be grown in the soil of Gaziantep. Not to mention that twenty years is required to become a master baklava chef. All these

important ingredients contribute to the special qualities of the local baklava.

Gaziantep baklava is famous throughout Turkey, even the world. The delicacy is Fed-Exed overnight to connoisseurs the world over. I have to agree with the experts: you haven't had baklava until you've had it fresh in Gaziantep. It is addictive. And very fattening. What passes for baklava elsewhere pales in comparison.

The buttery richness and dry crunch you feel as you bite through the numerous layers of phyllo is unique. Not to mention the luscious taste of the pistachios. Never again the wet, syrupy sweet stuff that passes for this delicacy elsewhere.

This ethic of baklava mastery spills over into the other crafts made in town: saddles, shoes, iron tools and especially the copper work.

In the bazaar and the streets surrounding it, small shops are packed tightly together, all bustling with activity. Gaziantep is famous for copper work. Store after store displays glistening copper and brass pans, utensils, tea sets, and dinnerware. Motorbikes roar through the aisles, swerving in and out of the shoppers. The staccato of hammer on metal penetrates the alleys. Some sculptural work rises to the level of art.

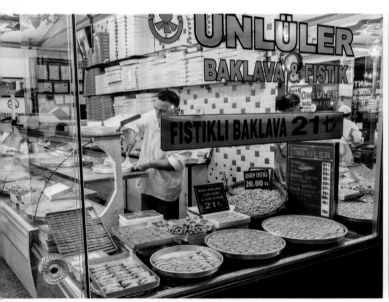

At work in Gaziantep's iconic pistachio baklava industry

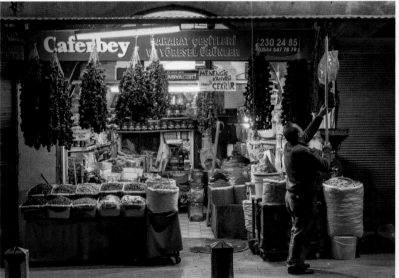

Closing time at a spice store in Gaziantep

146

Tahmis Kahvesi, perhaps the most atmospheric kahvehane, coffee house, in Gaziantep

Along a side street outside the bazaar, cobbler after cobbler sits at his bench, practically shoulder to shoulder. Taking up much of the sidewalk, they are busy working away, repairing shoes or chatting with friends and customers outside their tiny shops.

Caravansaries from the Silk Road days are abundant. Their ancient courtyards that stabled camels and horses have been renovated into chic cafes surrounded by shops selling quality products to locals and tourists alike. Some *han*s had subterranean storage cellars excavated from the native rock. One of these has been renovated into a multi-caverned restaurant tastefully decorated in the oriental style.

We are disappointed to have to conclude our visit without attaining my primary goal: the Zeugma Museum, the brand new, multi-million dollar facility built specially to house the finest collection of Greek and Roman mosaics in the world. Unfortunately, travel plans took us here on days it was closed. The Kale, the 2,000 year old fortress high on a hill and overlooking the old quarter, is closed as well, this time for renovation; so, too, is the Gaziantep Museum of Archeology.

We will have to return, not only to see the gorgeous mosaics, but to again savor the most delicious baklava in the world.

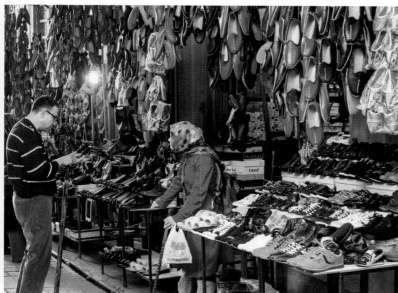

Bargaining for new shoes, Bakırcılar Çarşısı, Gaziantep's labyrinthine bazaar

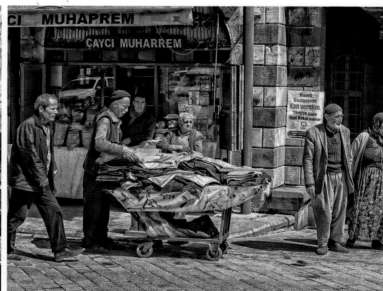

On the streets of Gaziantep

The great intersection halfway through the obligatory island tour. Phaetons constantly come and go.

A phaeton, Büyükada's horse-drawn taxi

BÜYÜKADA — THE LARGEST ISLAND OF ISTANBUL'S ADALAR DISTRICT

Friends we met in Bodrum invited us to visit them at their home on Büyükada, the largest of the nine Princes' Islands in the Sea of Marmara, just south of Istanbul. Knowing that motor vehicles were prohibited and that all transport was by horse and carriage, this was an opportunity to experience an earlier era that couldn't be passed up.

Because we only have a few days left before we return to the US, the idea of relaxing in a setting from the 1890's was very appealing after two somewhat frenetic months of travel.

Returning to Istanbul's Asian-side airport, Sabiha Gökçen, we take a bus to the ferry at Kartal, on the Sea of Marmara. Twenty minutes later, our friends meet us outside Büyükada's 19th century, white and turquoise ferry terminal.

They walk us through the tiny town center and into the queue for the carriages. Since they are among the few winter residents, most drivers know them. We climb onto the wicker seats of the festive, fringed two-horse phaeton and we're off through the deserted tree-lined streets of Victorian Era Ottoman mansions.

Bob is an American. That is, his mother is an American doctor and his father is a Turkish businessman. He grew up first in Istanbul and later in Canton, Ohio, and is a citizen of

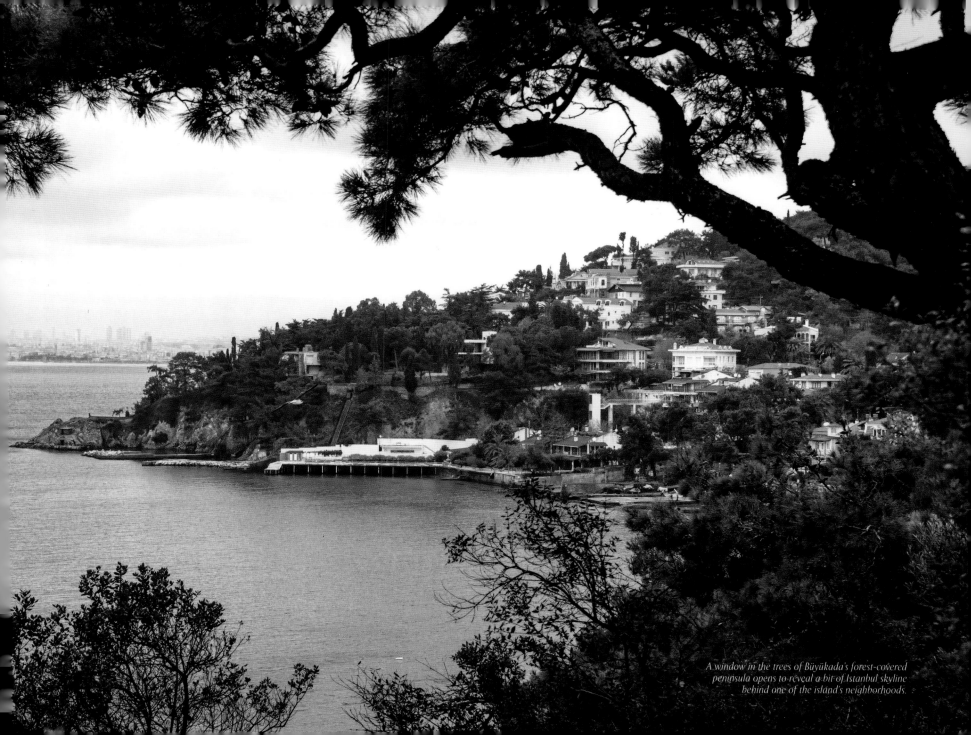

A window in the trees of Büyükada's forest-covered peninsula opens to reveal a bit of Istanbul skyline behind one of the island's neighborhoods.

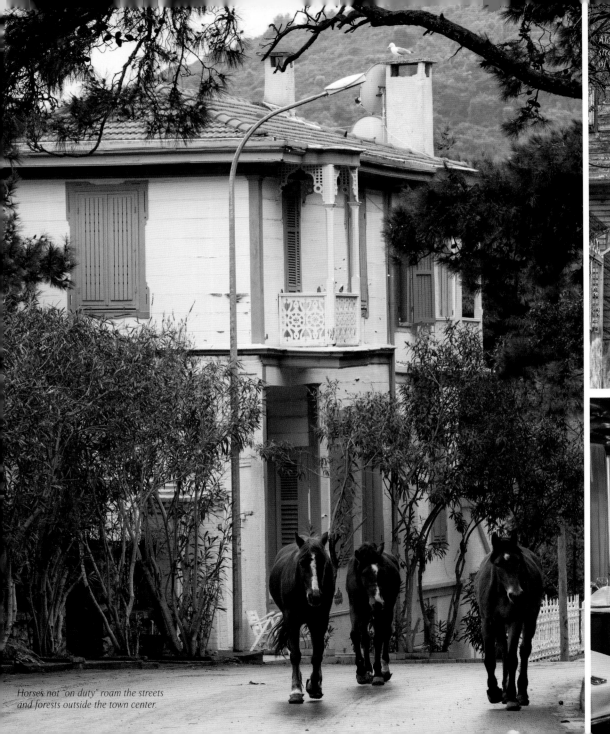

Horses not "on duty" roam the streets and forests outside the town center.

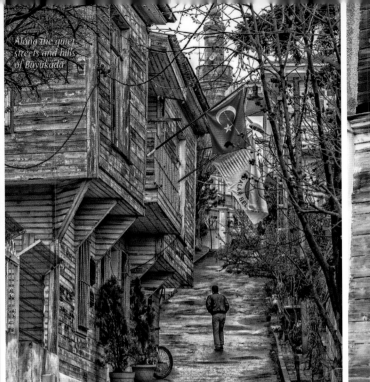

Along the quiet streets and hills of Büyükada

Maintenance of the Ottoman mansions on the island ranges between non-existant and immaculate.

both countries. He met his lovely, Turkish wife, Betiş, at college in Ohio and has returned to inherit a house on the island.

As we come to realize, we are fortunate to be here in the off-season. Ninety percent of those owning homes on the island are only here from May through September. In addition to this swelling of the population, ferry loads of day-trippers from the megalopolis across the water descend upon the islands all summer. The broad, lonely promenade that greeted us swells to a shoulder to shoulder horde. This is something I'm happy to miss. Today though, the tree-lined streets of Victorian Era Ottoman mansions are empty but for a few pedestrians and colorful phaetons.

The Princes' Islands, so named because a Byzantine prince had built a monastery here and Ottoman royalty were exiled here, became a favorite retreat for 19th century aristocracy. Gingerbread-decorated mansions were built in the ornate style of the 1880's and 90's. Pashas and princes, viziers and the wealthy, then as now, sought refuge from Istanbul's sweltering summer in the cooler, breezy climes of the islands.

Grand, wooden homes for extended families sprang up, each outdoing the other in opulence. Upkeep in this damp environment is very expensive. Though there are many, stunning mansions and villas, there are probably an equal amount bereft of paint: hulking, forlorn, gray edifices decaying from neglect.

During the evening, we all walk the steep path through our friends' small development down to the street. Spring is all around us. Roses bloom in plots along the path. A type of Palo Verde is thick with yellow blossoms. As we descend, clouds of fragrance part with our passing.

Awaiting us at the gate is a phaeton, multi-colored and fringed, the horses sporting yellow, green and red tassels like Christmas ornaments dangling from their harness. The driver, knowing it was Bob's birthday, anticipated he would need a ride to a restaurant. As dusk descends, we ride along the quiet streets, up and down gentle hills, passing the occasional phaeton and a myriad of architectural styles.

The restaurant is one among a long line of seafood restaurants on the water. The lights of Asia sparkle across the narrow strait. Bob, his Turkish flawless, asks about the fish of the day, caught just off the island, and we let him do the ordering.

We are the only ones in the restaurant. A few families sparsely occupy the remaining restaurants. In a couple of months though...

After a memorable meal and conversation, we catch a phaeton home. The streets are deserted. It is a wonderful feeling of tranquility and nostalgia to ride in a horse-drawn carriage through the dark streets of a town without motorized vehicles.

The following morning, our friends return to Bodrum, where they're furnishing a vacation condo

One of the several dining rooms at Beyti's, Istanbul's finest restaurant, each room has its own distinctive decor.

they've bought. We move into a venerable hotel in the center of the village and spend the next few days luxuriating in long walks along the shady streets and out into the forested country-side of the island. Pools of rainwater from last nights' rain reflect a leaden sky. It is cold and dreary. But the sheer pleasure of wandering streets without cars and noise in such a lovely setting outweighs the overcast.

Large gardens abound within the realms of the filigreed mansions. Flowers proliferate. Carriages of tourists taking a tour of the island pass us, galloping up the long hills, the subdued clop-pity-clop of their rubber-shod hooves resounding off the asphalt.

Beneath the high boughs of the pine forest, tiny yellow and white flowers punctuate the lawns of early spring grass. It is intensely green. Horses graze freely among trees with the sea in the distance.

A small peninsula juts from the middle of the island. Its narrow, rocky beaches and pine-covered park provide a tranquil view of Heybeliada, a smaller island perhaps a mile across the water to the northwest.

Walking a few hundred yards beyond finds us in Birlik Meydanı, or Union Square, a large, crossroads plaza in the dead center of the island, filled with touring Phaetons. One of the restaurants offers a quiet perch from which to watch the international circus and sip tea.

A steep road uphill from Birlik Meydanı leads through the forest to Yücetepe, Exalted Hill, and the church of Aya Yorgi, which has breathtaking views of the other islands and the Sea of Marmara. Besides the views, the courtyard restaurant offers sizzling kebaps, grilled eggplant, salads and abundant Turkish—*mezes*—appetizers, of all kinds. Perfect for a mid-hike meal.

Another, less steep road at the crossroads takes us up the island's second highest peak, İsa Tepesi, Jesus Hill, and to the hulking dilapidation of the world's largest wooden building. Longer than a football field and a hundred feet tall, it was originally built as a hotel at the height of the belle époque by an international hotel and travel logistics company. The Sultan, however, didn't issue a permit for the operation of the building for gambling and entertainment, so the building was bought by a philanthropist and donated to the Orthodox Patriarchate to be used as an orphanage in 1902. It was abandoned in the 1970's and as I understand, the Patriarchate now wants to convert it into an interfaith center. The amount of work involved in bringing this enormous hulk of decaying wood back to something serviceable would be daunting.

On the fourth day, we have reservations at a hotel near Atatürk International Airport before our 7:00 am flight back to Denver. We don't have to catch the ferry until early afternoon and today being the first sunny day we've seen on Büyükada, we make the most of it.

Taking full advantage of the early spring weather, we wander the quiet streets once more and then walk along the waterfront. The hills and suburbs of Asian Istanbul stand out clearly across the two and a half mile strait. We end our sojourn by enjoying another lunch of fresh-caught fish before reluctantly boarding the ferry to Kabataş, on the European shore of the Bosphorus. After these four amazing days living in a bygone era, we are not anxious to have our tranquility spoiled by the teeming chaos and noise of a megalopolis.

The ferry stops at several of the other smaller islands and we get a taste of their character before heading off across the Sea of Marmara to our destination. It is a glorious day. Istanbul is at its finest on this bright, spring afternoon. The magnificent skyline of this venerable city provides a dramatic backdrop to the ceaseless bustle of ferries and boats on the Bosphorus.

This has been the perfect end to an amazing journey. We leave Turkey with a greater fondness and respect for the Turkish people than before. The wonders of this ancient land have been enhanced by the unfailingly gracious hospitality of the Turkish people. We cannot wait to return.

A ferry from Istanbul approaches Büyükada's iconic Ottoman ferry terminal.

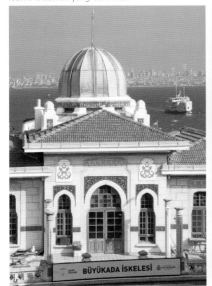

Door detail, Büyükada

Phaeton driver with his beloved horse

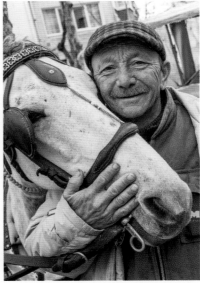

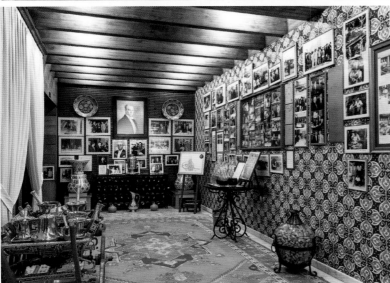

Photos of international celebrities line the walls of the upstairs foyer at Beyti Restaurant.

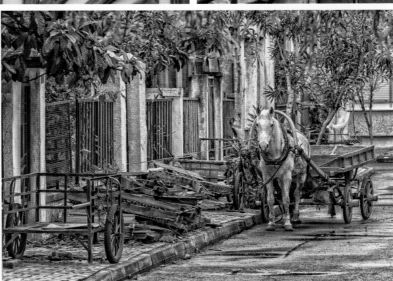

Hauling construction debris on Büyükada.

WORK

As in every part of the world, in Turkey, work assumes a myriad of forms unique to its region. In spite of the aura of modernism in the cities, many vocations still cling to traditional methods. As you move into the villages and countryside, labor holds to even more conservative values. Traditions handed down through generations are still manifest in today's Turkey, even though automation and modern machinery have made deep inroads into the workplace.

In the U.S. and most European countries, many of the traditional trades and crafts have been eliminated or become anachronistic and practiced only by a few dedicated craftsmen and artists. Think blacksmithing, tack-making, coopersmithing and coppersmithing, calligraphy, much woodworking and the hand-making of shoes, soaps, carpets, and eating utensils.

Along with these and other forms of employment lost to mass production are those lost to overseas manufacturing. Who but a dedicated craftsman would ever consider hand carving a wooden spoon, making a barrel, or hand-embossing a copper bowl?

In rural areas of Turkey, many of these handcrafts are still practiced by craftsmen and not yet replaced by mechanization. They are the basis for much of Turkish art, an art where practicality is a dominant quality and where skill and mastery play a central role.

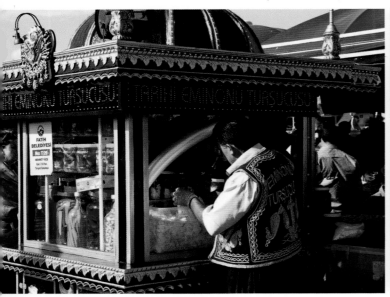

Snack vendor in Eminönü

Hand-made shoes on display outside a cobbler's shop, Gaziantep

Katharine Branning writes in her insightful book, **Yes, I Would Love Another Cup of Tea**, ..."the artist wishes to create a useful object of beauty, using the utmost level of skill with a desire to execute an object that will reflect his love of God and his family and that will be of service to his fellow man." She continues, "Turkish artisans know that the excellence of art lies in the fusion of use and beauty....being skillful is praise to God."

There is an implied emphasis on the words usefulness, service and practicality of a craft. These values are what I sensed during my travels. Turks take pride in their traditional crafts as a part of everyday life that other cultures are losing through their drive toward modernization.

There is something of cultural importance inherent in small-scale production that serves people on a personal level. The demise of artisans who provide their communities' daily implements is an earlier manifestation of the same values that are causing the disintegration of the culture of mom and pop businesses in America. The dead and dying Main Streets of small towns in America are littered with their boarded-up skeletons. These once thriving commercial districts, bastions of community vitality in their heyday, have been driven out by big-box retailers down the road. This is what I fear for Turkey and her people.

An antique shop in İzmir

Soap in a bewildering variety appears to be a speciality product of Mardin.

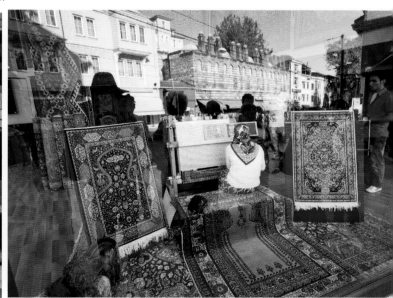

Window of a carpet store where an artist weaves a Turkish carpet.

Old wooden work implements, Sultan Han, Aksaray

Old wooden work implements, Sultan Han, Aksaray

*Framed hand-painted calligraphy in
the Sultanahmet Mosque, Istanbul*

*Carved wood Ottoman door,
Urfa museum, Şanlıurfa*

Detail of a hand-carved Minbar (pulpit) of the Ulu Mosque, Mardin

Ornamental detail on the exterior of an Istanbul Mosque

Whether current values can be sustained in the face of a youthful population influenced by the onslaught of western culture is yet to be seen.

The streets of the traditional quarters of Turkish cities still brim with craftsmen and street vendors turning out products and doing jobs that are extinct in most westernized countries. Walk though the bazaars of any of the cities of Anatolia and you will see work, performed primarily by men, that in the west is done almost exclusively in factories and on assembly lines.

The old bazaar of Gaziantep provides perfect examples. Shop after shop is filled to overflowing with copper, brass and tin products. Copper sauté' pans, elegant tea sets, beautifully hand-chased bowls, goblets, chafing dishes, coffee pots, sugars and creamers are produced by hand, either directly in the shop or in a workroom close by.

In a different section of the bazaar, blacksmiths, working at their forges in the gloom of smoke-darkened workshops, produce the business-end of shovels, hoes, rakes, cleavers, and pickaxes. Farther down the covered alley, a man turns wooden handles for these same farm implements on a lathe. Outside a busy crowded workroom, a tack-maker displays saddle bags made from old carpets along with harnesses, bridles, feed bags and saddles. In a neater, brightly-lit store, artisans are putting the finishing touches on a very large and shiny copper kebap stand for a sidewalk restaurant. A huge crate awaits its shipment to a customer.

Wandering farther along the narrow alleys I find a display of hand-made wooden utensils: spoons, lemon squeezers, mortar and pestles, bowls, cutting boards, rolling pins, and even backscratchers. On tables outside several shops down a different aisle, women peruse a huge assortment of hand-crafted, leather shoes in all colors of the rainbow. Peering inside the workrooms, I see cobblers busily creating the product.

This is what I mean when I say that American and European craftsmen are next to extinct. Other than in a few historical settings like Williamsburg, Virginia, where the old trades are practiced to impart a sense of the past, you will never see these types of craftsmen. It is not a part of everyday life, nor are these trades a sensible economic option for any but the most dedicated, highly talented, and specialized entrepreneurs.

Again, in Gaziantep, I believe baklava provides the perfect metaphor for the qualities and pride of craftsmanship I am thinking about. Here, a lifetime can be devoted to baklava, to becoming a master baklava maker—where quality, tradition and pride of product becomes life's goal. It takes twenty years to become a master baklava maker. Where does a boy begin? At what point in the process? I would expect he starts by cleaning up the flour-saturated kitchen, because a lot of flour is thrown around while creating the multitude of paper-thin layers of phylo. I've seen video of seemingly fog-filled kitchens as the masters practice their magic. And how many years would an apprentice spend cleaning up before he climbs to the next rung on the ladder—whatever repetitive drudgery that might be?

Whether it is this ethic spilling over into the other trades in Gaziantep or a general Turkish attitude I cannot say. Nowhere though is this pride of craftsmanship seen throughout Anatolia more so than in the women who weave Turkey's most iconic export, Turkish carpets. This entire industry is unique unto itself. Every step along the path to a fine hand-made carpet is dependent upon specialized skilled labor.

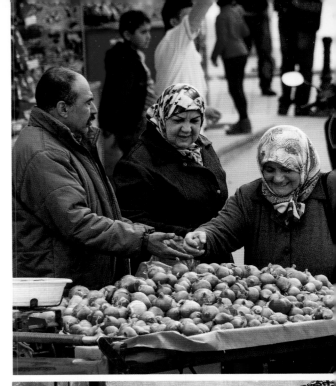

Shopping for potatoes in Gaziantep

Though parts of the steps may now be to some extent mechanized, each is still performed primarily by hand: the raising and shearing of sheep, carding the wool, dyeing the wool with hand-harvested minerals, herbs, and vegetables, spinning the yarn, making the looms, knotting the rugs, and finally selling the finished product. With silk rugs, add to this process the unraveling of threads from the silkworm cocoons. There seems to be no substitute for a young woman's nimble fingers when it comes to this all-important operation.

Each step along the path requires human hands. Each rug's design is an expression of one women's creative vision.

All across Turkey, I sense a pride in craftsmanship, whether the product be a shovel, tea set, bridle, soap, basket, copper pot, tin plate or hand-tailored piece of clothing. With the elimination of so many vocations through industrialization, we in the west have lost a valuable resource and a wellspring of employment.

Although mechanization provides cheaper goods and frees many people—not all—to pursue their interests and develop their talents, there is something lost when mass production predominates. Clearly, many job opportunities are lost. Entrepreneurial options are limited for those without high levels of education, whose skills lay in their hands or whose values lean toward a slower-paced, more personal world.

Much work focuses less on skill than entrepreneurship. The modern world offers only niche opportunities in which to provide a service. There are the multitude of vegetable and fruit vendors, the shoe-shine men, the notion peddlers, the fish mongers and the fishermen themselves. But even more unique is the man I found near the Galata Bridge in Istanbul with his tiny, mobile photocopy and laminating service and the man in Mardin with his highly-decorated, mobile knife sharpening and notions business.

These are just two of a myriad ways of earning a living in the modern world that have emerged through people's enterprising spirit. But a picture is worth a thousand words, so they say. The photos included here are a paean to the innumerable forms of labor I encountered during my travels and to the persistence and dedication of the craftsmen, laborers and entrepreneurs who make them their life's work.

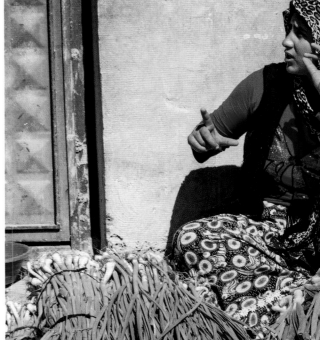

Selling vegetables on the sidewalks of Gaziantep

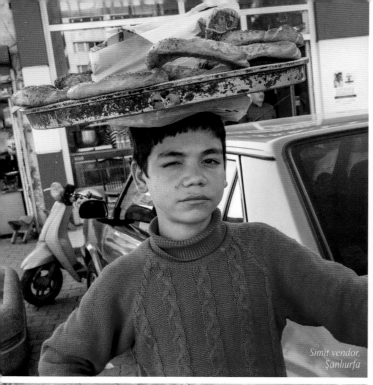

Simit vendor, Şanlıurfa

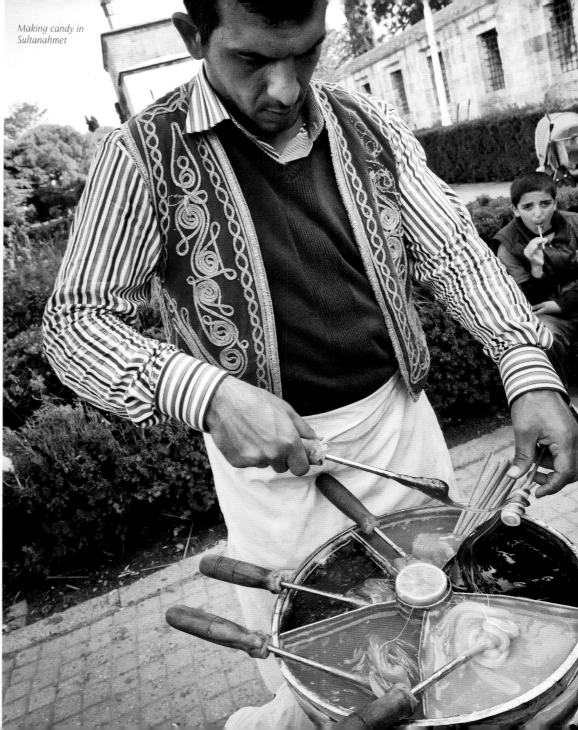

Making candy in Sultanahmet

AFTERWORD

Scene outside an antique store in the Grand Bazaar

I will return to Turkey. Though I have traveled extensively throughout Anatolia, there is much more to see, much history and culture to experience.

I would love to spend more time in the Kurdish southeast. Serkan, our friend and guide from the first tour, has family in Diyarbakır he suggests we visit. Now that the Kurds are feeling less discrimination and more freedom to celebrate their unique ethnicity and language, wouldn't it be wonderful to experience Nevruz, their celebration of the first day of spring, and photograph them at night jumping bonfires as is their tradition?

And what about that city with the most intriguing name of Batman? Wouldn't you just love to visit a city with a name like Batman? I have no idea what's there other than history, but with a name like that, how could it be anything but interesting?

The young professionals Yolanda and I met in the historic city of Mardin would graciously welcome us into their lakeside city of Van, sharing their friends, families and the beauty of the surrounding mountains. Between the two cities, extending all

the way to the Iranian border, is another of Turkey's mountainous regions: a vast landscape of alpine peaks, hidden valleys and lush plateaus that must offer gorgeous vistas and few tourists

To the north and east of Lake Van, tucked along the border with Iran, is Noah's Mt. Ararat, Turkey's highest peak. Rising some 12,000 feet in only a few miles, the volcanic peak must tower over the neighboring landscape as it reaches its full 16,854 feet of elevation. It would be wonderful to see the lovely verdant valleys in which İzzet, our bedouin friend from Şanlıurfa, spent his youthful spring days herding goats and sheep at the foot of the mountain.

Farther north is Kars, a very traditional city and protagonist of Orhan Pamuk's novel, *Snow*. For millennia, this region along the Armenian border was the stepping stone to Anatolia. Caravans passed back and forth between the Orient and the Mediterranean, as did the earliest Turkic nomads who later established the great Seljuk and Ottoman empires that evolved into today's modern republic.

Northeast of Kars is another moun-

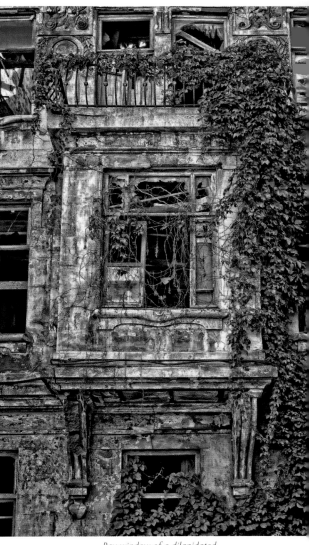

*A window in one of the dilapidated
houses around Sultanahmet*

A soap store in Mardin

*Bay window of a dilapidated
Ottoman mansion in Beyoğlu*

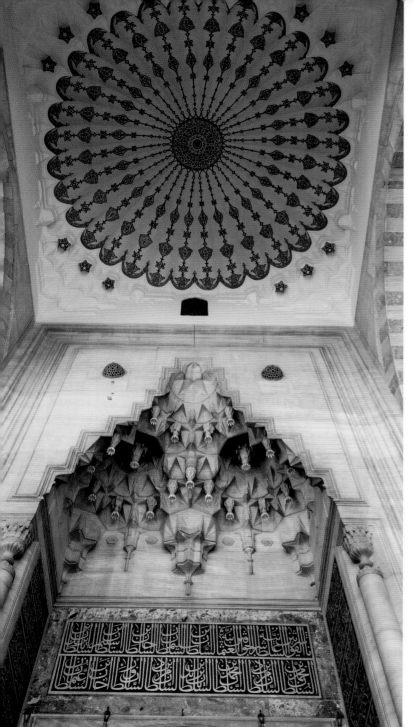

tain range, the Kaçkar Mountains, where we spent time exploring the Eden-like valleys and mountain peaks around Barhal on our first trip. What intrigues me most is the Black Sea coast on the northern side of the highest peaks I saw. I have yet to see the Black Sea. Driving along the coast between here and the Bosphorus tantalizes my imagination with visions of a sweeping coastline falling into a storied sea, as do photos of the splendid architecture of the Trabzon monastery etched as it is into its mountainside perch.

To the extreme west, in European Turkey, almost to the Bulgarian border and along the tracks of the legendary Orient Express, lies the former Ottoman capital of Edirne. For one hundred years prior to the conquering of Constantinople by Sultan Mehmet II in 1453, Edirne was the capital from which the Ottoman sultans launched campaigns into Europe and Asia. Here are some of the most elegant examples of early Ottoman architecture, designed by one of Islam's greatest architects, Mimar Sinan.

Then there is the entire western coast of the Anatolian Peninsula, a lush Aegean region of bays, islands, rocky peninsulas, and warm turquoise water extending south to the Bodrum Peninsula. I would more than willingly return to our room in Bodrum at the Manastır Hotel overlooking the lovely bay, its crusader-built castle and the Greek islands to the west.

From here we would hop on a sailing excursion that would take us to the calm, uninhabited crystal-clear bays and beaches along Turkey's southwest Aegean coast, a paradise for barefoot sailors where snorkeling reveals the submerged detritus of the ancient world.

A return to the Mediterranean resort city of Antalya would be the next stop, with excursions into the Taurus Mountains to its west, the finest preserved Roman theater in the world to its north, and the warm water beaches to its east. Continuing east, I would explore the coastal mountains around Alanya and Gazipaşa, before walking in the footsteps of the Apostle Paul in his birthplace of Tarsus.

Along the eastern-most Mediterranean coast is a sliver of Turkey extending south into Syria. Here, among the ghosts of the past, I would swim in the Asi (or Orontes)

River in Antakya, near ancient Antioch, where Cleopatra, Queen of Egypt and by far the richest person of her day, made her way-beyond-over-the-top royal procession to capture the doomed heart of Rome's most powerful general, Antony.

Northward again and back to Gaziantep, not just to savor the finest baklava in the world but to photograph and write about the entire process and culture surrounding this delicacy. And having done that, I could finally gaze upon the gorgeous Roman mosaics of Zeugma—missed on our first trip—along with the archeological treasures of the Gaziantep Museum and the Kale, both under renovation at the time.

Ultimately, I would return to Şanlıurfa. This time, knowing how close I am to the earliest glimmers of civilization, I would rent a car and vow to make a pilgrimage to stone-age Göbeklitepe to see for myself the oldest religious structures known to man. I would go to Harran, the small town with the unique beehive houses and the place where the Prophet Abraham, father of the monotheistic religions of Judaism, Christianity, and Islam, made his covenant with God and ceased human sacrifice. This time, I would also visit the well where Biblical Job is said to have spent his years of trial, as well as his tomb, one of several claimed in the Muslim world.

But above all, I would make certain that this time the roses in the beautiful gardens and around the sacred ponds and Mosques of Gölbaşı would be in full bloom. Yolanda and I would wander the winding paths swathed in clouds of fragrance, taking time to smell at least a few of the tens, if not hundreds, of thousands of blossoms. We would again climb the steps at dusk to the cave restaurant beneath King Nimrod's fortress. Sitting on plump colorful cushions at a low table outside the cave overlooking Urfa and the beautiful rose-filled park, we would drink in the peace and tranquility of the evening as we partake of Turkey's ruby-red tea in its iconic tulip glasses. Once again, and hopefully not for the last time, we would be startled, and then enchanted, as the evening turns magical when the musical phrases of the loveliest Adhan in all of Turkey pours forth from the Mevlid-i Halil Mosque below, calling the faithful to prayer; "*Allahu Akbar, Allahu Akbar* – God is Great, God is Great."

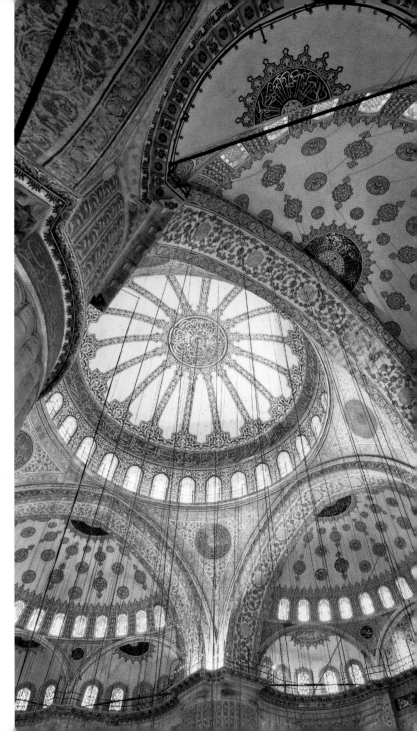

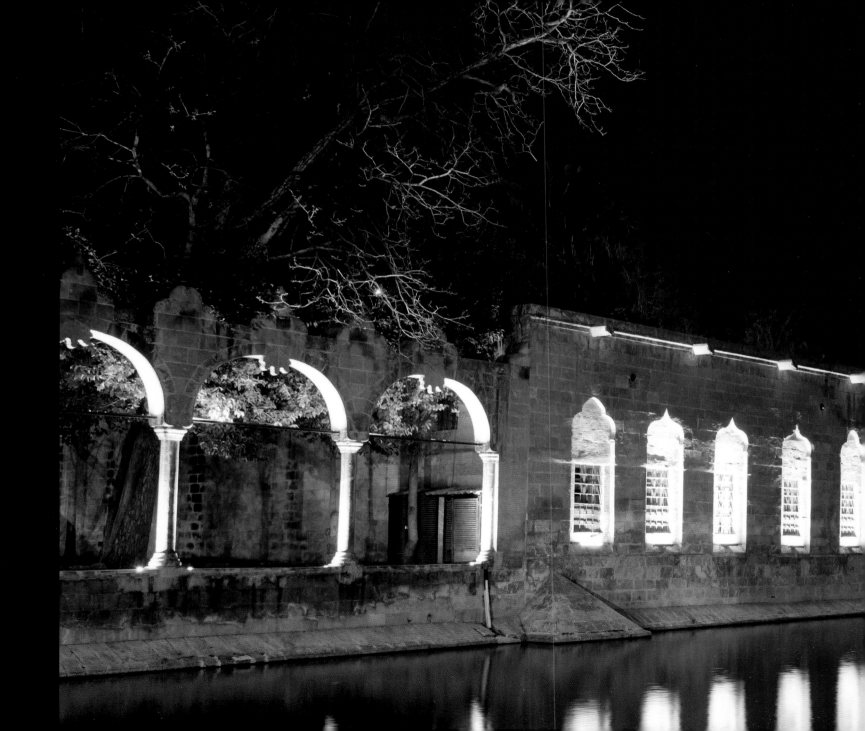

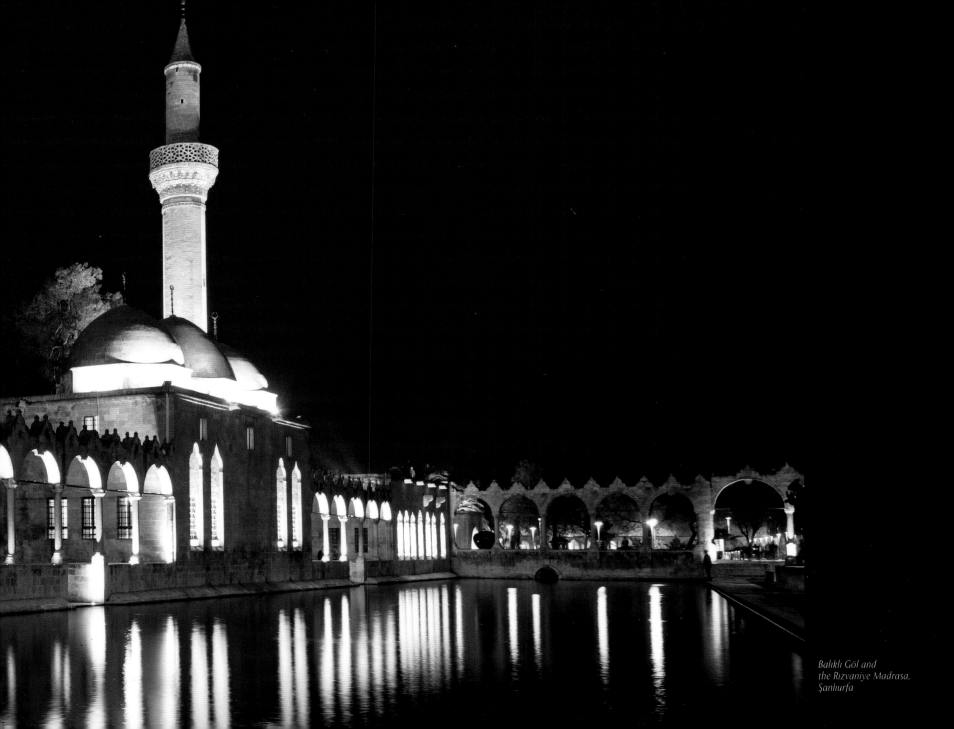

*Balıklı Göl and
the Rızvaniye Madrasa,
Şanlıurfa*

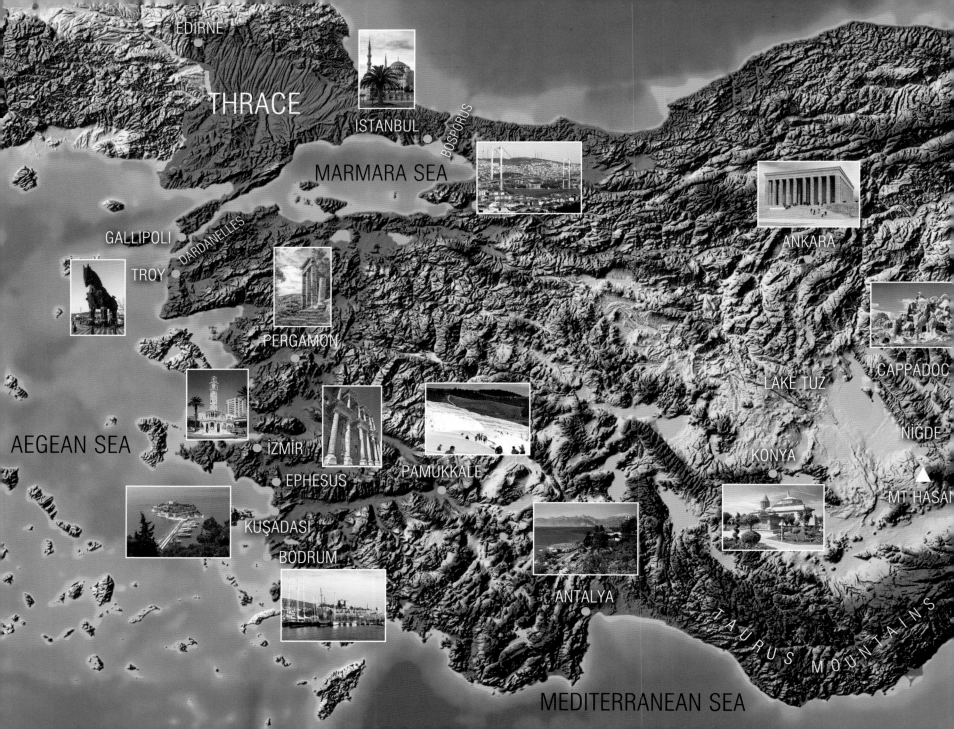

EDIRNE

THRACE

İSTANBUL

BOSPORUS

MARMARA SEA

ANKARA

GALLIPOLI

DARDANELLES

TROY

PERGAMON

CAPPADOC

LAKE TUZ

NİĞDE

İZMİR

KONYA

EPHESUS

PAMUKKALE

MT HASAN

AEGEAN SEA

KUŞADASI

BODRUM

ANTALYA

TAURUS MOUNTAINS

MEDITERRANEAN SEA

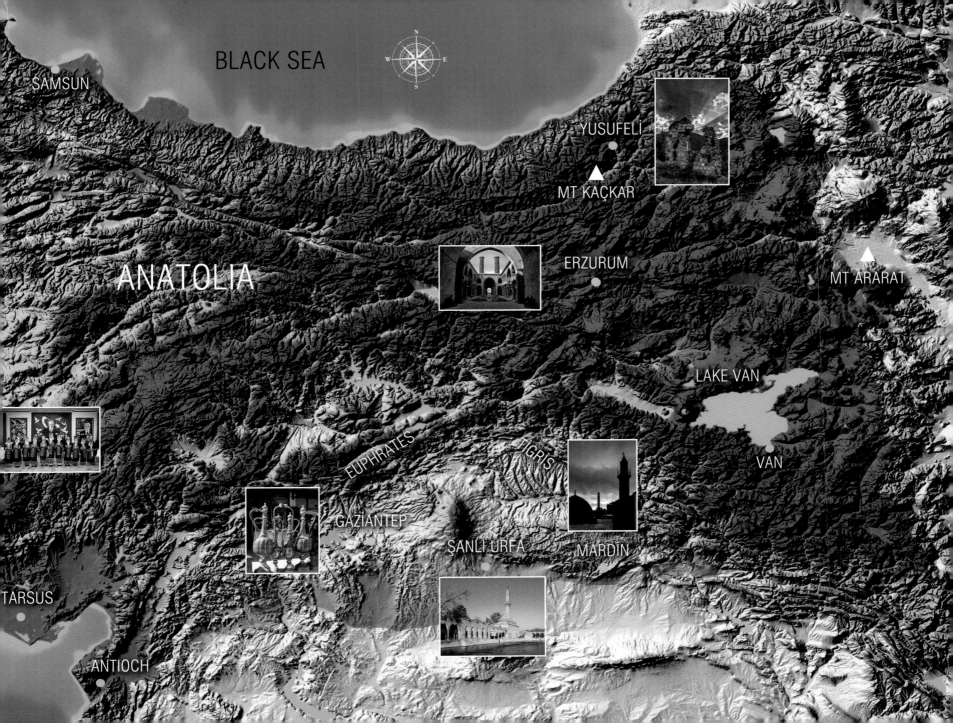